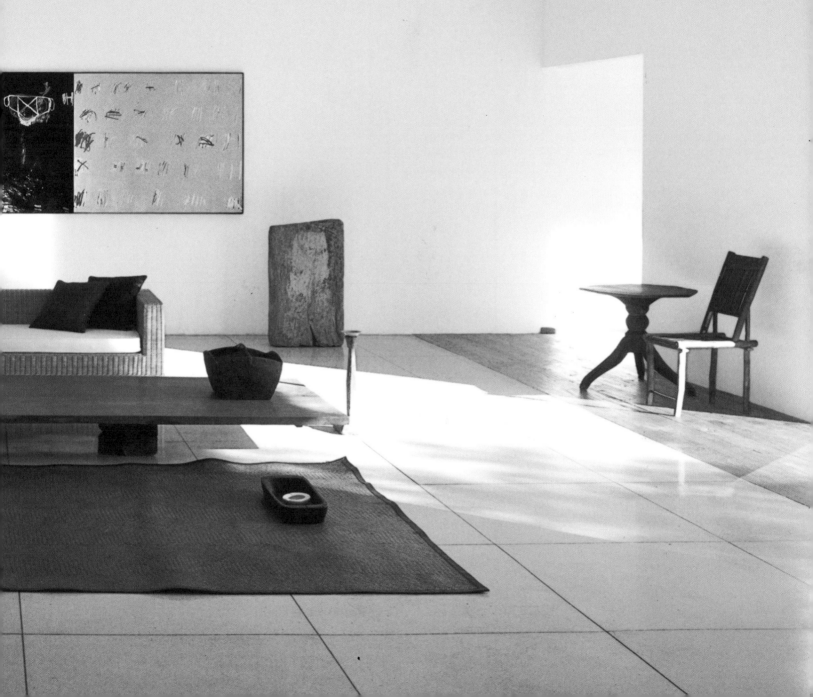

D1093244

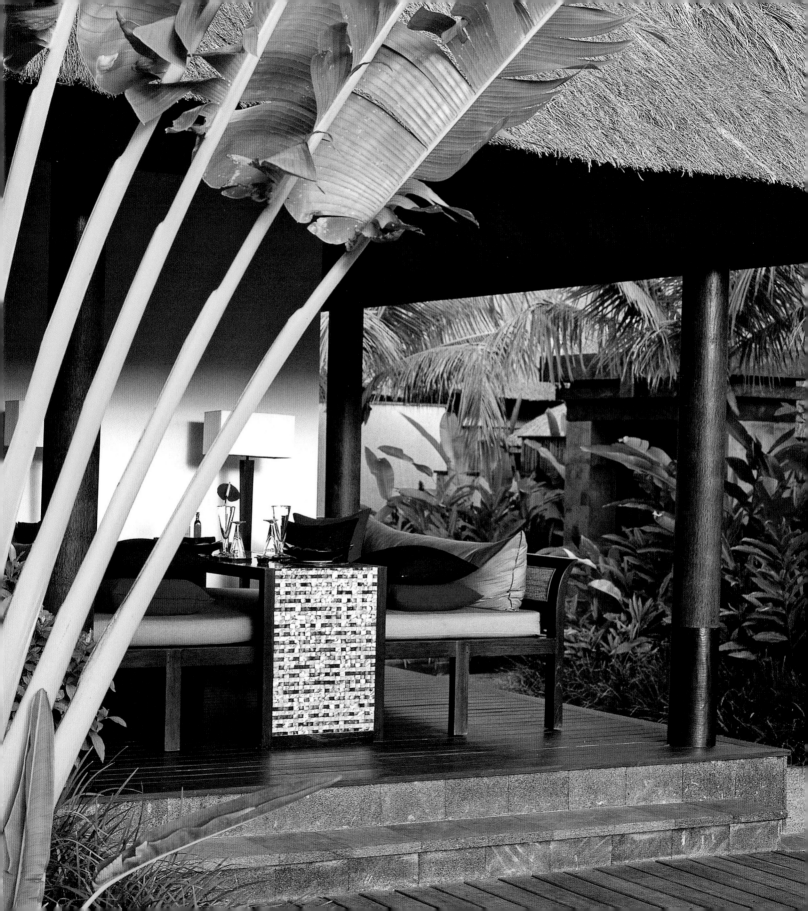

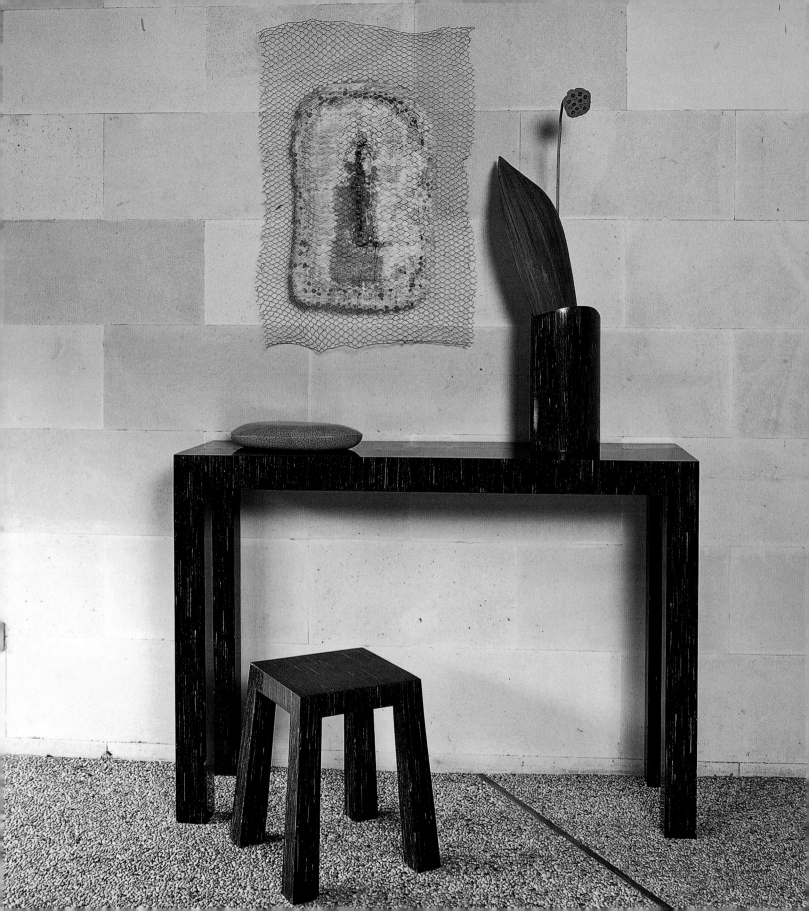

747.0959
I 52

# BALI HOME

## Inspirational Design Ideas

KIM INGLIS

Photography by LUCA INVERNIZZI TETTONI

TUTTLE PUBLISHING
Tokyo • Rutland, Vermont • Singapore

8/17/2010

7768

Published by Tuttle Publishing, an imprint of Periplus
Editions (HK) Ltd., with editorial offices at 364 Innovation
Drive, North Clarendon, Vermont 05759 USA and
61 Tai Seng Avenue, #02-12, Singapore 534167.

All rights reserved. No part of this publication may be
reproduced or utilized in any form or by any means,
electronic or mechanical, including photocopying, recording,
or by any information storage and retrieval system,
without prior written permission from the publisher.

Photos © Luca Invernizzi Tettoni
Text © 2009 Periplus Editions (HK) Ltd

ISBN 978-0-8048-3982-2

Distributed by:

**North America, Latin America and Europe**
Tuttle Publishing
364 Innovation Drive
North Clarendon, VT 05759-9436 U.S.A.
Tel: 1 (802) 773-8930; Fax: (802) 773-6993
info@tuttlepublishing.com
www.tuttlepublishing.com

**Japan**
Tuttle Publishing
Yaekari Building, 3rd Floor
5-4-12 Osaki; Shinagawa-ku; Tokyo 141 0032
Tel: (81) 03 5437-0171; Fax: (81) 03 5437-0755
tuttle-sales@gol.com

**Asia Pacific**
Berkeley Books Pte Ltd
61 Tai Seng Avenue
#02-12, Singapore 534167
Tel: (65) 6280-1330; Fax: (65) 6280 6290
inquiries@periplus.com.sg
www.periplus.com

Printed in Singapore

12 11 10 09
5 4 3 2 1

TUTTLE PUBLISHING® is a registered trademark of Tuttle
Publishing, a division of Periplus Editions (HK) Ltd

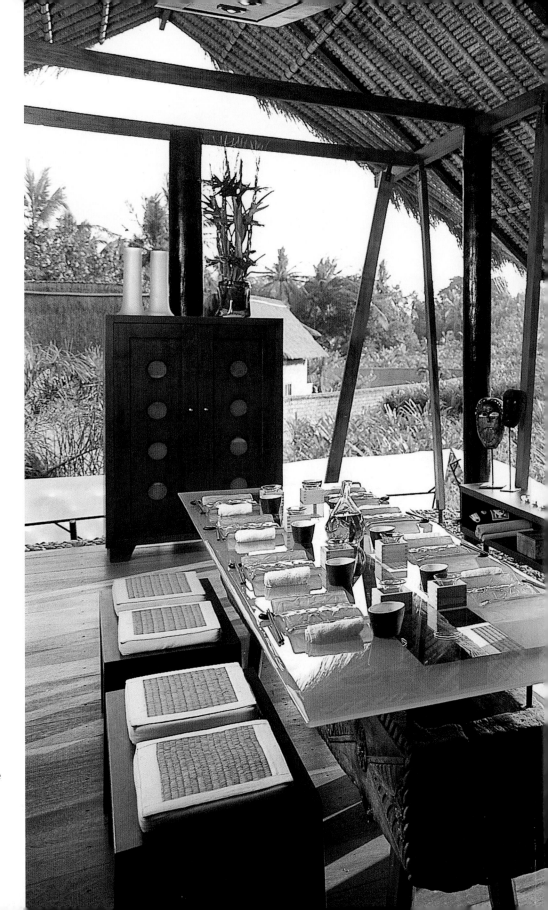

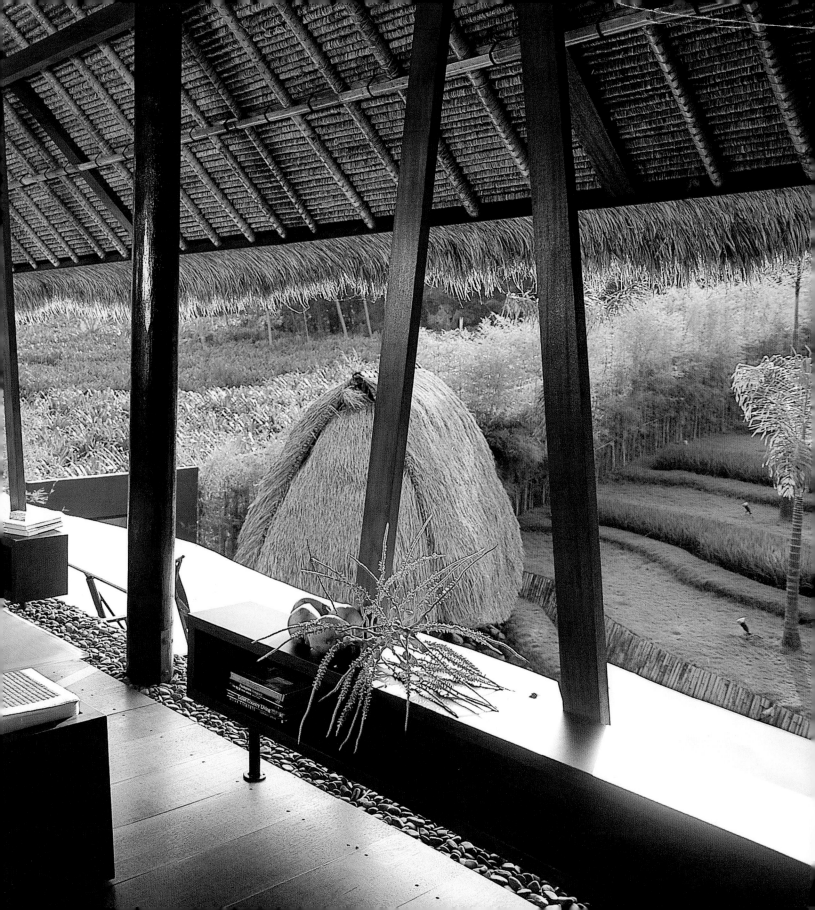

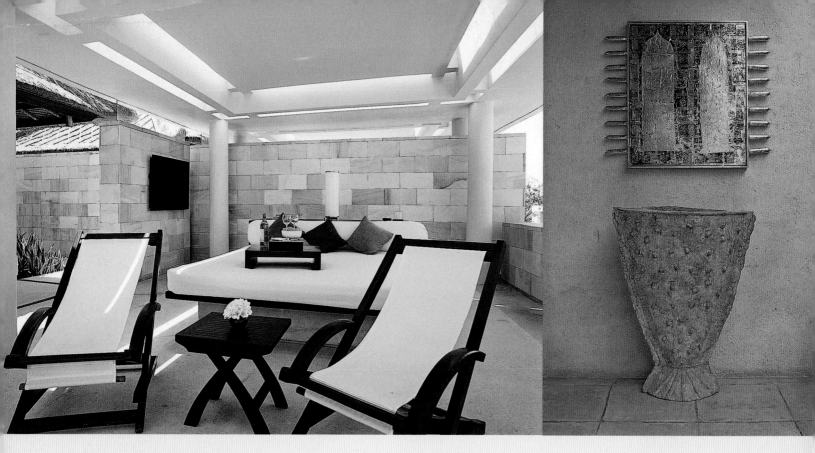

# CONTENTS

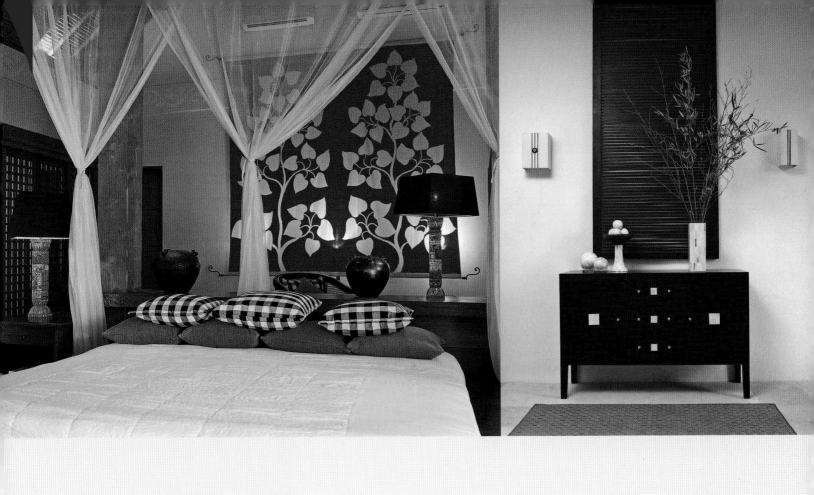

# DESIGNING A BALINESE DREAM HOME

Louis Kahn, one of the mid 20th-century's most influential architects, once said: "I don't like to see a space nailed down. If you could move it and change it every day, fine."

It's a pertinent remark—and one that is backed up by much of the Asian attitude to space. Here, the form and function of a room is often fairly loose. Traditionally, sleeping rooms were often found on balconies or verandahs, living rooms merged with eating areas, the kitchen (often in an outhouse) was the social domain of the home. The idea that space is a fluid concept and could be used for many different activities was both practical (limited resources, smaller homes) and inherent. Quite frankly, the idea of a formal, fixed dining room would be greeted with amusement, and bemusement, by many Eastern cultures.

Kahn's ideas on the fluidity of space are reflected in traditional Balinese courtyard architecture. The domestic compound, housing an extended family, usually comprised, and still does to a certain extent, a series of pavilions set within a walled enclosure. The function of each individual structure, unless religious in nature, is often arbitrary and depends on who is living in the compound at the time. Such flexibility, in its purest form, was what Kahn yearned for. It can be seen in many of the homes, villas, hotels and houses we look at in this book.

Even though each chapter introduces a new space, be it a verandah, open-plan living room, bedroom or bathroom, we show how many of these individual "rooms" can take on other capacities. Verandahs become dining rooms or lounging spaces, dining rooms merge with kitchens, Bali's famed outdoor bathrooms, in many cases, are in actuality mini-gardens. It is really only the bedroom that retains its primary function.

The capacious verandah of this home in Sanur, owned by Italian Carlo Pessina, exemplifies the multi-functional nature of Bali's modern tropical villas. The placement of the dining table, designed by Pessina in resin-based terrazzo with brass insets, allows diners stunning views of the garden whilst eating. If the table is removed, it can easily be replaced by loung-ing chairs or left clear of furniture—perfect for a cocktail party.

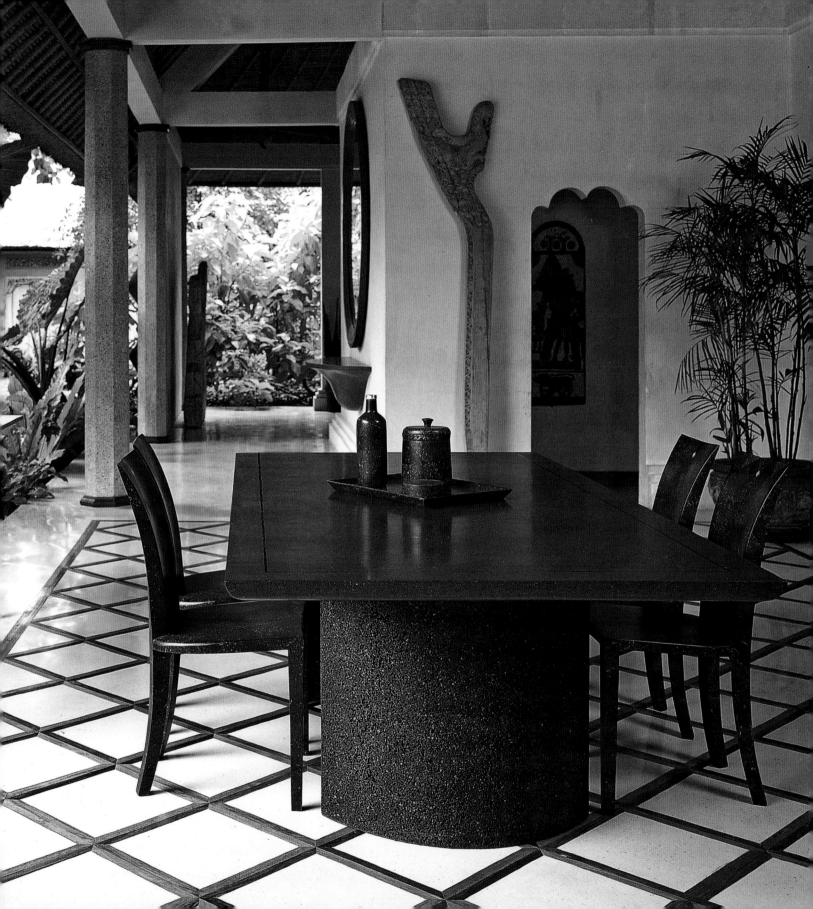

An elegantly curved indoor-outdoor kitchen, designed by architect Valentina Audrito, is compact and open-plan with a picture window that invites the garden into the cooking space. Made primarily from terrazzo, it features open shelving with Jenggala Keramik crockery and wicker baskets for storage.

This blurring of boundaries is a particularly Asian concept. In this book, it is obviously related to the fact that all the properties we feature are in Bali. Situated only a few degrees south of the equator, Bali has a balmy tropical climate and a topography characterized by picturesque rice terraces, lush forests and plenty of water bodies. The climate, culture and geography are conducive for the type of indoor-outdoor living so sought after by tropical dream home seekers.

## The Development of the Boutique Villa

As most people who have picked up this book will know, there's been a long and often fruitful dialogue — in architecture, art and design — between Westerners and locals, much of it inspired by the seemingly innate creativity of the Balinese. Foreign architects, interior designers, artists, sculptors, carpenters, textile specialists and so on are lured to the island by the possibilities they see within its shores: they set up shop; they use their Western knowledge and mix 'n' match it with local materials and talent; they build a tropical dream home or estate . . . Voila, the island becomes a burgeoning "style" centre, with global attention focused on every new development that occurs.

In addition, foreign architects are commissioned to design and build villa-style hotels to cater to the ever-expanding tourist market. As with the domestic house market, these have seen varying degrees of success.

Over the years, these homes, hotels, villas and estates have evolved and changed in style, situation and substance. New ideas and forms are constantly emerging and — even though it's been done before — it's interesting to trace the history of what is termed loosely (and erroneously)

the "Bali-style villa". Purists would argue that there is no Bali-style as such, but other commentators declare that certain tropical traits, both in the interiors and in the architecture, have emerged from the island; these have been adapted and used elsewhere all over the globe.

Most design commentators agree that the first Western house built in the Balinese style was that of the German artist Walter Spies in the 1920s. It is, in fact, an adaptation of the posted *wantilan* structure. Still extant today and comprising part of a boutique resort in Campuhan, Ubud, it paved the way for the second wave of expatriate experimentation: The homes of Han Snell and Rudolf Bonnet, the cottages at Sanur's hotel Tanjung Sari and Theo Meyer's studio home in Iseh, amongst others.

The early 1970s saw a collaboration between the famous Sri Lankan architect Geoffrey Bawa and Australian artist Donald Friend with his business partner Wija Waworuntu at the Batujimbar estate in Sanur. Unfortunately never completed, the project comprised a series of Balinese pavilion-style homes set in classical Balinese gardens. Bawa's masterplan divided the estate into 15 plots, each individually designed with raised living/dining pavilions with loggias and thatched roofs leading into enclosed sleeping rooms decorated with thick walls of rubble and coral. Each was set around a pool, amidst a profusion of decorative masonry and statuary, water features and tropical ornamentals.

With its inspiration rooted in the 19th-century palaces at Klungkung and Amlapura, Batujimbar became known throughout the tropical world for its vision of indulgent, elegant indoor-outdoor living. It paved the way for Peter Muller's ground-breaking Hotel Kayu Aya (later the Oberoi): an organic project, this eventually comprised 75 individual one-bedroom

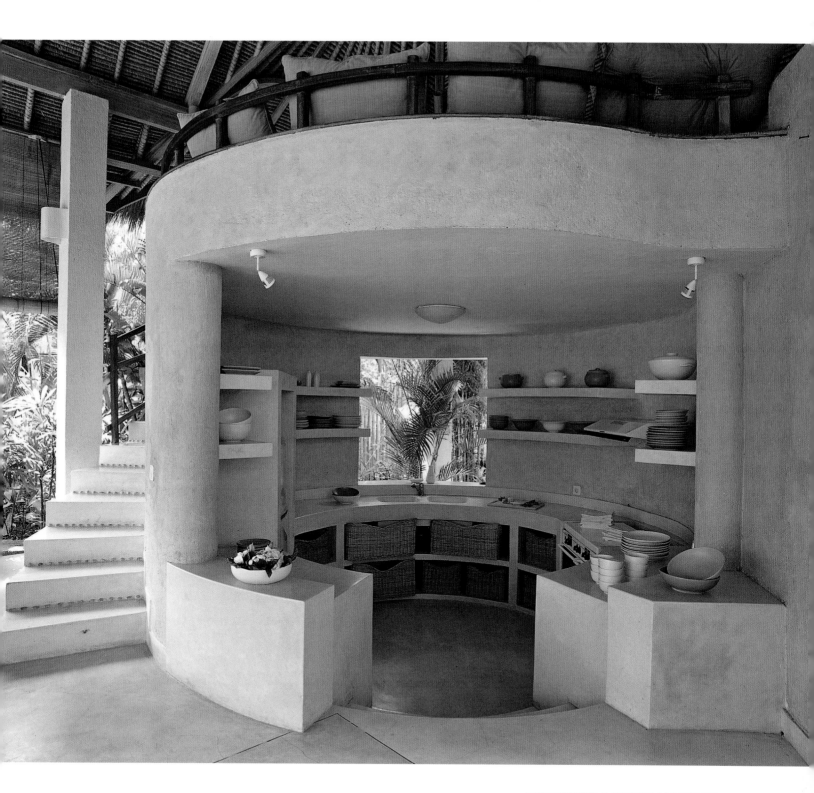

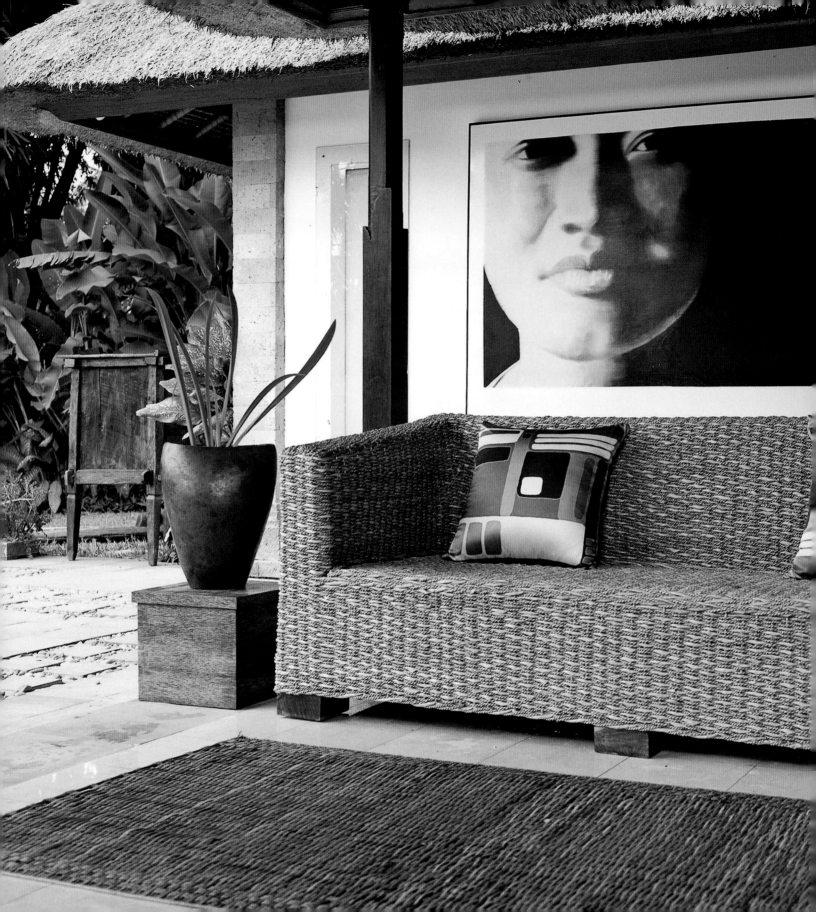

villas set in small Balinese courtyards. Using *alang-alang*, coconut wood, bamboo and coral and rubble walls, it also introduced for the first time the concept of the indoor-outdoor bathroom.

The 1980s saw further developments in both domestic and hotel design: Balinese-style villas began to be exported overseas, specifically to the Caribbean. David Bowie commissioned a Bali-style villa in Mustique and Richard Branson followed suit with a holiday home in Antigua. At home, the Amandari and Four Seasons Resort at Jimbaran Bay were conceived, again in "Balinese village" style. By this stage, constructions were bigger and bolder; interiors ever more lavish; amenities multiplied (for example, at Jimbaran, each villa had its own private plunge pool); and gardens were larger, lusher and more elaborate.

Also, during this decade, landscape designer Madé Wijaya conceived and designed his atelier home in Sanur. Whimsically named Villa Bebek (Duck Villa), it comprises a series of pavilions, courts and water bodies arranged around a central swimming pool. Constantly evolving with ever-changing plantings, statuary, walls and pathways as well as new color schemes, artworks and furniture arrangements in the various interiors, it is much loved and much lauded the world over. Wijaya cheerfully calls it a "work in progress", but in reality it is much more: A showcase for Balinese creativity and talent, as well as a mirror of Wijaya's eclectic, sometimes eccentric, yet always spot-on and tasteful, eye.

As the '80s turned into the '90s, villas became ever more abundant, hotel projects larger, bigger and brasher, and, in many cases, the beauty of Bali was subjugated by a more homogenized tropical style. In the best case scenario, such villas and boutique hotels were termed "Zen-style", "contemporary-Asian" or "minimalist New Asian"; in the worst case, they were downright ugly. Earlier villas' expansive verandahs and open living rooms were eschewed for boxy terraces on very cramped plots. In many cases, their air-conditioned interiors are more suited to a cul-de-sac in suburbia than a rice field in Bali.

**The Villa Scene Today**

However, it isn't all doom and gloom. Naturally, amongst the dross, some jewels shine. Talented designers and architects still work in Bali and continue to produce dream homes of exceptional beauty. Some of GM Architects' tropical-modern villas, sporting a thoroughly contemporary interpretation of indoor-outdoor living, distinctive roofs and sensitive use

Modern meets vernacular beneath the eaves of this outdoor seating area in a gallery in Ubud. Whilst both the sofa and the mat from Borneo are made from local weaves, their designs are fairly contemporary, as are the cushions with their boxy, geometric print. A portrait by Filippo Sciascia is placed off center to counter the rigidity of mat and sofa.

Plunge pools, Jacuzzis, outdoor baths and saunas are now de rigeur in the higher-end villas in Bali. This up-market villa has its own Jacuzzi and herbal mist sauna, as well as semi-private mini-garden. Reeds in boxy planters, a stand of gingers and an old frangipani tree protect the enclave.

of local materials, are masterpieces of design, while Cheong Yew Kuan, Glenn Parker and a handful of other architects continue to produce work that is more than noteworthy, even in a global context.

Whether it's a garden estate near Uluwatu containing remodeled and modernized Javanese *joglo* structures or an eco-friendly wooden villa overlooking the Sayan ridge, these designs look to the future. With sustainability the new buzzword, architects are utilizing building methods that impact less on the environment, recycling old materials (or at least using local, organic ones) and minimizing the inclusion of harmful chemicals and solvents in construction. Such practices are increasingly important to clients committed to sustaining Bali's beauty.

### Interior Design and Decoration

Of course, the decorative schemes employed within the villas varies widely too. In keeping with global trends, over-ornamentation and opulent color have been eschewed for a palette that, for the most part, seeks to soothe and calm, rather than advertize its presence from the rooftops. Overtly Balinese or Asian decoration is on the out, with modern furniture and furnishings, often imported, mixing with local items.

Accents — tableware, lighting, artworks, soft furnishings and the like — are particularly impressive right now. Glass and ceramic artists, textile and lighting designers and all manner of sculptors, potters, carpenters and artists continue to flourish in Bali, producing works of originality and increasingly high quality. There seems no limit to the number of small cottage industries and home ateliers designing and manufacturing homewares for both the local and global market.

Sculptural lamps fashioned from glass and *merbau* wood, blown glass and delicate bamboo, outdoor garden lights in steel and resin, small items of furniture, vases and bowls made from tiny pieces of coconut, shells, silver and mother-of-pearl cut, polished and assembled by hand, hand-fired ceramics and finely woven cushions and bed linens are only some of the items you can source locally. Combining these with different color schemes and bespoke decorative distresses and finishes make for homes of great originality.

We showcase some of Bali's best: Rental villas, hotels, homes, garden estates, beachside *balés*, ricefield views. There are tips for wannabe troppo interior designers and villa owners — how to use color, how to combine wood and white, what accents work, what don't. We guide you through numerous scenarios: how to create a serene garden bathroom, how to elongate a space, what to employ when you want to enlarge a verandah (bring the garden in!). We even discuss the exterior: Pools and poolscapes, pool edging, garden courts, outdoor lighting and the like.

For the most part, the design suggestions work on the premise that less really can be more. We're not advocating the bar, over-stark (or Starck!) '90s style, but we do suggest that restrained and neutral are preferable to loud and overtly ornamented. We advocate fewer, high quality and bespoke, rather than more and mass-produced. There's also a strong commitment to sustainability, with lots of ideas for recycling and remodeling.

"Practical and pretty" probably sums up the book's philosophy. As Kahn was desirous of flexibility, so are we: Let rooms morph into each other, invite cross-habitation and celebrate the unexpected. Your home, as well its inhabitants and guests, will thank you for it.

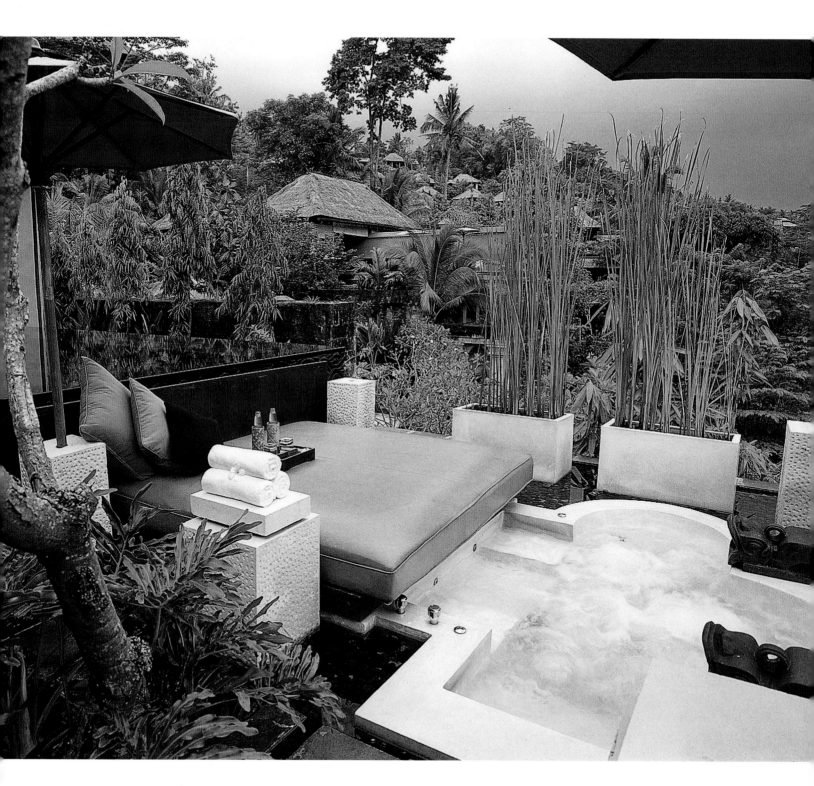

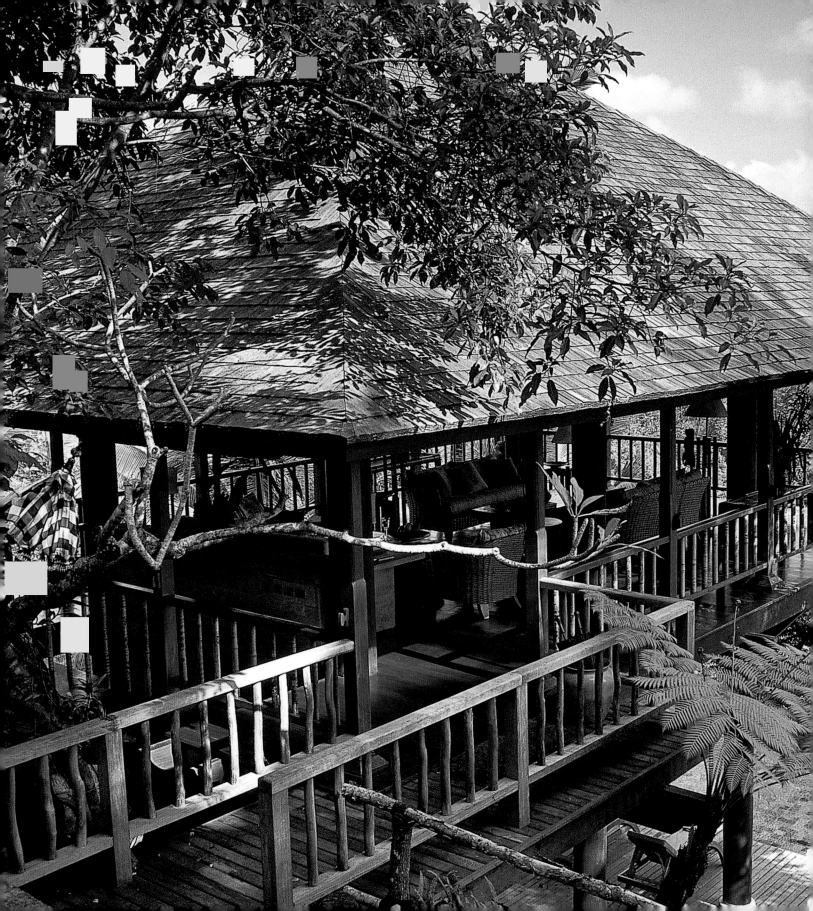

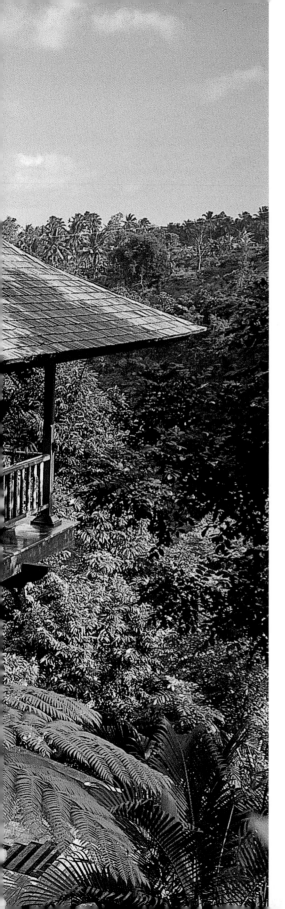

# OPEN-PLAN LIVING

**Whether modern-day Asian designers** realize it or not, most (the good ones anyway!) are influenced to some degree or another by the seminal works of Sri Lankan architect Geoffrey Bawa. The essence of his oeuvre is encapsulated in a combination of respect for local landscape and traditions with a realistic commitment to present-day needs.

As such, the room that dominated his private homes was the living room. Invariably open to the elements, in fact often totally transparent, it always featured an imaginative manipulation of interior space. Glimpses of what lay beyond the immediate environs — be it a planted garden, a sculptural object, a shaft of light — were constants in his designs. A subtle sense of surprise was at its heart.

On the following pages we feature a number of homes with living rooms that pay homage, in one way or another, to this great master. Each is surprising in its own way: There's usually a connection to the outdoors, with water and plantings a possibility, as well as an interior design scheme that emphasizes craftsmanship and detail. There's transparency, often in the form of wall-to-ceiling glazing or a complete absence of walls. Modern artworks are often central to the interior decoration and every small detail is intricately worked.

There may be a more minimalist aesthetic in the furniture and furnishings than was prevalent in Bawa's time, but this simply reflects the global trend to interiors that provide sophisticated calm as an antidote to the increasingly frenetic world outside. The white-on-white palette features prominently, as does a commitment to local materials: these may take the form of recycled old teak, for example, but more often show an ingenuity in the crafting of artifacts and furniture from coconut shards, shells and mother-of-pearl, bone, resin and the like.

Metallics are also seeing a welcome resurgence. Taking the form of abstract sculptures and interior items such as lamp bases, balustrades and bowls, they're made from hammered aluminum, bronze or embossed stainless steel. When paired with soft linens, organzas, silks and cottons, often embroidered or hand-painted with floral motifs, they're a classic combo of hard and soft, durable and delicate. There are plenty of ideas for wannabe decorators in the pages to come.

Bali's home-grown design ateliers are dab hands at hammering, firing, sculpting, sewing and carving increasingly high-quality furniture and furnishings for the island's garden estates, hotels and villas. Combining Western expertise and high-tech solutions with local materials and the innate artistic ability of the Balinese has proved a successful formula.

Turn to the following pages to view the rooms at the heart of some of Bali's most beautiful homes — many with garden vistas and drop-dead ocean or ricefield views to boot. There's a whole section on using different colors in decorative schemes, as well as top tips on furniture, fabrics, metalworks and organic accents for the home.

Begawan Giri Estate, a collection of villas designed by original owner Bradley Gardner and architect Cheong Yew Kuan, is a garden estate unparalleled in Bali, if not in the world. Here we see an open-plan, open-air pavilion living room: seemingly floating above the surrounding forest, it is anchored to a Holy Tree on left.

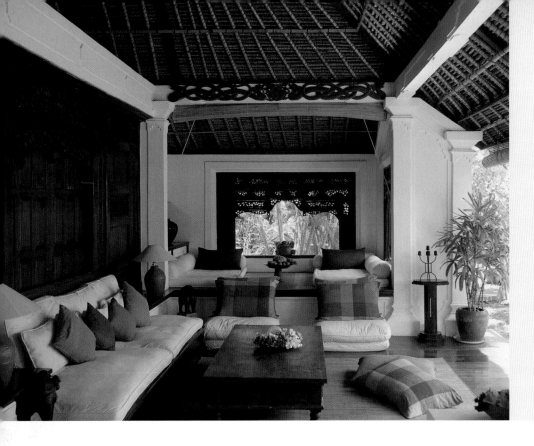

**Left** Open on three sides, this archetypal tropical living room features intricate Javanese lattice windows, elaborate wood carving, low level seating with tropical check fabrics and wooden floors — and of course a traditional organic roof.

**Right** Open on all four sides, this pavilion-style living room at Begawan Giri mixes outstanding tropical views with wood-and-wicker furniture in neutral shades. The fabric with retro bamboo print in foreground is by Bruce Goold (of Mambo fame).

# BENEATH THE **BALINESE ROOF**

**Tropical homes often employ** thatch (*alang-alang*), bamboo, hardwoods, wooden shingles and other organic materials in the construction of the roof. Not only are these practical (they protect from both intense sun and rain, as well as allowing a building to "breathe"), they can also be extremely beautiful.

In recent years, one Bali-based architecture firm called GM Architects has taken the organic-themed tropical roof to another level. In their projects, the roof is typically angular with bold structural lines, often cascading from a high pinnacle to almost reach the floor. Sometimes formulated in multiple repetitions, the roof doesn't so much house a home, as hover above it like a giant parasol or the upside down keel of a boat.

Such protection that it affords allows for an extremely fluid transition of space beneath. Traditional entrances and windows are often eschewed for a central cut between two wings of roof, thereby encouraging cross-ventilation and the admittance of light through such partitions. From an internal perspective, the geometric planes and angles formed by the roof add dynamism to any interior scheme.

Here we show a selection of living spaces, often with fluid indoor-outdoor transitions, that illustrates the beauty of the Balinese roof. Note how the surrounding gardens often form an integral part of the "indoor" furnishing scheme.

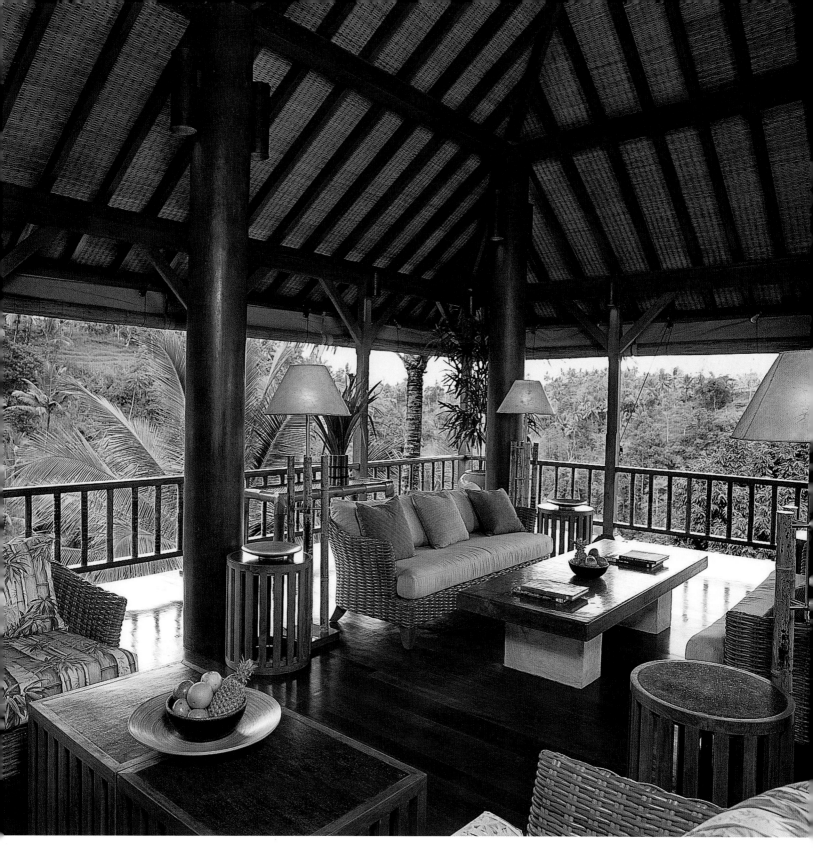

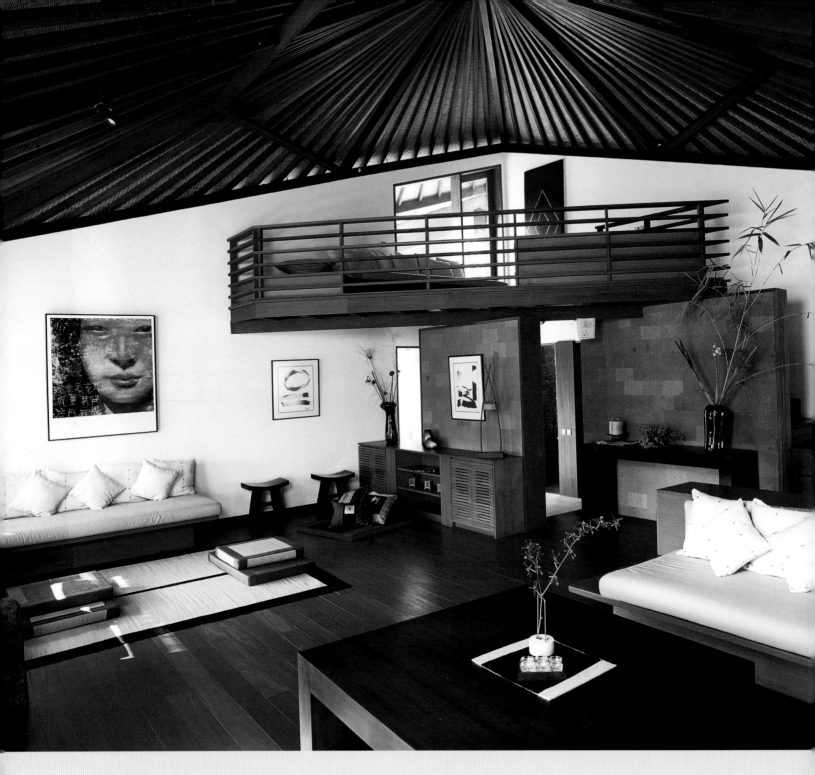

**Above** Perfect pitch: A clever pentagonal roof soars above this double-storey living room, notable for its size and spaciousness. Ethnic and Western furniture, artworks and design details create a fusion-themed interior.

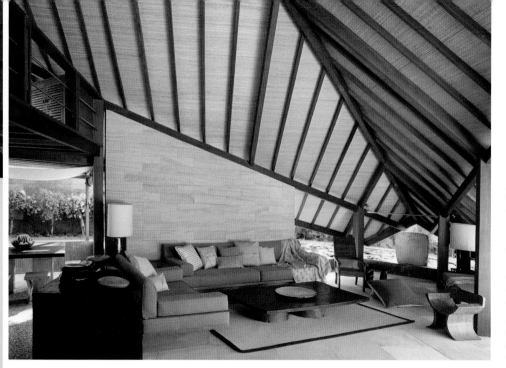

Left Tactile stone, a sloping wood-and-weave roof, neutral colours and natural woods in the furnishings and picture windows to the garden give this indoor-outdoor living room a tranquil feel.

Below Simple furniture upholstered in black, white and grey allows garden views to take center stage in this open-plan living room. The defining roof, with woven matting inside and Borneo wood shingles on the exterior, is the fundamental architectural element. As with all GM Architects' projects, its articulated form defines the contours, spaces and layouts of the "rooms" and their contents below.

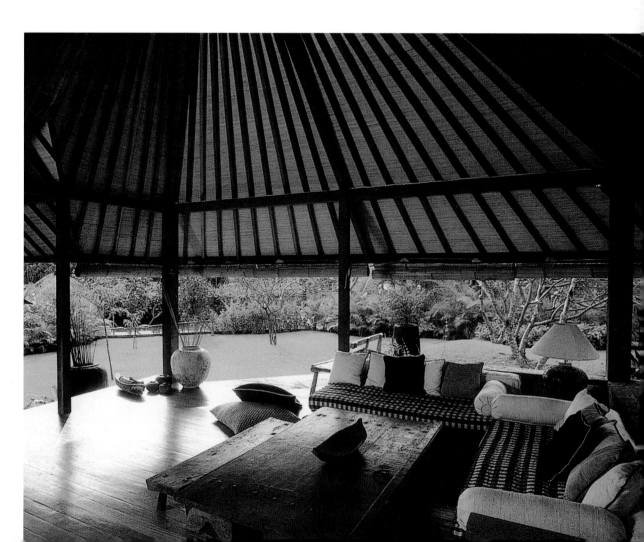

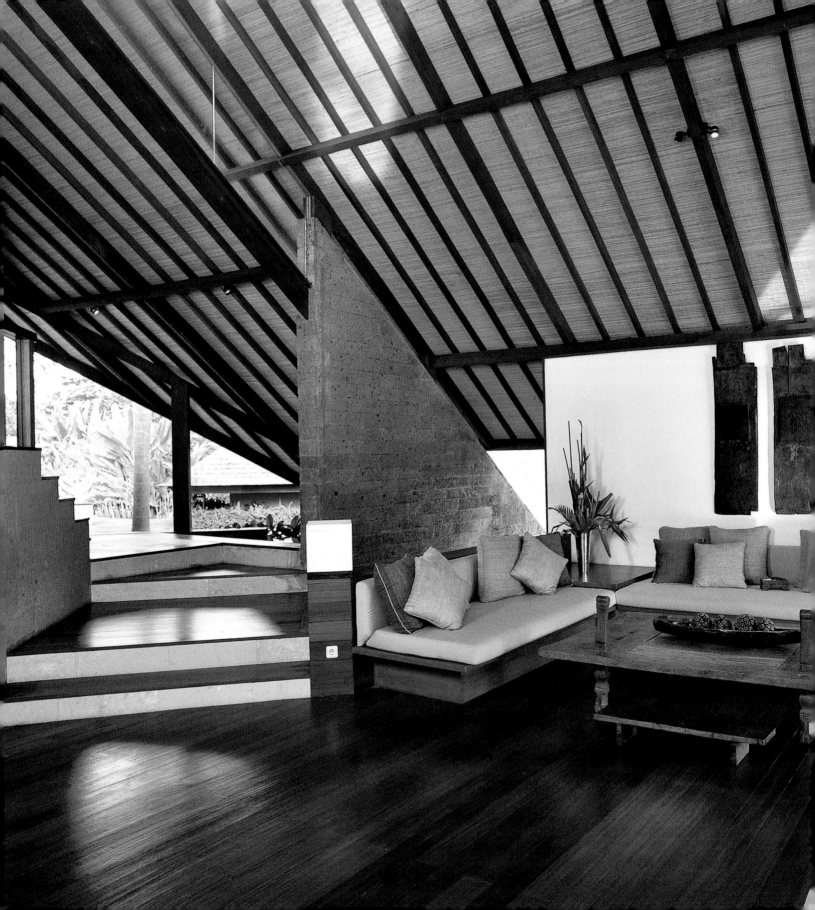

Left Different levels in the flooring and different articulations in the roof (rather than walled-in rooms) define different spaces in this home designed by GM Architects. A communion with nature is encouraged with plentiful views of the surrounding gardens. Below A huge double-height pavilion living room with upstairs viewing platform is furnished with elegant silks and cottons in deep sage and beige.

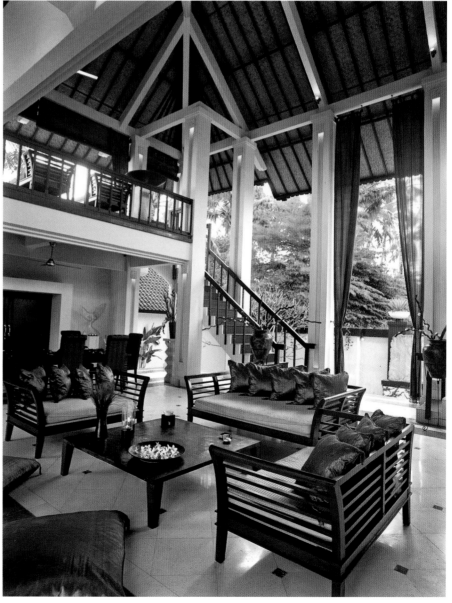

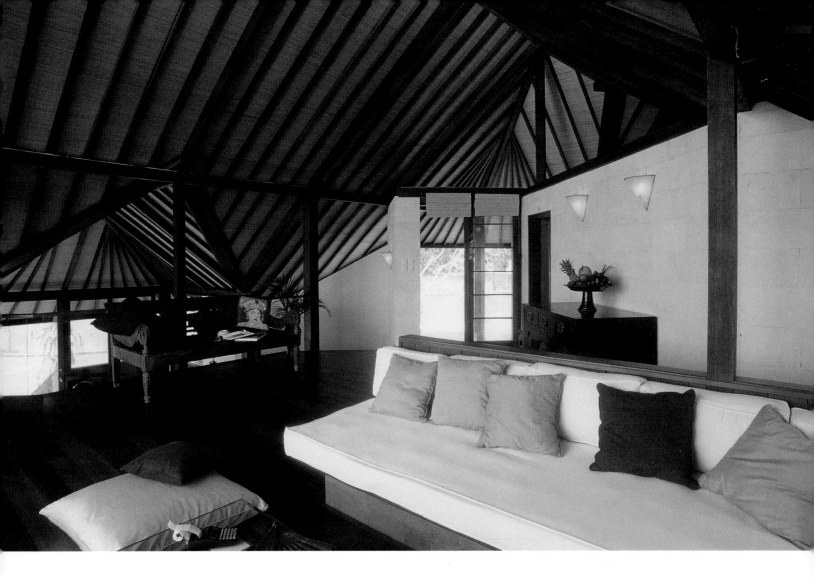

# USING FIERY SHADES OF COLOR

**Even though the opposite should appear** to be true in the tropics, vibrant fiery colors with accompanying textural detail can work well against a neutral backdrop of white. You think they would heat up a room; in fact, they do the opposite especially if paired with white plaster, pale stone or concrete, or bleached wood. Somehow, a neutral background allows the bright shades to make an impact, but not to the extent of becoming overbearing.

Similarly, asymmetrical stripes and planes of color can add character and boldness, contemporizing a room without totally dominating it. If working with hot shades at home, don't allow the heat to take over the kitchen, as it were. Keep it contained with a feature wall, a picture window, or some bright accessories in the form of scatter cushions or abstract art.

Allow the room to breathe with plenty of neutrals as well: your ideal combination is a backdrop of white or grey and plenty of texture in your reds. Warm earthy colors — oranges, terracottas, coppers, magentas — bring to mind tropical sunsets; light has a magical effect on such colors, so use them carefully. Restraint is all.

**Left** This living room could be diminished by its articulated and oversized triangular roof that extends almost down to the floor on one side, but saves itself with the appropriate use of color in the scatter cushions. They bring the eye down to seating level — and allow the roof to hover, not bother.

**Below, clockwise from top left** Le Corbusier once remarked: "Color adds to the total experience of architecture; it can make space infinite." The fiery shades seen below can open up spaces for dramatic effect. Bold graphics are teamed here with plain red, a great example of imaginative textural pairing. Curtains and hand-embroidered cushions with Laotian motifs from French fabric designer Dominique Sequin are refined and delicate. Bright sunset shades of yellow, orange and fireman's red in soft Indian cottons work well for quilts and cushions. In this artist's residence, red acts as a counterpoint to the dark wood-and-white theme in the living room. The painted wooden chair and low-level sofas bring life and vitality into a somewhat subdued space.

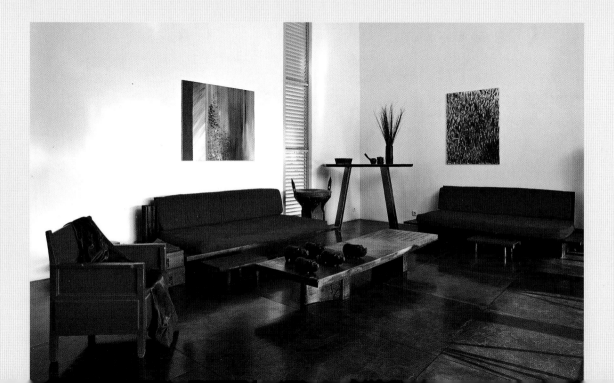

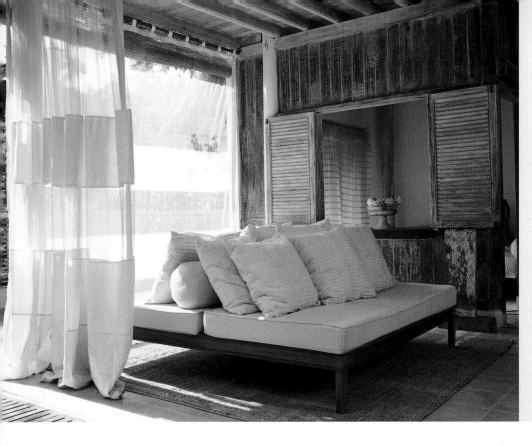

**Left** Texture can take on new connotations when working with white, cream, ecru and eggshell fabrics. Here, soft cotton cushion covers and delicate drapes from the Esprite Nomade line become more contoured, more organic with the absence of other colors. **Right** A modernist home in Bali designed by Cheong Yew Kuan relies on wood-and-white for its decorative scheme. Views of the garden on all sides bring enough color into the picture; ivory stone columns and beams, resin-washed, polished floors and low-level cotton drill seating are strictly neutral in comparison.

# USING **WHITE ON WHITE**

**We are told that white isn't actually a color** at all, but a blending of all colors together. Ask any designer — and they'll concur. This is because white takes on the hues of other colors, transforms constantly according to the time of day, and also reflects light, thereby changing other colors and shades around it.

White works well with almost any color, but the current trend of white-on-white goes well with ash or bleached woods, neutral concrete, ivory or sand-blasted stone, polished resin-covered floors and plentiful natural light.

"People are often apprehensive of using white," says interior designer Karina Zabihi of Singapore based kzdesigns, "it is much maligned." She, however, loves using it in her work as she sees the many shades and tones of white offering infinite possibilities. She suggests introducing contrasting textures — a crushed velvet throw on a pure white cement bench, for example, is both sensual and soothing. Sheep skin rugs on a white stained timber floor, an old rocking chair painted a distressed white, big oversized off-white cushions and soft lighting instantly create a comfortable beach house feel, she says.

Our advice? Put aside misconceptions of white, and use it daringly for more than a splash of panache. You'll get instant summer-fresh appeal in any interior.

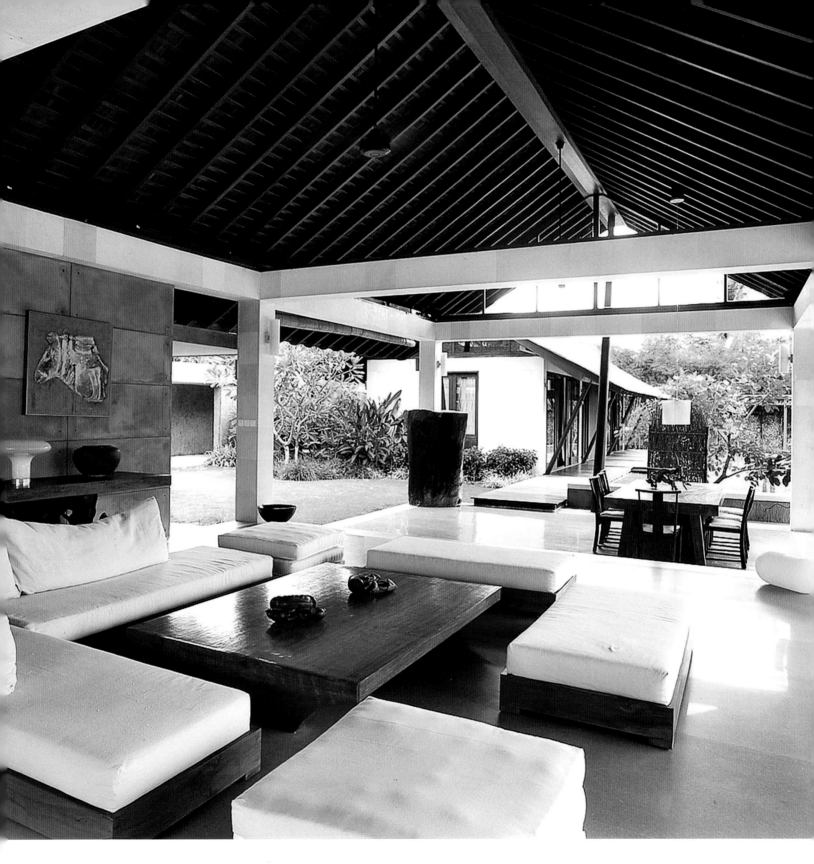

# COOL BLUE

**Serene is the best word to describe** the effect that blue can have on a room in the tropical home, but the color also translates effectively into cooler climates where deeper shades of blue can be both warming and nurturing. Either way, it is a color with enormous versatility and potential.

The trick in the tropics is to focus on the details: A splash of color here, an abstract painting there, and some choice accessories in the lightest of light blues will bring a sense of restful ease into any tropical room. Glass works well with blue, allowing spaces to take on a somewhat dreamy, underwater feel at certain times of the day, whilst neutral sisals, plain woods and cool marble are the best floor coverings to bring out its different shades. Ivory or white on walls is a must.

Asia's rich batik tradition lends itself to some wonderful decorative patterns of blue and white as does the traditional blue-and-white porcelain of China. For a more updated ceramics look, we recommend almost transparent blue glass vases, pots and bowls; when teamed with metallics, these can look very chic. And for fabrics, team different shades and textures — cobalt, natural denim, sackcloth and chiffon — for an unfussy, pure effect.

Far left In this villa living room at Downtown Villas in Seminyak, fussy patterns and florals are eschewed for larger expanses of blue and white — on the floor, upholstery and walls. Accessories and accents, such as the lamp-shade and glass bowl on the table, continue the theme.

Left A feature wall with washed blue background and silver stenciling is sublimely restful in a bedroom.

Below, left Calm blue is particularly appropriate in tropical bedrooms: textured linens in blue and white make for pleasing bedfellows.

Below, center Natural light reflects off the white wicker from this Peter Bunter Design chair to bring out the deep cerulean blue of the cushion. It gives a tint of blue to the marble floor too.

Below, right Batik, with its complex symbolic patterns, is a popular medium for interior design. Here, a wooden stand, traditionally used to hold the piece of cloth whilst the design is being drawn, is used as a decorative item in itself.

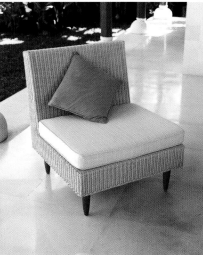

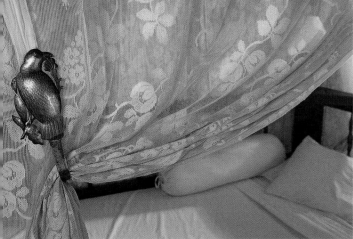

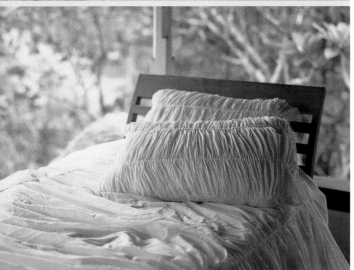

Top This antique four-poster day bed called a Raffles bed is decked out in old lace mosquito nets or *kelambu*; the silver hook, fashioned in the form of a diamond-eyed tropical bird, is also an antique. Recycling old fabrics is a great way to tell a story in any space.
Above Ruched cushions in pristine white from Esprite Nomade give this lounger comfort and character.
Right An exotic relaxation niche is characterized by texture and color: shielded by an organza drape hand painted by textile artist Dominique Seguin, it draws the eye with its silk scatter cushions in lavender, burgundy and hot cerise.

# WORKING
# WITH FABRICS

**Fabrics are the life-blood of the home:** combining with light, they add texture, focus, atmosphere, color, contrast and/or soul to any room. Many designers say that they start with the fabrics when formulating an interior scheme; the right choice is crucial for the overall effect.

Visual balance is the aim of a well-designed space, along with comfort, personality and atmosphere of course. Fabrics can be key in obtaining this balance: when teamed with furniture, flooring, wall coverings and more, they are the sensual, textural icing on any room's cake. Without them, a space can seem bare and uninviting.

Fabrics don't always have to be super luxurious to be effective: soft cottons, felts and towelling can be just as sensual to the touch (and sight) as expensive organzas, silks and suedes. In Asia, it is often the cheaper, local fabrics that work best: try using sarongs and batiks for cushions and soft furnishings and dress up windows with floaty drapes or Roman blinds. Clever shielding of the hot tropical sun can create different patterns of light and shadow at different times of the day.

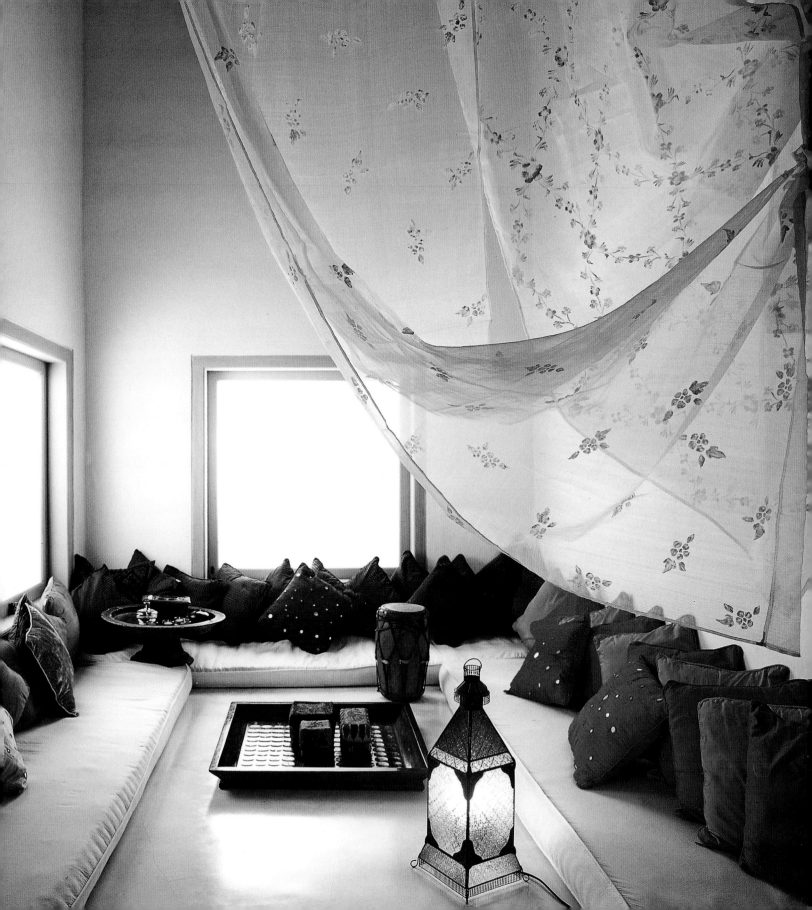

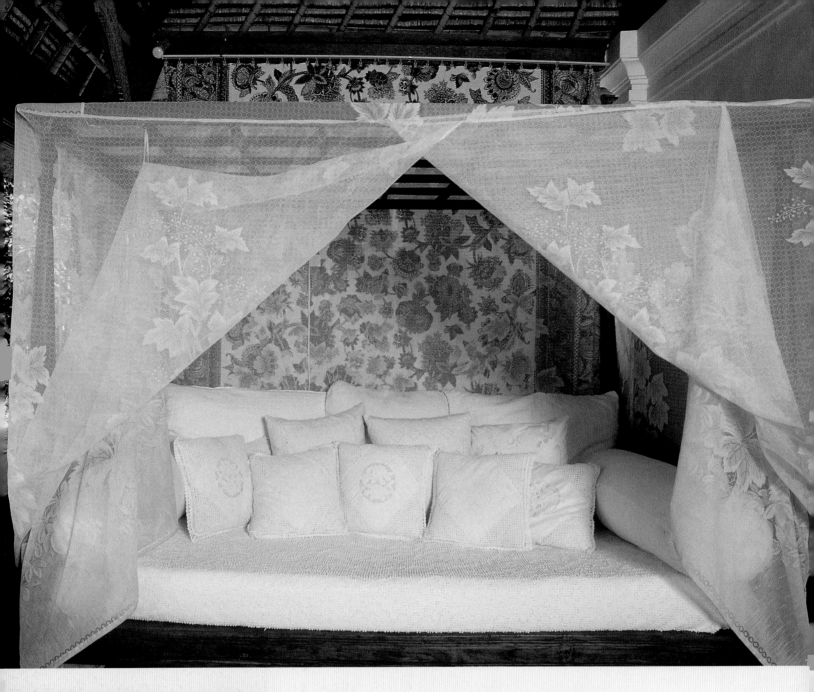

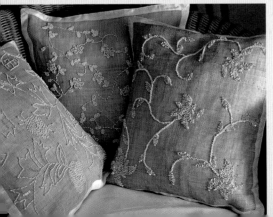

**Above** Good design is about avoiding the obvious, and this composition — where ceiling, built-in sofa, upholstery, floaty drapes and cushions work harmoniously together — allows the delicate textiles on the wall behind to become the main focus of the whole.

**Left** Texture and contrast are key elements on these hand-beaded scatter cushions, designed and manufactured by Dominique Seguin. Teamed with white and wicker, they are delicate, almost ephemeral.

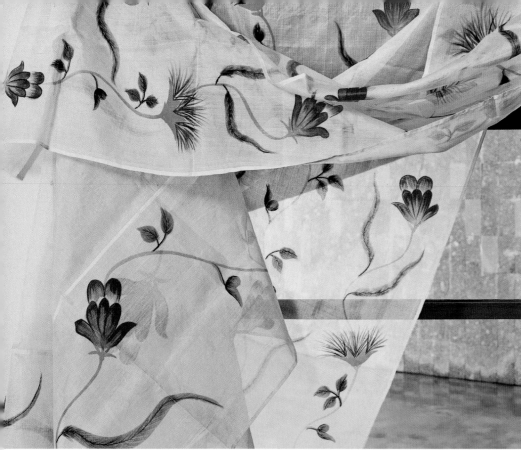

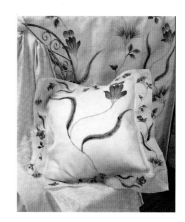

**Above** A highly feminine effect is achieved here with hand-painted pink and green floral patterns on high-quality organza bed linen. By Dominique Seguin.

**Right** Multi-layered cushions and bolsters designed by Anneke van Waesberghe for her Esprite Nomade range complement this space decked out with bleached wood, natural matting and organic accents. The voile and silk hangings, along with extended eaves outside, keep the area cool during the heat of the day. A central mosquito net is useful if guests need the sofa to double up as a bed.

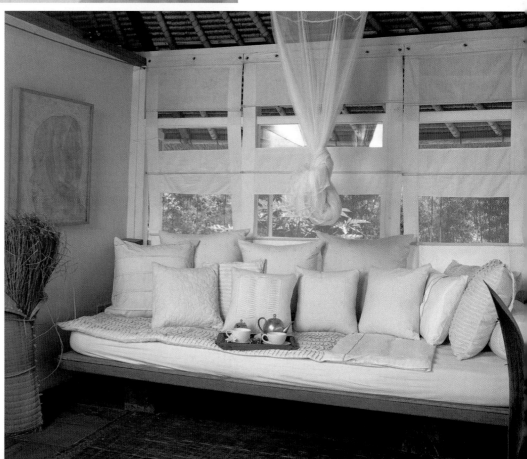

# ORGANIC
# ACCENTS

**Items fashioned from the natural** world bring the relaxing tones of nature into any interior: a connection with the outside world, they add warmth, texture and spirit to a home.

Wood, sometimes recycled and reinterpreted, is often the basis for organic artworks. Its grain and color are key in such pieces. In Asia, it isn't unusual to find hardwoods, bamboo, local timbers, thatch and plant fibers (to name a few) finding new life as modern-day artifacts, furniture and furnishings. Adding authenticity to any interior, they are often combined with other substances, such as stone and glass.

Many artists working with organics cite the sensuality of the raw materials as their major inspiration. That, plus a sense of history, contributes to making their artworks unique so they become — literally — one of a kind.

Of course, how such pieces are displayed is of crucial importance. Designers maintain that the art of display is often overlooked, because so much effort, time and work has gone into formulating the "bigger picture" of an interior. We suggest going for bold, unexpected and contrasting combinations: squares with circles, hard with soft, durable with living. The more daring you are, the more enduring the effect.

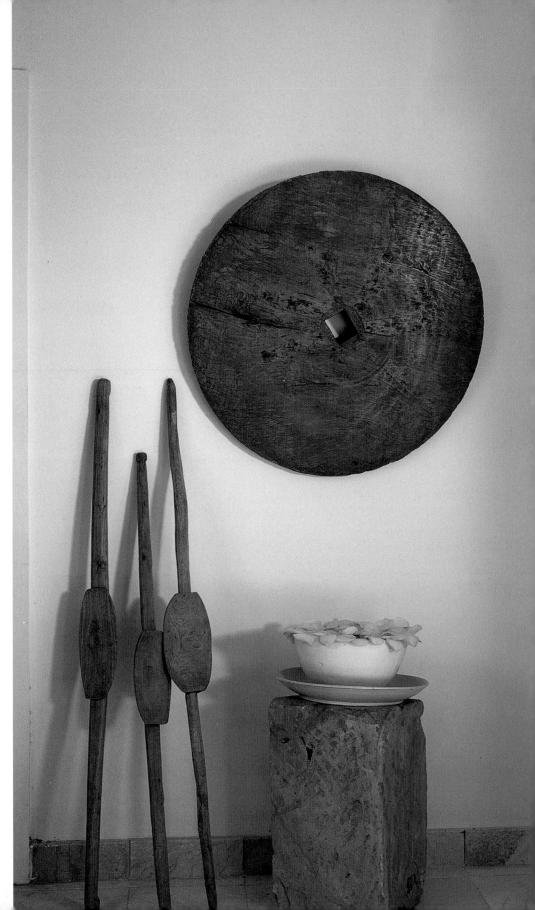

**Opposite, top** The iridescent shades of turquoise, deep blue and yellow work well with this antique wall panel to form an arresting, surprisingly contemporary, artwork.

**Left** Old farming implements have found a new home set against a wall in the Komaneka resort in Ubud: seemingly randomly displayed, they make for an attractive composition.

**Right** Streaming natural sunlight gives definition to this imaginative combination of stones and organics; the wall behind almost seems to dance in the light.

**Below** Definitely decorative rather than utilitarian, Bali-based glass artist Seiki Torige's "Lombardi Chair" is sculpted from weathered teakwood planks, recycled glass and metal. Again, old forms make for a modern artwork.

**Below, right** Ubud-based artist Sumio Suzuki specializes in taking different hardwoods and transforming them into quirky art pieces. Here, the warmth of wood is brought out in a mini table fashioned from a recycled piece of teak, a child's chair made from one piece of mahogany, and an over-large lamp in rice paper and mesh.

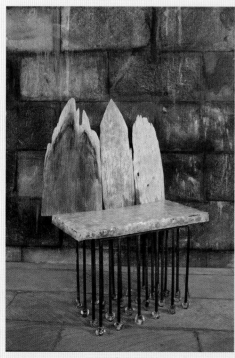

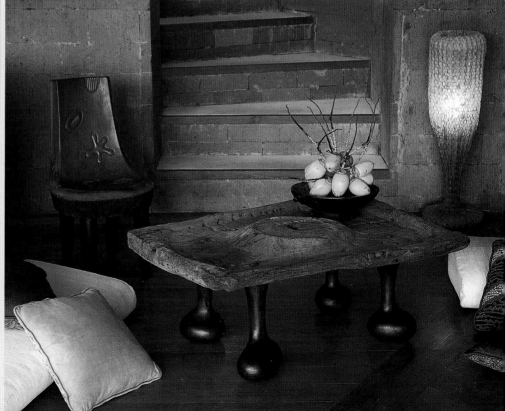

# METAL
# WORKS

**Metalworks are currently** experiencing a resurgence in popularity in the home due to the fact that metal artists are increasingly producing both functional and decorative items of extraordinary beauty. Carved, cast, moulded, modeled, wrought and welded into sinuous, shiny shapes, they add a tactile feeling in any interior.

Aluminum, bronze, iron, stainless steel and copper are just a few of the metallics that sculptors are working with these days. Using both traditional and modern methods of fabrication, the range of objects produced is truly mind-blowing. Lyrical and uplifting abstract pieces seem to be just as sought after as more useful items such as gates, grilles, furniture pieces, candle-holders, vases and the like.

Bali-based metalsmith, Pintor Sirait, began working with steel but found it rusted in the tropics. He then used paint on metal, but found that the paint didn't last. Eventually he settled on stainless steel, a material that is very difficult to manipulate. As an industrial material "it raises the interesting and challenging question of how it becomes a part of the art and design scene," he says, but ultimately he enjoys the tension he believes it brings to his work.

In addition to Sirait's work, we also showcase some other metal pieces; take inspiration from these household objects that transcend their functionality to become works of art.

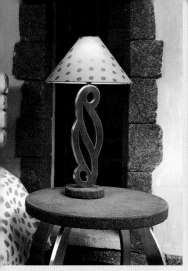

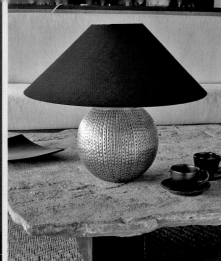

Above, from left to right Stainless steel lamp with polka-dot elastane shade and lavastone base, designed by Pintor Sirait; the shape is inspired by a *parang rusak* or double helix design, often used in batiks. An undulating metal mesh forms a clever screen behind which nestles a light bulb; when lit it casts dancing rays of light on the wall behind. From Galeri Esok Lusa. The rotund hammered metallic base of this textured lamp contrasts with its angular shade for pleasing effect. The purity of this metallic vase by Pintor Sirait is accentuated with a bunch of white flowers: clean-lined and fresh.

Opposite The restrooms at Lamak, a restaurant designed by Madé Wijaya in Ubud, are accessed through heavy metal doors with culturally-inspired sculpted detail. The retro fittings and colonial-era Dutch tiles ensure a trip to the toilet a worthwhile expedition.

Right Huge, semi-circular staircase in stainless steel with wooden treads is inspired by *lamak* designs and realized by Pintor Sirait for Lamak restaurant. *Lamak* are mats woven from coconut and banana leaf that one finds hanging from shrine altars in Bali.

Below Simple, organic shapes in asymmetric styles form the basis for these cute stainless steel lamps with Thai silk shades. Also by Pintor Sirait.

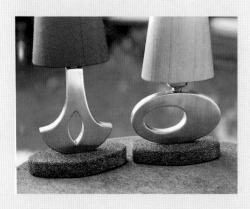

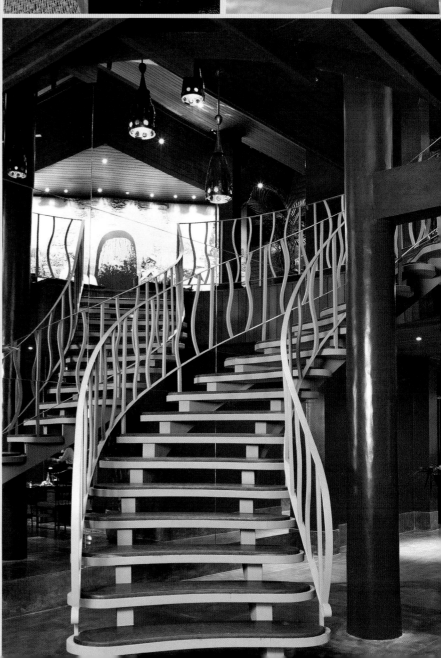

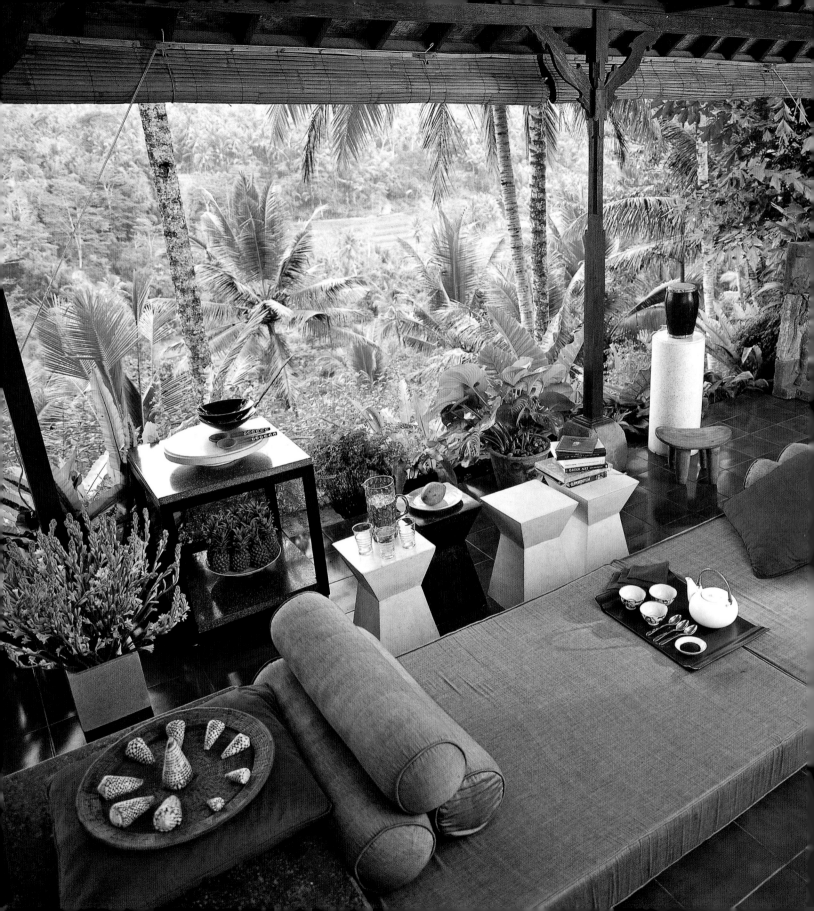

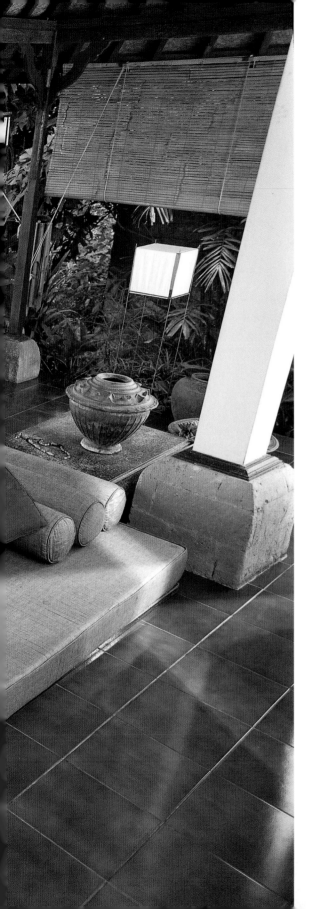

# ON THE VERANDAH

**The verandah, that archetypal indoor-outdoor "room" of the tropical home,** ranges in design from the extremely simplistic to the highly stylized. The examples on the following pages depict all shapes and sizes, with decor to match: whether it is a simple bench or chair with a view over a fragrant tropical garden or an artfully arranged cluster of exterior furnishings that architecturally extends the home's interior, is unimportant.

What is important is the way in which this space is organised, what is found beneath its extended eaves, and how designers are interpreting this most traditional of inside-outside boundaries.

In warmer climates, the verandah is so beloved because it has all the advantages of the outdoors, but is protected from both burning sun and violent rainfall by copious overhangs and, sometimes, by rattan blinds or "chicks". An "in-between" space, it encourages cross-ventilation of breezes, casual indoor-outdoor relaxation and a connection with the garden. In many cases, it becomes the focal point of the home.

In temperate countries, it is often amended with the addition of glass, thereby giving the illusion of outdoor living, but maintaining protection from the elements. And, increasingly, air-con aficionados play the same game in the tropics; the transparency afforded by floor-to-ceiling glazing gives the space the appearance of a verandah, yet it is, in fact, enclosed.

Leaps and bounds have been noted recently in verandah furniture and furnishings. Designers are now talking about exterior furniture in the same way that they wax lyrical about high-end Italian brands of interior furniture. Traditional teak loungers, colonial-style wicker and cane chairs and Victorian wrought-iron repros are increasingly being replaced by all-weather furniture made from synthetic fibers in a variety of textures, styles and colors. Glamorous and sophisticated, these pieces can withstand extreme heat, rain and cold. Furthermore, they're incredibly varied: opt from modernistic, metallic and sculptural styles to curvaceous recliners in neo-weaves.

The use of color in shower-resistant cushions and coverings is another development that favors contemporary verandah design: High-performance materials have allowed designers to experiment with a more ambitious palette, and increasingly traditional beiges and browns are being replaced with hot neons and cool blues. White, of course, remains a popular favorite; as well as changing with the light, it reflects other colors around it.

Turn to the following pages for a selection of open-air verandahs that are guaranteed to inspire tropical dream-seekers everywhere. The domain of the diehard colonial has found new life with natural organics (decking, driftwood, stone finishes), strong colors (cerise, purple, hot pink) and even urban, streamlined pieces — perfect for a penthouse or cityscape.

Escapist? Probably. But that's the point of this most casual of indoor-outdoor spaces, isn't it?

A combination of traditional (bamboo chicks, wooden supports, *alang-alang* roof, terracotta tiles) and modern (Japanese-style floor-level lounging, a cool color scheme of grey and red) characterizes this stunning tropical verandah. The overwhelming feature, naturally, is the view.

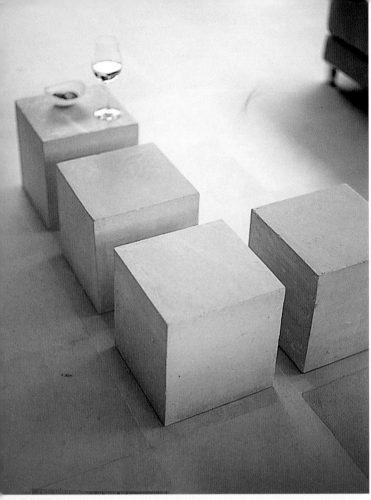

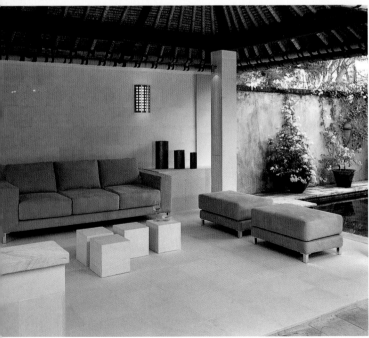

# CUBES **OF COOL**

**The construction and layout of homes** in Asia is in large part a response to climate and culture, as well as to the availability of building materials. However, it also reflects the deeper philosophies and preoccupations of the occupants.

Most traditional homes followed strict guidelines as to their orientation, the placement of certain areas (ie ancestor altars, family shrines, cooking spaces and so on) and the relationship between indoor and outdoor spaces. Highly valued was a sense of order and harmony.

To achieve this order and harmony, different cultures have developed different practices. The Chinese employ the principles of *feng shui*, the Indians rely on *vaastu* and the Balinese have a number of building laws known as *asta kosala kosali*. Even though there are variations in the forms they take, the primary function of these systems is to ensure that the gods are appeased, the occupants are happy, the spaces are functional, and greater harmony between the spiritual and the physical worlds is attained.

This cool verandah and court with attendant pool is a classic example of Asian order. Geometry is to be found in the rectangular and square shapes of both spaces and furniture; there are no ugly angles or hidden corners; symmetry is paramount; and the cooling pool allows both fresh breezes and positive *qi* or life force to enter the living space.

Opposite, top Limestone blocks from West Java are positioned in a propitious L shape to make unusual tables.
Opposite, bottom Soft grey sofa and ottomans, limestone pillars and floor, and stainless steel in the lighting form the neutral palette for the airy and open verandah. The design is by Richard North-Lewis of Stoneworks.
Below "*Qi* rides the wind and scatters, but is retained when encountering water" goes a saying in *The Book of Burial* or *Zhangshu* by Guo Pu (276–324). This verandah is perfectly positioned to capture a vibrant flow of *qi* or life energy as it is secured by the attendant pool.

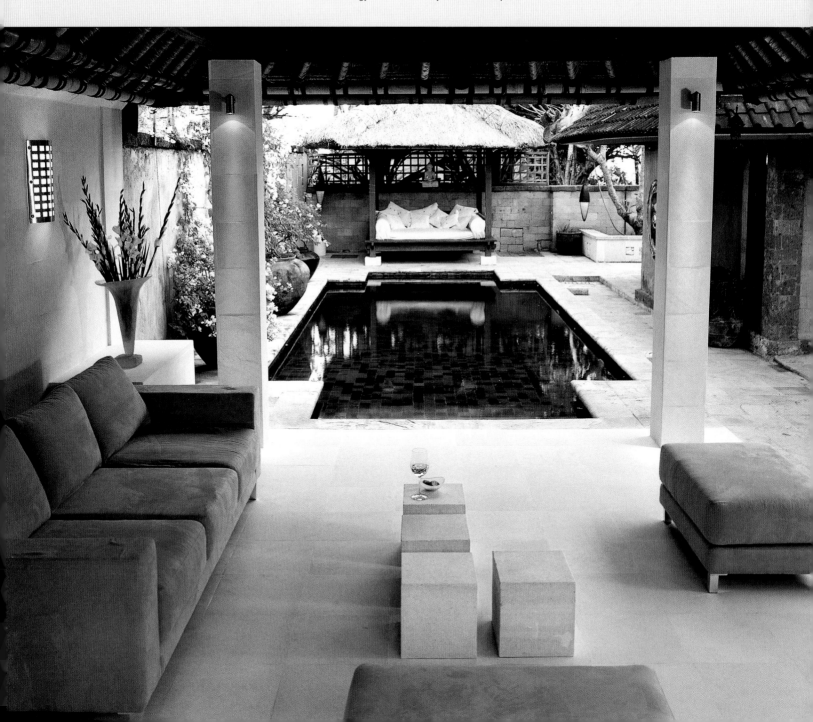

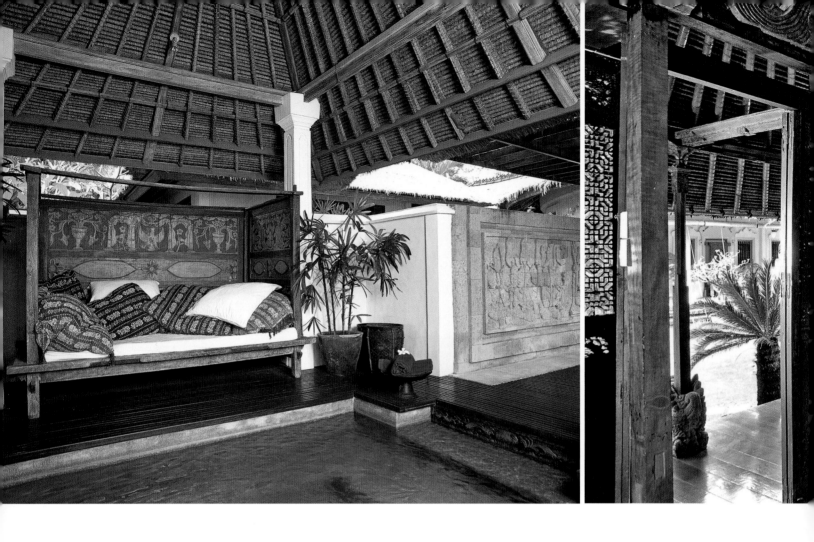

# THE BALI
## DAY BED

**In the traditional Balinese compound, furniture was a rarity,** with the exception of one item that was deemed a necessity: the *taban* platform bed. Every Balinese pavilion had one. In fact, it was often in-built into the pillars that supported the roof and was used as a bed, a lounger and a table combined. Other Asian countries tell similar stories: the Thais have their *tang*, the Chinese their *ta* and *chuang*, the Philippines their *papag*. All, including the *taban*, have gradually evolved into the form of what we call the Asian day bed — a super-sized lounger. Suitable for reclining, dining, chatting, reading, relaxing, sleeping and more, its multi-purpose use is directly descended from its humble origins as a simple platform.

Generally made from teakwood, although there are bamboo, coconut and cane versions, the day bed is invariably far deeper than the average sofa. It comes in a variety of styles with optional accessories including roll arms, intricately carved backrests, posts, wicker insets, removable bamboo "roofs" and drapes. Still tending towards the vernacular in style, although streamlined modern versions do exist, the day bed encapsulates everything that is romantic about the tropics. When positioned on a secluded verandah with a view over rice field and river, it guarantees siesta satisfaction.

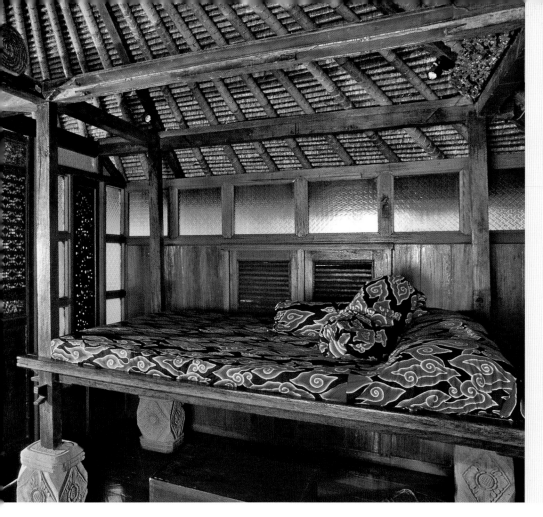

**Above** Dreamy drapes enclose this simple day bed set on a low platform with impressive garden views. All the cushions and curtains are from the Esprite Nomade range.

**Far left** An antique Javanese day bed with stylized, courtly painted panels overlooks an internal whirlpool in a villa near Kerobokan.

**Left** A fine example of an early 19th-century twelve-poster *balé gede* housing a day bed that is built into the structure. Covered with a bright Cirebon batik bedspread featuring the *mega mendung* (rain cloud) motif, its leg bases are hand-carved from volcanic tuff stone.

**Below, left** A traditional Balinese frieze acts as the backdrop to an in-built day bed that sports carved decorative posts and chunky cushioned seating.

**Below, right** A carved day bed with protective "roof" and drapes, as well as sturdy posts, is made from simply carved wood. The green paintwork works well with the naif Balinese painting behind.

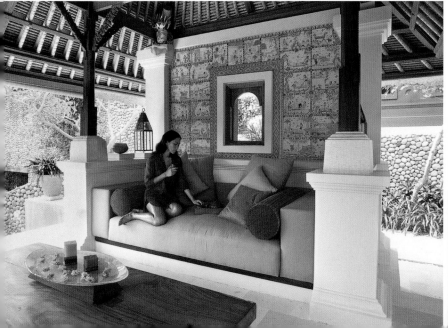

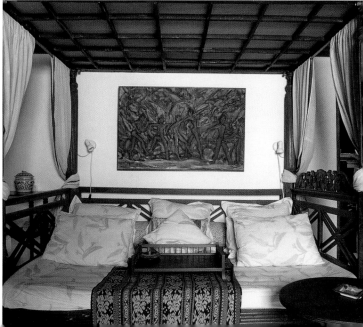

# THE TROPICAL CHAISE LONGUE

**With its origins in Roman Etruscan times** (300-100 BC), the chaise longue (French for "long chair") has a long and colorful history. Research suggests that it was originally used as a seat during the day and a bed at night, but today it is generally accepted as a daytime item of furniture. Its primary purpose is for relaxation.

Developed in different countries at different times for different uses (for example, in England during the Victorian era it was reserved for the bed chamber as people weren't supposed to be seen with their feet off the floor; in 19th-century French salon society, it was de rigeur for reclining beauties), the chaise longue is renowned for its elegance.

It was a popular piece in the Rococo period (asymmetry was popular in rococo style), achieved iconic status in 1929 when Le Corbusier exhibited his LC4 chaise longue at the Salon d'Automne, and became a must-have item on every modernist designer's list in the mid 20th century. Even today, many people like to showcase a chaise longue on a patio or verandah as a "designer piece".

The examples we showcase range from the decorative, even unpractical, to the comfy and utilitarian. Whatever your view of this furniture item, you'll have to agree it always ups the ante in any decorative scheme.

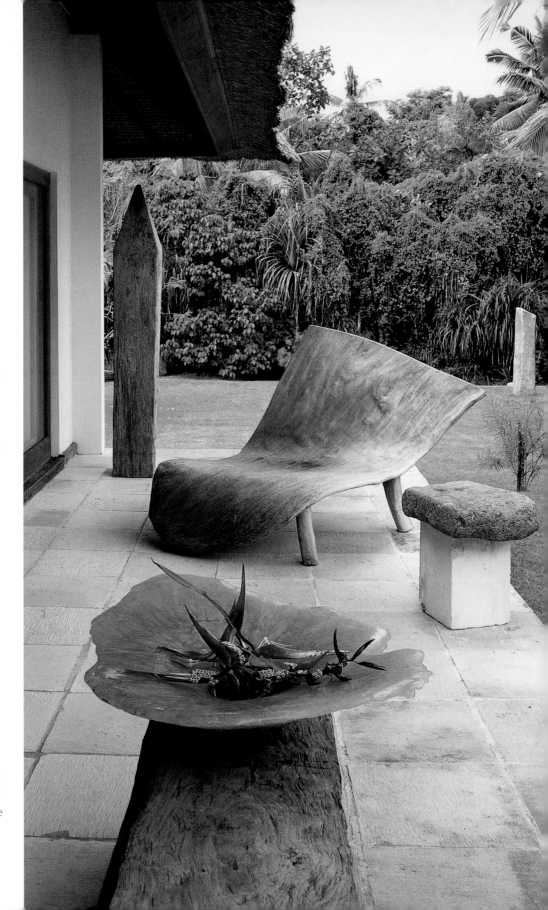

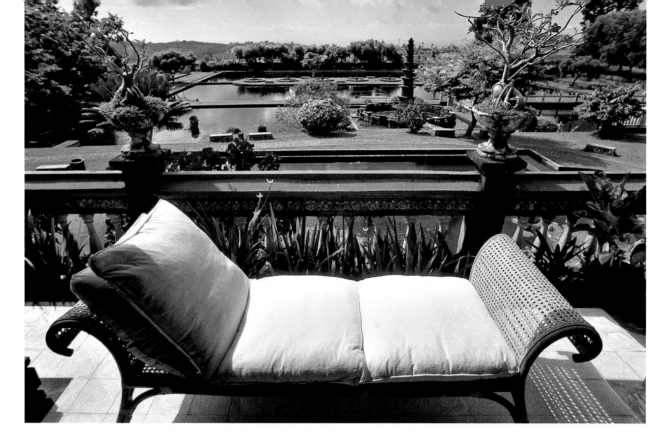

**Left** Primitive modern best describes this scenario, where a swirling chaise longue sculpted from a single piece of teak is accompanied by a variety of recycled wood and stone pieces.
**Below** Deceptively simple metalwork and pristine white upholstery form the basis for this refined chaise longue. There's more than a touch of decadence about the whole ensemble — private Jacuzzi, sandstone bas-relief, crystal-and-silver artwork and a *lit-de-repose* extraordinaire.

**Above** Le Corbusier dubbed his chaise longue design as the ultimate "relaxing machine" and this beautiful rotan-and-wood version with plumped-up cushions and views over Tirta Ganga's water gardens invites serious recliners. Design by Carole Muller.
**Below** Tropical version of the chaise longue in wood and wicker is perfect for the outdoors. The weave ensures that the lounger is able to "breathe", an important consideration in the tropics.

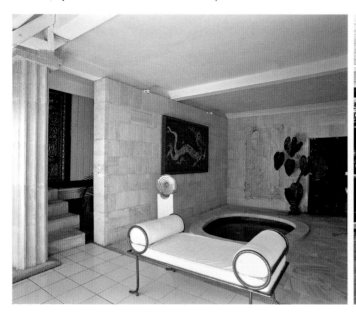

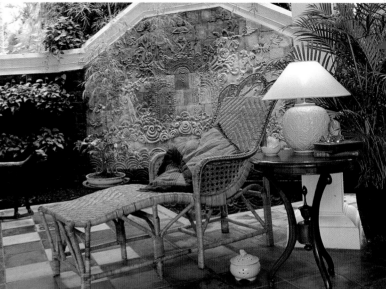

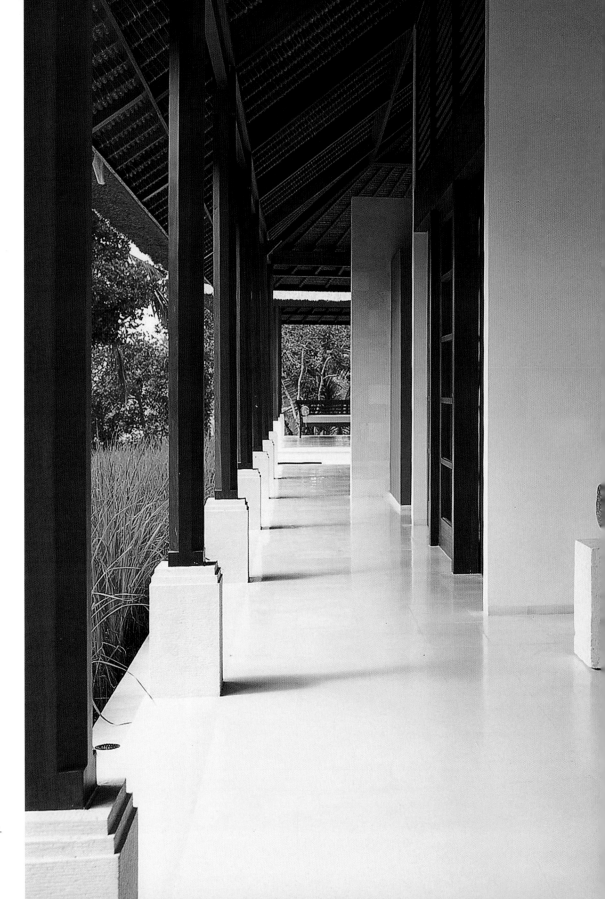

Raised on blocks of wood, this simple lounger employs a palette of white and deep olive green, echoing the colors from the garden. Naturally, it faces west, so superb sunset viewing is guaranteed from this vantage point.

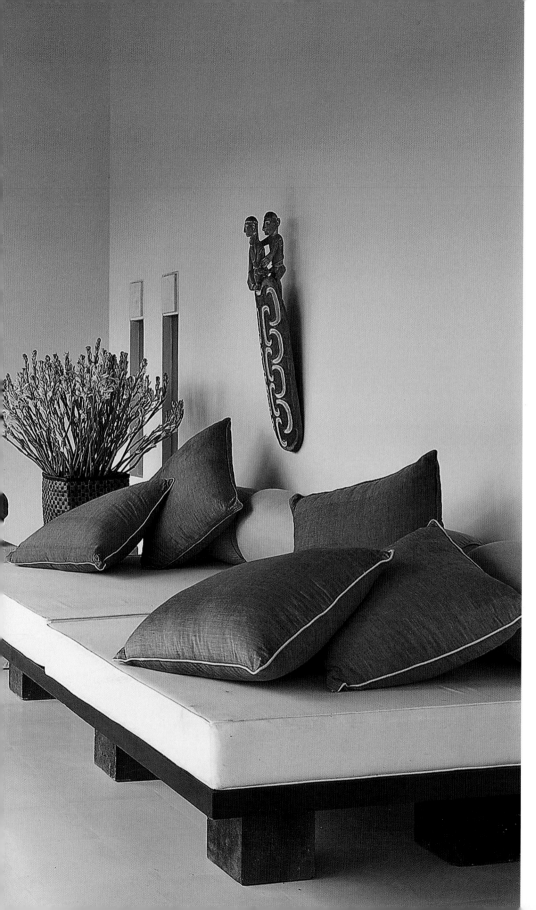

# LONG LINES,
# **THIN SPACES**

**Long, thin spaces pose challenges** for the wannabe home designer: should the space be broken up into smaller segments or elongated to accentuate its length? Would it be better left open-plan, or would some artwork, sculpture or furniture give it more life?

When confronted with this walkway that connects the living quarters and bedrooms, the architect owner of this home opted for simplicity. Detail is to be found in the octagonal load-bearing columns and polished cement flooring, so he deemed the addition of a simple low-level day bed sufficient for the space.

Interior designer Karina Zabihi of kzdesigns agrees that the narrow space should be accentuated rather than broken up. "This is a fabulous space to work with," she declares, "I would hang white diaphanous drapes in between the columns to emphasize the white walls and floors. Placing a stunning sculpture at the end of the verandah would draw the eye along the length of the space. Once the breeze catches the drapes, it will also create a peek-a-boo effect with the sculpture."

A triptych of similar tall sculptures on plinths would also highlight the narrow space. This creates a magnificent depth of field and is a great showcase for works of art. Another solution is to create spatial diversity by using raised platforms, again either as a showcase for artworks or as a raised lounging area.

# RUSTIC LOOKS: BRINGING THE OUTSIDE IN

**With so much new villa design embracing** contemporary themes and minimalist detailing, it's refreshing to find homes in Bali that invite you to flop down on an old, colonial-style verandah, put up your feet and take in the scents, sounds and sights of the surrounding tropical garden.

Whether it is the garden or the verandah that came first is a moot point. When the painter Walter Spies built his multi-tiered home on the edge of a precipitous gorge in Campuhan, Ubud, his verandah with its dramatic views of the surrounding ravine and jungle became famous almost overnight. Hosting many a celebrity party in the 1920s and '30s, he put the island of Bali, with its indoor-outdoor living style, firmly on the global map. Similarly, Colin McPhee, living in Bali in the 1930s in a rented house in Sanur waxed lyrical about the view from his verandah and the Belgian artist Adrien Le Mayeur de Merpres declared that the house he built in Sanur in 1935 was more garden than house. Now home to a museum dedicated to the artist, it is built in pavilion style with a series of loggias and verandahs overlooking a statue-studded garden and views to the sea beyond.

The list of Bali's famed residents and their verandah vistas is seemingly endless. Suffice it to say, all that is really needed is a wide semi-outdoor living space, some lounging furniture and a verdant tropical garden. The rest can be resurrected with gin and tonics at sundown.

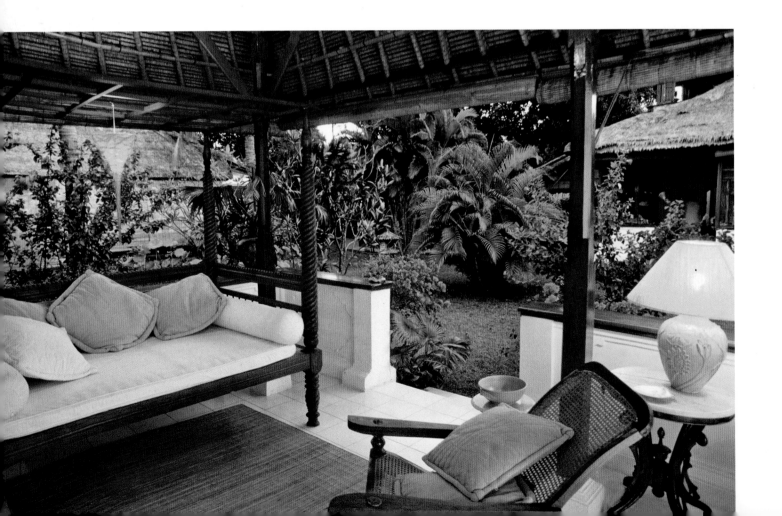

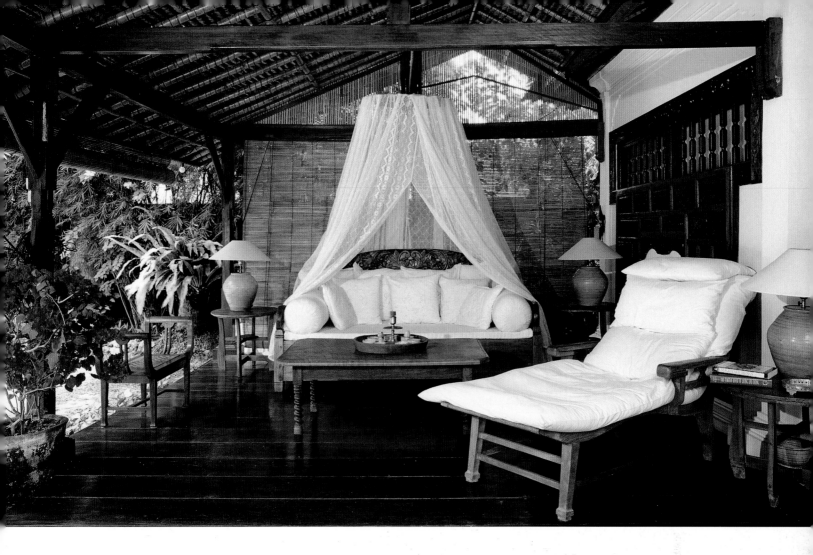

**Above** Old world glamor is epitomized by this draped day bed and cushioned planter's chair on a Legian verandah; the vibrant bougainvillea brings the color of the garden into the house.

**Left** Functional white tiles covered with a simple mat form a practical base for this lower-level open-plan living room. The Javanese day bed and wicker planter's chair provide relaxing seating nooks from which to view the surrounding garden.

**Right** Traditional carved figurines and ethnic art set the tone for rustic-chic verandah decorating.

**Far right** Documentary film maker Lorne Blair's indoor-outdoor home with substantial verandah flows into a garden that resembles a semi-tamed jungle. With its antique doors, recycled teak furniture and wide-planked wooden floors, it almost resembles a tree-house.

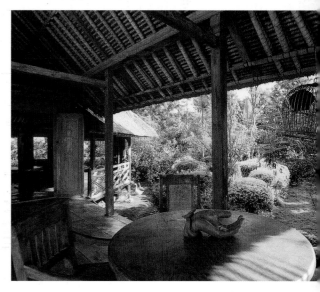

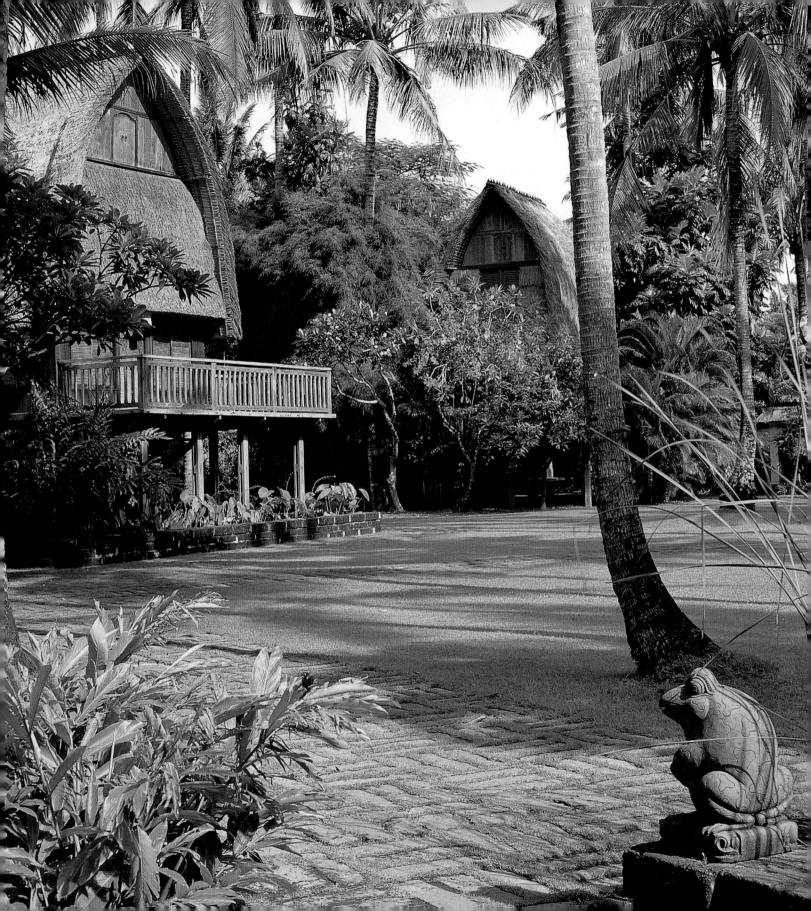

Left Both upstairs balcony and downstairs verandah in this *lumbung*-style home in Taman Mertasari are fully integrated with the surrounding garden. The whimsical frog statue in foreground is the work of Ubud sculptor Wayan Cemul.
Right "If you have a great verandah, it is obvious that you need a great garden, so we tried to create layers of views — hoping to treat the eye not only with the obvious but also with some subtle surprise waiting for discovery," explains home owner Bruce Carpenter when describing the decorative scheme of his cooling verandah. His wraparound verandah snakes around the perimeter of the home: here an antique Javanese bench is flanked by two planters with ferns.
Below Colonial-style furniture, terracotta statuary and floor, and a plethora of ferns and other assorted plants give this huge verandah life.

# A CERTAIN **FORMALITY**

**If good design should incorporate** an element of surprise, the idea of a formal verandah may not be a total anathema. Taking this most informal of spaces and dressing it with dignified, stylized pieces of furniture may seem crazy in principle. Yet, in practice, it can work.

Straight-backed chairs, upholstered loungers, chandeliers and elegant accessories can bring a sense of order to a well-proportioned verandah. Bespoke pieces — perhaps more readily spotted in an up-market restaurant than a casual café — can have a place in relaxed spaces. But when planning your formal verandah, don't go too staid and serious; rather, think light and luxurious, comfortable and refined.

High-quality materials such as polished marble for floors, soft leather for seating and glass and chrome for tables can be combined with state-of-the-art lighting and one or two (at the most) artworks for contemporary effect. Keep the look "international" rather than "tropical"; after all, the space itself, embracing as it does the garden, is tropical enough in its own right.

This style works best if the rest of the house is geared towards a more relaxed living style. The formal verandah won't fit into any old house, but when styled successfully gives contrast and visual interest — and provides a talking point for surprised guests.

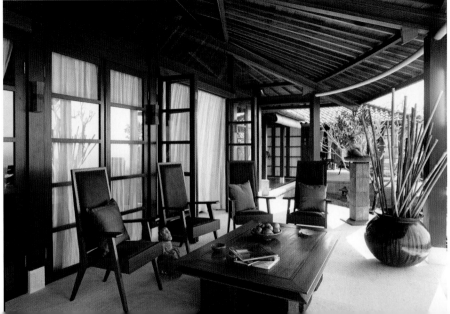

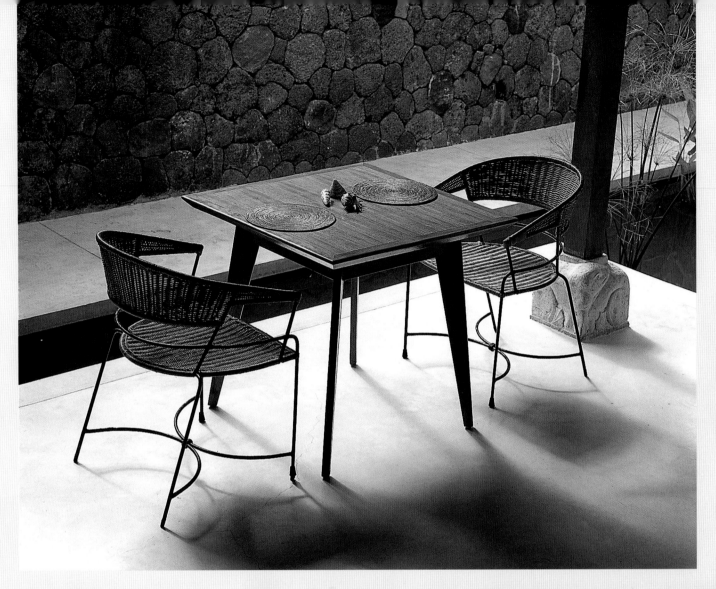

Opposite, top A high roof, contrasting textures and tones in walls, floors and upholstery and select artworks create an elegant setting for this villa verandah.

Opposite, bottom Sober tones of black, grey and white along with the shape and detailing of the somewhat severe leather-and-wood chairs gives this space a restrained, yet pleasing, air.

Above A soothing backdrop of running water and asymmetrical natural stone wall gives these contemporary wicker-and-iron chairs and simple square table a minimalist formality.

Right More an extension of the house and only partially roofed, this area employs high-backed chairs and oblong table for a formal effect.

Far right European-style lounge chairs and table allow the detailed carvings on the volcanic tuff wall to take center stage. They depict *legong* dancers copied from Miguel Covarrubias's seminal book *Island of Bali* (1937).

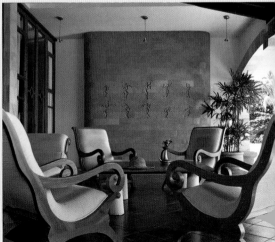

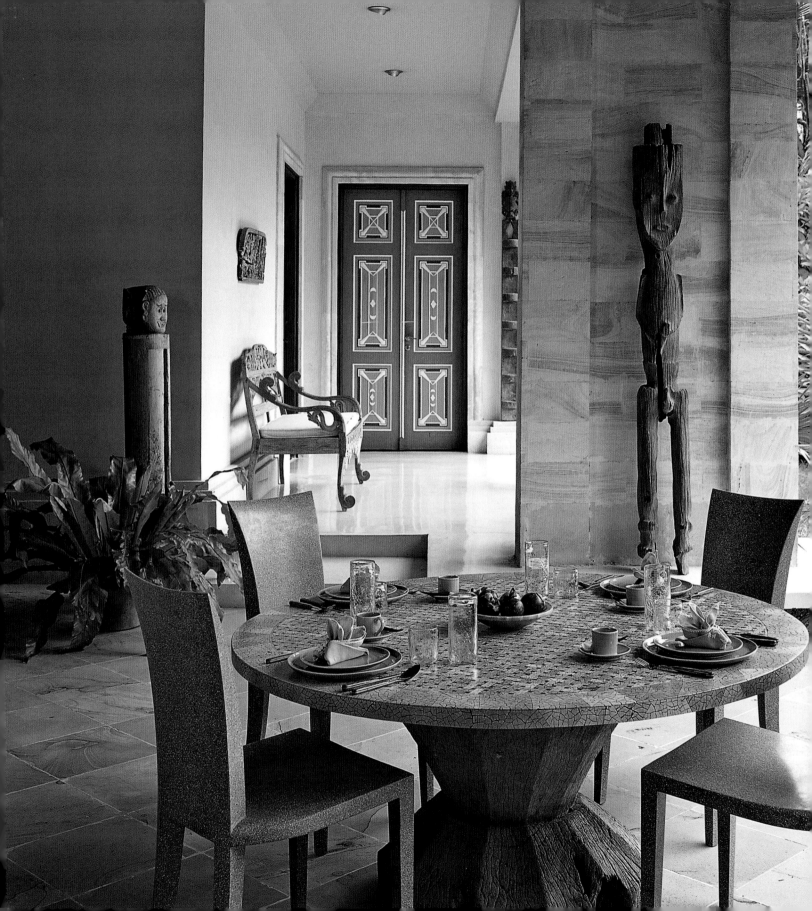

# TROPICAL DINING

**Asians live to eat,** they don't eat to live as in other parts of the world.

Eating — like shopping! — is central to every Asian's heart. As such, gatherings of family and friends round communal tables with dishes cooked to be shared are part and parcel of everyday life.

It therefore comes as no surprise to discover that the dining room is considered one of the most important spaces in the tropical home. However, many homes don't have a specific room that is reserved for dining. Historically, because of the diversity of the weather, the dining room's main characteristic has been its adaptability. A moveable feast, if you will, it can take up residence on a terrace for shady snacks, in the garden for full-on al-fresco dining, or inside the house if there is a downpour outside.

In the past, it has rarely been attached to the kitchen, but open-plan permutations are becoming more common as Western design influences the region. Indeed, entertaining whilst cooking is no longer an anathema in Asia.

What sets our selection of dining rooms apart from the norm is the sheer variety of the venues. For the most part, formality (a somewhat Western concept) has been eschewed for a style of casual dining that suits hot and humid tropical conditions. Indoor-outdoor spaces, where soft breezes and cool garden views predominate, are often favored over enclosed rooms, and we even have some settings placed within their own private garden pavilions.

This doesn't mean to say that they are all rustic or ethnic in style. Indeed glass-and-metal tables with Bauhaus-style chairs are often to be found beneath the eaves of a tropical verandah, and the design of glassware, ceramics and cutlery is generally of a fashion-forward nature. Indeed, Bali is famed for its talented ceramic, glassware and linen designers, many of whom export their goods to the West. Frosted-aqua plates, soft cotton napkins with pearlised rings and elegant wine glasses crafted from recycled glass are made in Bali, sold to five-star hotels and dealers, and often find themselves in restaurants as far afield as New York and London.

In fact, some people attribute the imaginative progress of tropical dining designer wares to the extraordinary inroads made in the last two decades in the commercial sector. Hotels with flagship restaurants boasting $20 million dollar design bills aren't uncommon nowadays. To be competitive, the humble hostelry cannot remain humble any longer: Ambience, sex appeal, status, a celebrity chef or two, as well as cutting-edge interior design are necessary in these venues. This trend includes accessories and tablewares too. And that doesn't even take into account the food . . .

Indubitably, the designs seen in such establishments are finding their way into the home — and that's not such a bad thing. After all, who doesn't like to sit down to a well-cooked meal in a cleverly crafted space, where convivial dining and drinking may be had in comfort and style?

Carlo Pessina's verandah invites the outdoors in for stylish al fresco dining. The table in young coconut wood with shell inlay and terrazzo chairs works well with celadon tableware and chunky glassware in aqua tones, not to mention the painted Javanese door in the background and the green-grey palms in the garden.

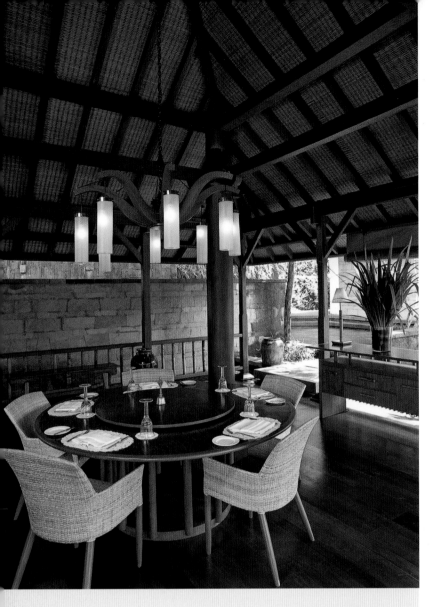

# TOP TABLES

**Dining tables shouldn't be conversation** pieces; they need to lend themselves to conversation. Convivial lunches that segue effortlessly into dramatic nighttime dining are the epitome of stylish entertaining.

Our selection, here and overleaf, is notable for both its variety and the quality of materials used. The minimalist table is ideal for showing off vibrant, tactile tablewares and it fades away between mealtimes. Choose from glass tops with steel or stone bases and almost office-worthy styles that are both businesslike and beautiful; they tend to work well with low-slung suspension lamps as well.

A well-crafted wooden table, on the other hand, with a polished veneer or super sanded finish lends itself to a more high-end effect. Chinese diners wouldn't dream of lifting their chopsticks around a table without a lazy susan centerpiece: Even though it's an American invention originating some time in the 1700s, the lazy susan is more commonly found in Asia where many small dishes are often shared by everybody at the one table.

Whatever your choice, be sure to team the table with statement-making, yet comfortable, chairs: leather, cane or upholstered varieties are better than plastic for an engaging eatery.

**Above** Curvy, hand-woven chairs work well with this round coconut-wood table with lazy susan. Such styles, combining Asian and Western influences, are suitable for indoor-outdoor settings.
**Opposite** Precision is combined with high-quality materials in this triple-tiered table. The volcanic base allows for leg-free dining (a real bonus), while the high-backed leather-studded chairs have a touch of conference room style about them.

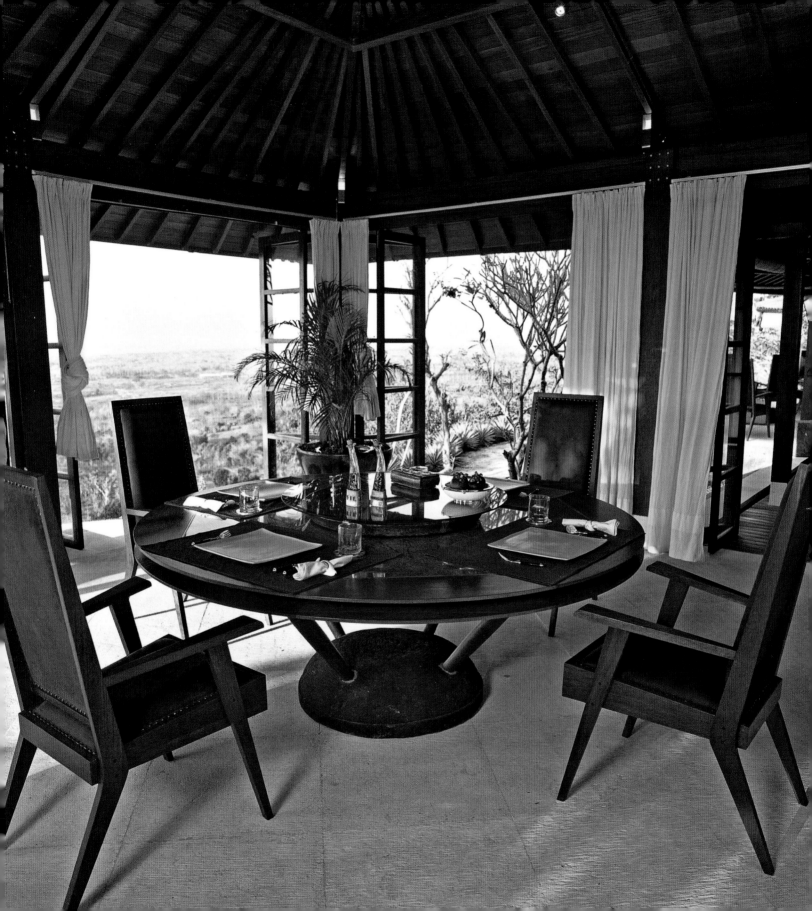

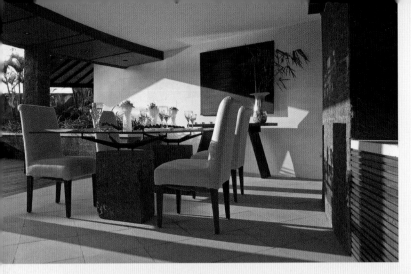

**Left** A sheer glass table with chunky *paras Kerobakan* base, designed by Dean Kempnich Bali, one of the island's many design houses, is sleek and elegant. A sense of place is secured with the choice of material for the base.

**Below** Differing roof heights and angles, as well as varying wall and floor textures, gives this room design interest. The polished wood table, set on two dark-dyed tree trunk bases, is accompanied by slightly chunky teak-and-rattan chairs. The antique wall hanging adds color.

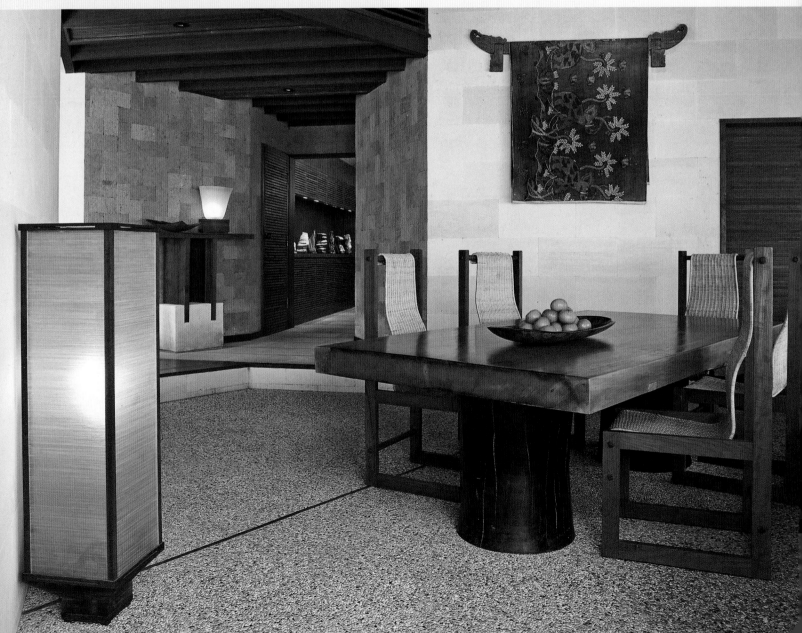

**Right** A selection of tactile materials — Javanese stone, sheer glass, metal and cool cotton — combine to create a harmonious whole here. The table is designed by Dean Kempnich Bali, while the chairs are dressed in pure white.
**Below** This roughly finished, textural table, made from a single block of teak, features Timorese motifs along its sides. It can be dressed up with modernist steel or chrome chairs for a modern-retro feel or remain rustic (as here) with minimal accessories.

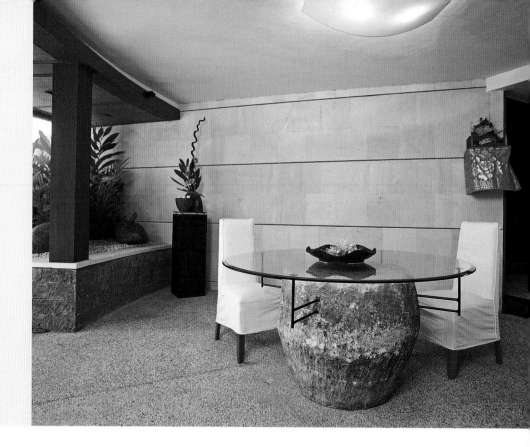

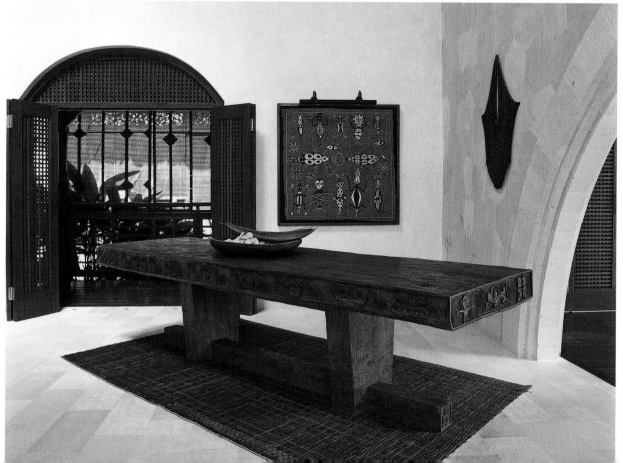

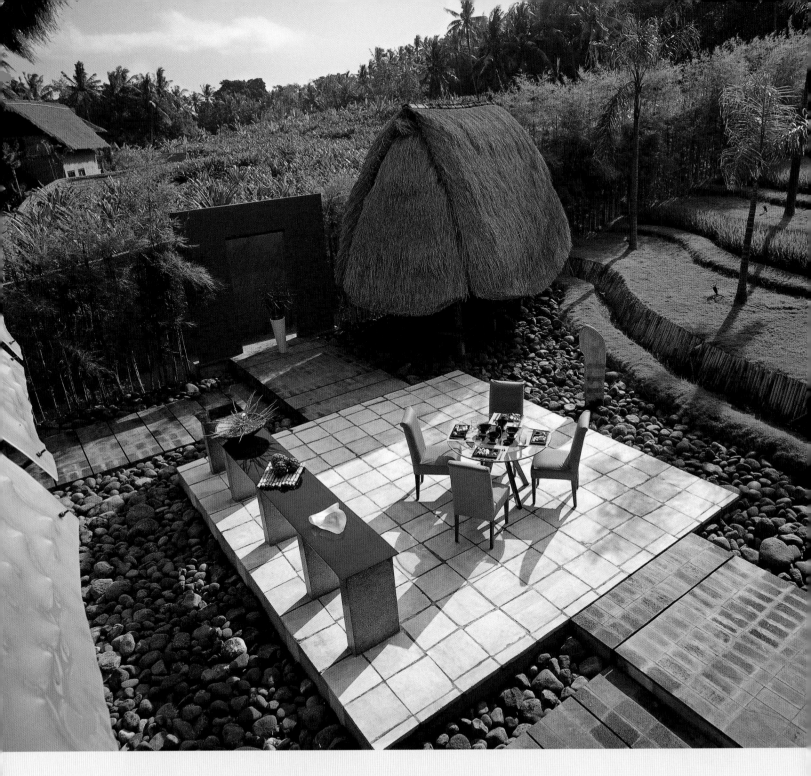

**Above** A glass table and fairly formal chairs are placed somewhat incongruously in a large outdoor patio for al fresco dining. The blue counter top and red "exit" add a playful touch.
**Opposite** Ceramic artists Graham Oldroyd and Philip Lakeman use every shade of turquoise, aqua and blue to create a picnic-style setting complete with table and benches for the outdoors. Their small patio is surrounded by an equally vibrant garden — perfect for outdoor entertaining.

# GARDEN **PARTY**

**Local, seasonal produce, a balmy summer's day,** a mish-mash of table and flat wares, and a view of a garden or countryside are the key ingredients for al-fresco dining. Whether it's morning coffee and croissants on the patio, lunch around the pool or a candlelit dinner on a rooftop terrace, most of us these days have the means to enjoy open-air dining.

Dining outside offers a great opportunity to get fun and funky with table settings. Informality is the name of the game here, so mix and match colors for plates, mugs, bowls, serving platters and glassware. Flea markets and second-hand sales are the perfect places to pick up mismatched items that somehow work together when placed outside; remember, if you're dining at night, place some votive candles in little glass containers on the table and in the garden for added atmosphere. They'll deter mosquitoes too.

Linens, tablecloths and napkins in vibrant shades are appropriate for the outdoors as are accessories with an organic theme. Scattered shells, scented pine cones or big "messy" floral arrangements make for decorative centerpieces and further the natural feeling of the great outdoors.

From a personal point of view, we suggest abandoning the labor-intensive barbecue; opt, instead, for summery salads, lightly grilled fish and big jugs of ice-cold juices. When served picnic-style outside, they somehow taste a whole lot better.

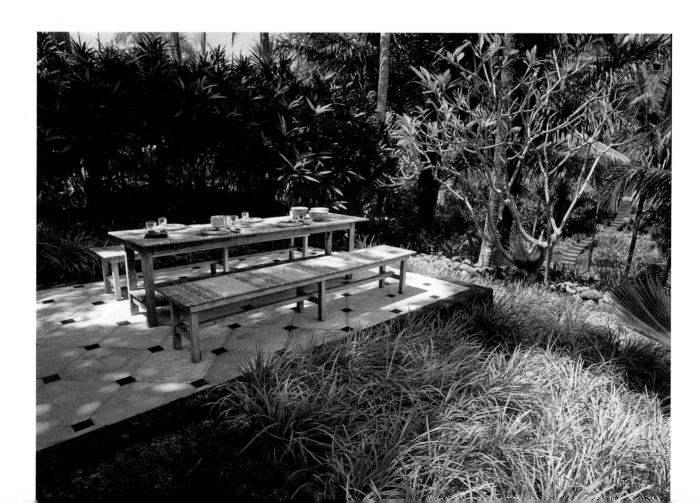

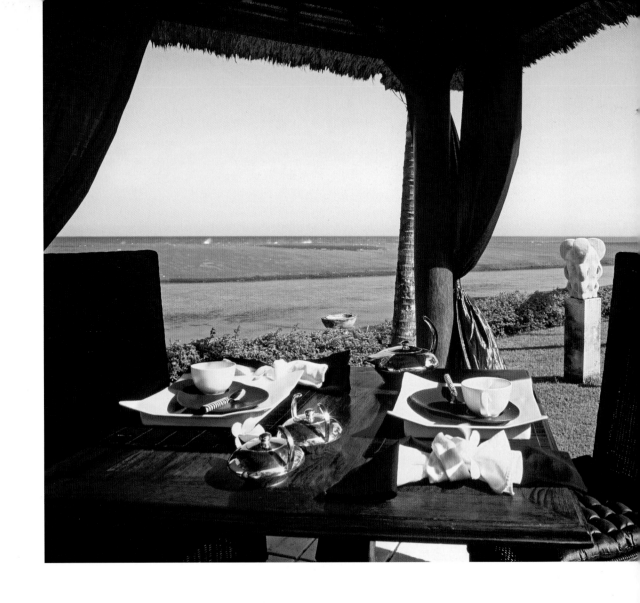

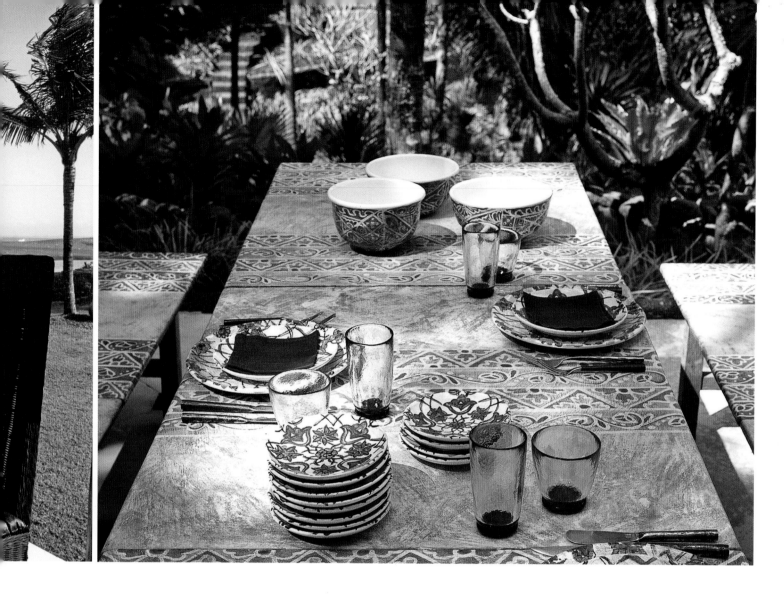

**Far left** Dining semi al-fresco is a truly tropical experience: here shade comes compliments of GM Architects, whilst furniture stalwart Warisan provides the rustic trestle table, benches and stools fashioned from teak. White ceramic tableware from novelty store Palanquin and Seike Torige recycled glass tumblers are cool and summery.

**Left, middle** A round table, inlaid with tiles from Pesamuan, makes for an informal dining experience. The Japanese-style garden, with yuccas, bamboos, pebbles and stones, is integral to the experience.

**Left** Architect Shinta Siregar and interior designer Jaya Ibrahim have taken a traditional Balinese *balé* at the Club at the Legian and transformed it with modern furniture and accessories into an elegant outdoor dining venue. Bright red accents, mother-of-pearl inlay tables and the surrounding tropical greenery are key elements.

**Above, left** Dark wood table and rattan chairs with rich silk cushions are the formal elements in this al-fresco set up. Informality is to be found in the superb sea views, the black sand beach and the breezy garden with lawn. The silver tea service is from India.

**Above** Blue, turquoise and white are combined for refreshing effect in outdoor table, benches and crockery in the garden of Graham Oldroyd and Philip Lakeman. If this doesn't epitomize halcyon outdoor picnics, what does?

# COUNTER
# **CULTURE**

**The simple sideboard or counter** is often neglected in the dining room because too much of the budget has been spent on the main event — the table and chairs. However, this indispensable piece of furniture can prove invaluable in a well-planned dining room.

Not only is the counter (often called a server or a credenza) useful for buffet-style serving, it can also house crockery and cutlery or act as a matching accessory to the dining table. Often used to house low-level lighting, it is frequently teamed with a mirror or painting as the examples shown here illustrate. Generally oblong in shape, it is a useful piece of furniture for breaking up a long wall; when placed asymmetrically it can add character to a room.

Craftsmen in Bali's design ateliers are dab hands at creating sideboards from a variety of materials: wood composites from coconut fiber and palm, glass and stone combos, recycled teak and planed and sanded solid wood are some examples. Take inspiration from some of these different styles.

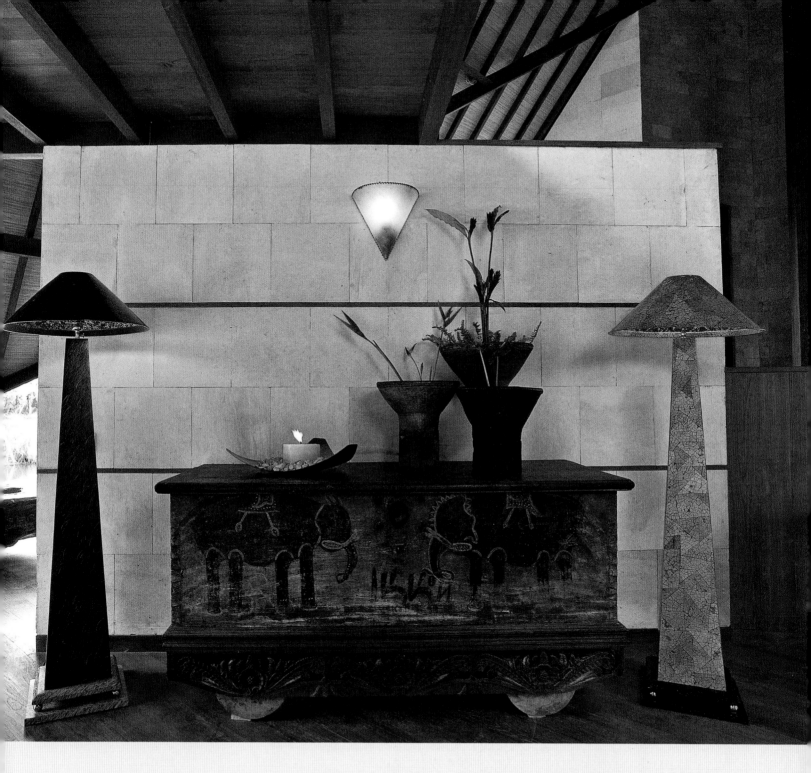

**Above** An antique Javanese *grobok* or rice container finds new life as a sideboard in this contemporary home. It contrasts pleasingly with the two modernist standing lamps in dark and light coconut shell composite.
**Opposite** Recycled pieces of teak are used by designer Giada Barbieri to create a sideboard with tapering legs — an unusual shape. The aboriginal-style painting behind adds visual interest.

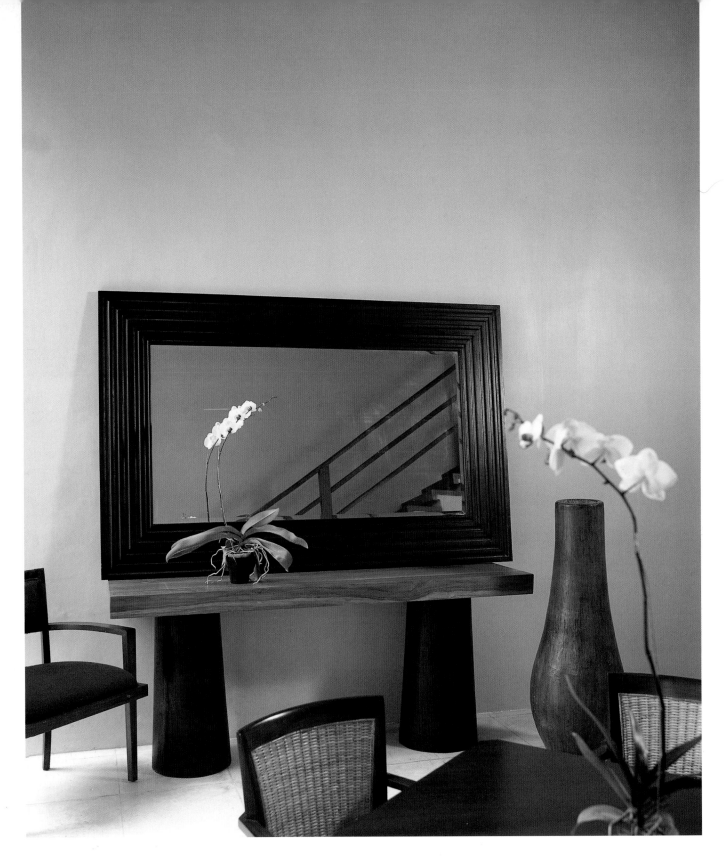

**Left** The solidity of this retro shaped teakwood console withstands a heavy mirror framed in dark ironwood and the proximity of the dining table.

**Right** Recycled teak planks make up both the coffee table and matching sideboard here, the latter of which is supported by two *palimanan* plinths. Its rugged shape works well with two pieces of primitive art and modern abstract painting.

**Bottom, right** Curvy console and anvil-shaped stool in solid wood by Milanese designer Giada Barbieri; the key to the duo is the pairing of the geometric and rounded shapes and the plain grey wall and floor.

**Below** A sleek composition of glass artwork and dark stained wood console makes a statement along a plain wall in this dining room.

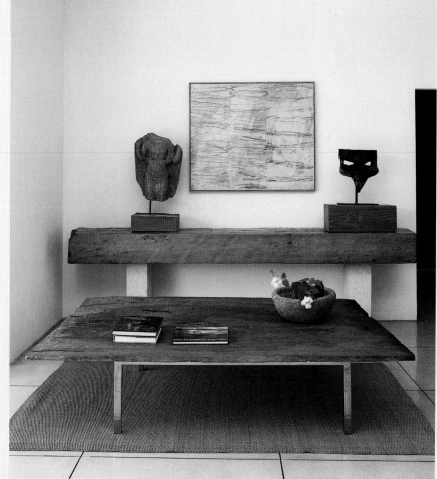

# KITCHEN **CONFIDENTIAL**

**The days of the stand-alone kitchen may not be over,** but they are seemingly numbered. Increasingly, we're seeing the kitchen amalgamated with the dining room; the cooking isn't divorced from the eating any more.

In the past, Asian kitchens tended to be located in separate out-houses, but of course this was in the days when households had extensive staffing. Staff quarters and kitchens were usually placed together behind the main building. But, as staff numbers decrease and interest in cooking whilst socializing increases, kitchen-diners are the first choice of many home owners.

Clever dining arrangements can turn a kitchen into an elegant entertaining space with the use of breakfast counters, island units and extended worktops. Keep an eye on detailing with stylish mosaic tiles, painted or recycled glass, sheer chrome, aluminum or stainless steel; use of such high-quality materials transforms a functional space into a luxe living environment.

If space is of a premium, consider the one-wall kitchen with open shelving (to decrease the visual mass of cupboards) and/or mirrors. In a corner kitchen, opt for a space-saving corner fridge. But whatever the design, the triangle of sink, fridge and cooker needs to be compactly worked — it's the backbone of any kitchen design.

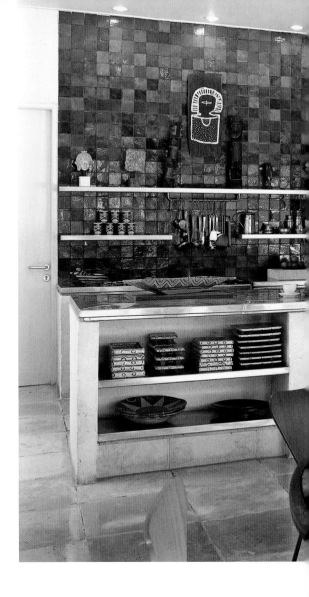

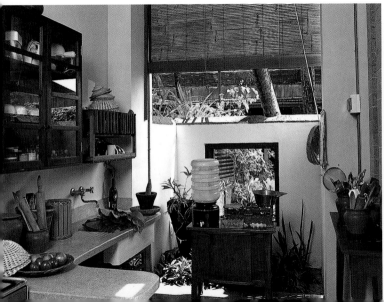

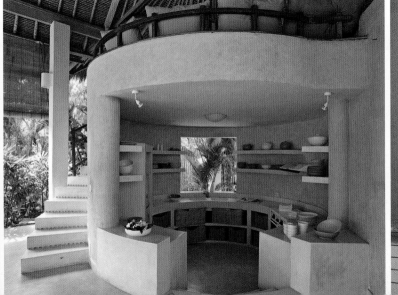

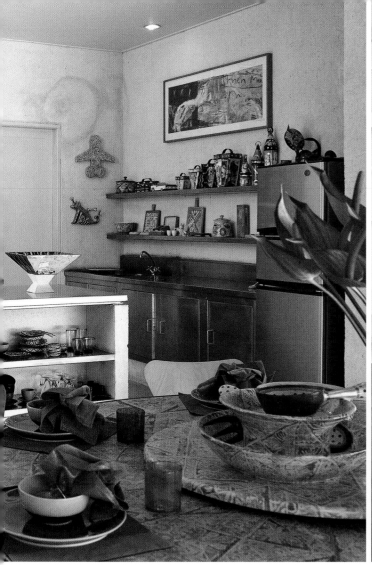

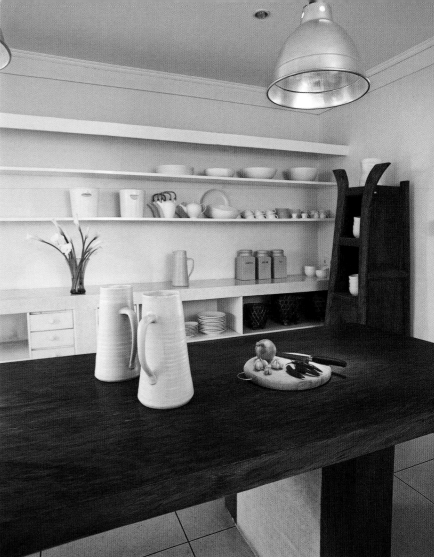

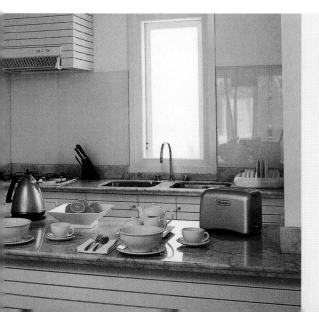

**Far left** This sweet kitchenette is separated from the garden by a wicker blind and open archway; integrating the garden into the design makes the space look larger.

**Left, middle** This unusual kitchen, designed by architect Valentina Audrito, is both compact and open-plan with a picture window that invites the garden into the cooking space. Fashioned from terrazzo, it features open shelving in natural ivory tones. The rounded contours give softness to the overall structure as well as a Mediterranean element to the design.

**Left** One of Fredo Taffin's Downtown Apartments in Seminyak offers a compact one-wall kitchen with painted glass splashback and marble-and-*merbau* wood breakfast counter. Painting the *merbau* a glossy white gives the illusion of more space, while the oblong window brings light and air into the area.

**Above, left** Brilliantly colored tiles and stainless steel worktops and shelves add opulence to the kitchen/dining area in Philip Lakeman and Graham Oldroyd's home. The central counter doubles up as a serving bench and storage unit, all the while delineating space between kitchen and diner.

**Above** Wood and white make for pleasing, easy-on-the-eye companions in this streamlined villa kitchen: the expansive teak table echoes the clean lines of the open shelving, while, in the corner, an antique Indonesian cabinet adds visual appeal.

# BEAUTIFUL
# **BASICS**

**No dining table** should be without beautiful cutlery, ceramics and extras that impart both a sense of place and a sense of style to the tabletop. Entertaining always appears effortless if the table is dressed with refinement, class and simplicity.

Bali's craftsmen are masters at taking local, indigenous materials — coconut fibers, palm tree wood, mother-of-pearl, seashells, bones, resins — and transforming them into highly decorative items that combine utility with sensuous forms. Mostly, materials are taken from nature (the island of the gods gives up its treasures willingly!), but the designs are about as far away as you can imagine from the roughly-hewn styles that one normally associates with "native crafts".

The selection showcased is only a taste of what may be found in Bali's numerous homeware design ateliers: think intricately crafted coasters in luminous shades, superbly sanded shining sushi platters, bowls created from hundreds of pieces of small wooden shards. Shapes tend towards the geometric, with circles and squares predominating.

Forget about saving certain tableware for best: Instead choose items that have a story to tell and enjoy them at every mealtime. Bali's natural history is encapsulated within our selection.

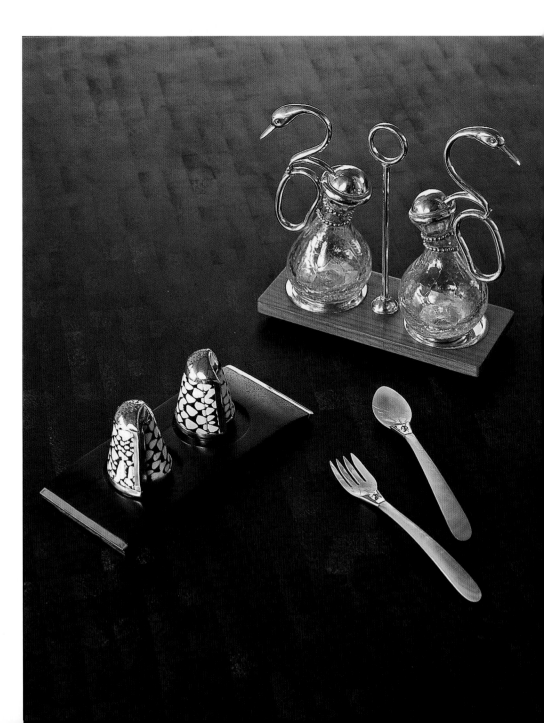

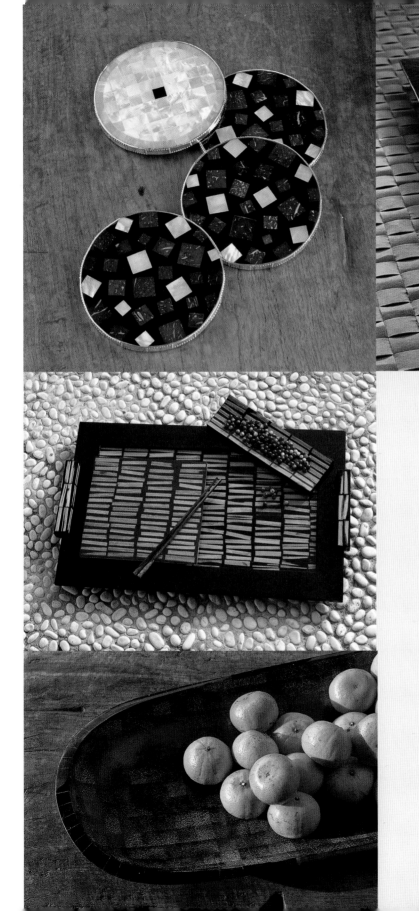

Opposite Architect-designer Guiseppe Verdachi is known island-wide for the balance and refinement of his creations: here we see (clockwise from top right) oil and vinegar containers in recycled glass and silver; mother-of-pearl, silver and coral cutlery; and sweet salt and pepper shakers in shell, silver and ebony.

This page, clockwise from top left Coasters crafted from mother-of-pearl, shell and silver are smooth and durable. A highly polished bamboo and black resin sushi platter from Produs Trend doubles up as a table display with mock fruit in white bone. A nest of tables in penshell, coconut wood and mother-of-pearl is designed and crafted by Carlo Pessina in a basket-weave pattern. Etienne de Souza-designed bowl in palm wood is textural on the inside and highly polished without. Leaning towards the rustic, but impeccably crafted nonetheless, this "Jungle" tray, made from bamboo, resin and dark stained wood, is from Produs Trend.

TROPICAL DINING / *BEAUTIFUL BASICS*

# BAR NONE

**The trend for having one's own private bar** is not a new one, with many tropical homes having a bar with high stools often situated on the verandah. Where there have been substantial inroads, however, is in the materials used to manufacture such bars.

Home bars run the gamut from enlarged drinks cabinets to full-on long bars with barstools. If placed outdoors or on a patio, they tend to be made from metal or treated wood, whilst indoors you're more likely to find lighter-weight numbers in rattan or some other weave. Synthetic rattan, a relatively new material made of polyethylene, a type of plastic, is weather-resistant; it is gaining market share because it looks just like rattan, but needs minimal maintenance. Often employed with an aluminum or steel frame, it is a versatile option.

Bars can also act as handy dividers in the home: sometimes used to separate the kitchen from the dining area, or as island units in larger rooms, they can be both practical and visually appealing. Another useful function? Beneath the bar top, cupboards can conceal storage too.

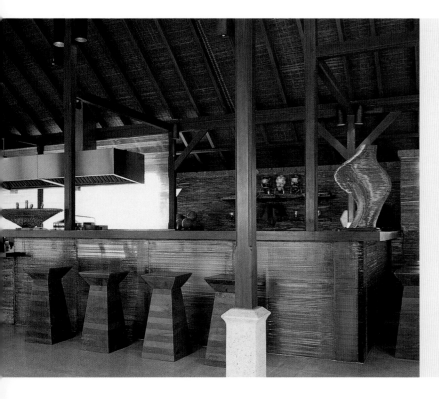

**Left** The high-tech, modern kitchen at Begawan Giri Estate's restaurant is elegantly concealed behind a laminated glass bar counter designed by Seiki Torige. The flared champagne cooler and torso sculpture add glamor to an already high-octane space.
**Right** Also designed by Seiki Torige, this bar with glass sides and warm wood top acts as a divider between the dining area of the pavilion and its entrance. Lights are concealed within small bamboo "tubes" below the counter top.

# SETTING THE **TROPICAL TABLE**

**Asia has a rich history of ceramics, weaving, basket and lacquer wares,** as well as carpentry — so is perfectly positioned to cater to all tastes and styles of table decoration. In Bali itself, the number of design ateliers producing homewares is phenomenal. Somehow, the fabled isle seems to attract the creative cognoscenti in their droves: artists, sculptors, furniture designers and the like integrate their skills with the innate craftsmanship of the Balinese — and produce fashion-forward goods as fast as architects construct new villas, hotels and dream homes in the rice fields.

Increasingly supplying the export market as well as local buyers, the quality of these wares has drastically improved in recent years. Often using local, natural materials, but employing an aesthetic that is more metropolitan than insular, there is no shortage of styles to choose from.

Depending on the mood you want to create — formal and structured or informal and casual — you won't be short of inspiration in Bali. Napkins, runners and tablecloths run the gamut from the richly ornate to practical and everyday; flatware and cutlery are ubiquitous; and ceramics and glassware come in all shapes and sizes — rough-hewn and ethnic to sleek and contemporary.

Let your creative juices flow and decorate your table to please yourself as well as your guests. Our selection showcases just a small taster of what the island has to offer.

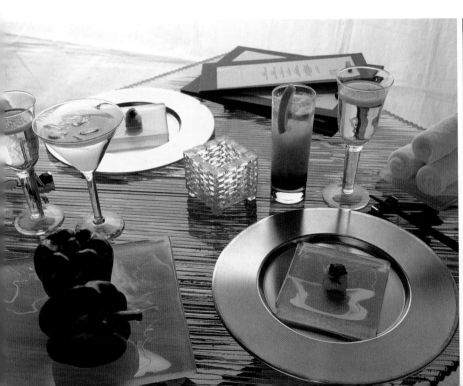

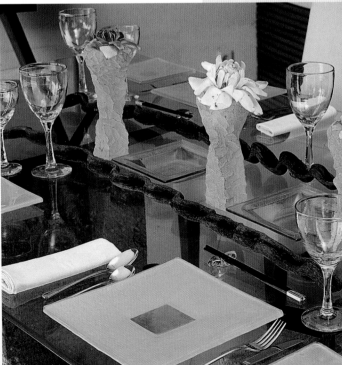

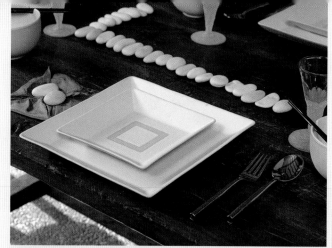

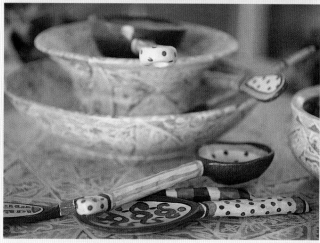

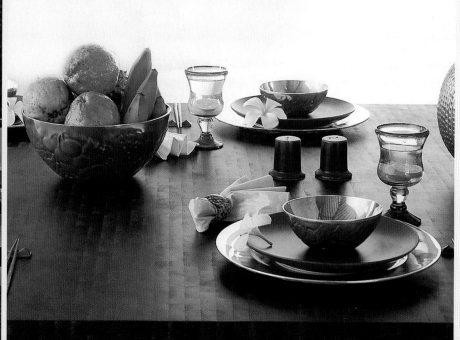

**Far left** Metallics and glass combine with blocky and circular forms for a modern look.

**Left, middle** A glass tabletop can work with glass tableware as long as frosted is combined with recycled, clear with opaque. Here, central chiseled glass vases anchor lighter recycled glass plates and wine glasses. All by Seike Torige.

**Left** Fashion designer Marilena Vlataki has turned her hand to tableware design here: combining metal with ceramics, her bowls and plates are restrained, almost severe, in feeling.

**Above, clockwise from top left** Bright pink place mats and napkins are vibrant companions for simple celadon wares. White ceramic plates and bowls from Palanquin with cute pebble detail and frosted-and-clear glasses work beautifully on this antique table from Warisan. Earth-toned crockery from inventive ceramic artists Philip Lakeman and Graham Oldroyd display a country style aesthetic. A deep blue, Japanese-style setting on textural mat is rustic, yet streamlined.

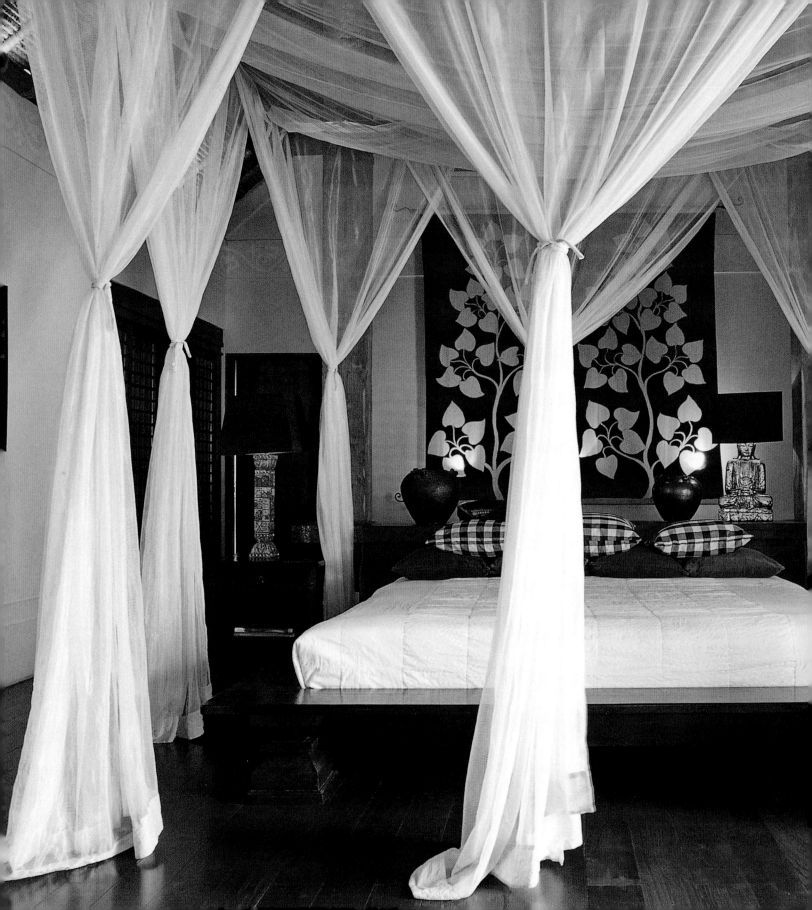

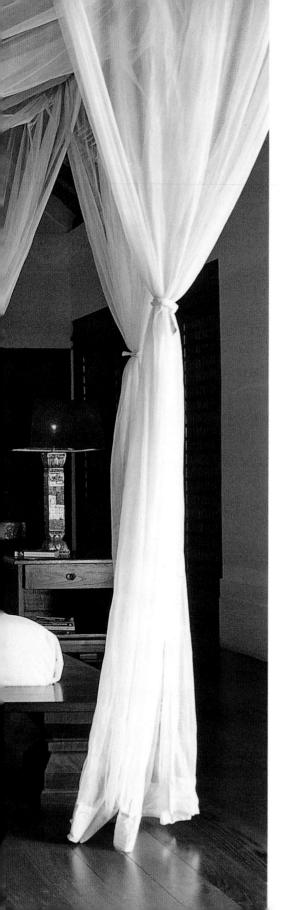

# BENEATH THE MOSQUITO NET

**Despite the advent of air-conditioning,** the mosquito net is still ubiquitous in tropical bedrooms. The fact that it is seldom used doesn't deter hosts of tropical home owners throwing voile curtains and gossamer netting left, right and center over revamped, remodeled or modernized four-posters.

Why, you may ask? We don't hark back to the days when a reed mat sufficed for a mattress and a basket and balcony rail worked as a wardrobe. Why the nostalgia for what is essentially an obsolete item?

This is where we cut to the crux. Nostalgia is a powerful emotion and the bedroom, that most private of spaces, somehow seems to conjure up sentimental responses in even the most hard-hearted. People who shun frills and florals very often opt for feminine bedrooms; monochrome freaks go for splashes of color; modernists eschew the B&B Italia bed or futon for an intricately carved Chinese day bed or Raffles bed complete with posts, headboard, height and hardness! It may be bemusing, but it's a fact.

We see the bedroom as a sanctuary, a place where the world won't disturb us. As such, it can be a little fanciful, with more than a touch of romance and drama. Even men, who wouldn't accept such frivolity in the public spaces of the home, seem to accept softer touches in this inner sanctum.

Of course, in the past, tropical bedrooms were all about open air, the sweaty equatorial night and a non-stop cacophony of frogs, crickets and barking dogs. Not to mention the bugs and the cockerels crowing at 4 am! Open to the elements (often on all sides), with a mosquito net and bolster pillow "Dutch wife" the only accoutrements, they offered little in the way of privacy. But plenty in the form of atmosphere, traditionalists would argue.

Some resorts and bungalows in Bali still have such colonial-style guest bedrooms, open on more than one side, with net-draped four posters set on platforms beneath a thatched roof. They may look out onto a private courtyard garden on one side, an open-air bathroom on the other and an unmatched panorama of rice field, jungle or ravine on another. But, increasingly, they'll have French windows or sliding doors that enable clients to shut out the tropical night if they so wish.

As with the open-air bathroom, where people seem to prefer to have at least a portion of the room beneath a roof, the most successful tropical bedrooms are those that offer choice. If doors can be flung open when required, so much the better; if there's an attendant balcony, study area or garden court, that's a bonus.

But if they can be enclosed, the encumbent ensconced in privacy and safety beneath a gauzy net drape, that is surely the best.

This majestic bedroom at Bali's Villa Umah di Beji offers drama and romance in equal measure. Chinese inspired antiques, gold-leaf stenciling in the wall hanging, transparent drapes and a seven-foot bed with *mahoni* columns all hark back to the past in atmosphere. Comfort, nonetheless, is fully present.

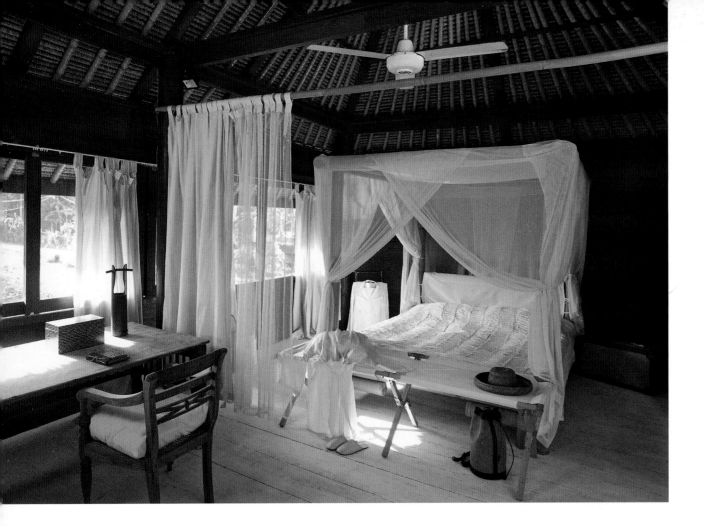

# WHITE DRAPES, **ROMANTIC ALLURE**

**Draped beds gained prominence in the 15th century in northern Europe** when it became customary for royalty to give audience in the bedchamber. As such, the bed was ornamented with curtains that gave warmth to the occupant and also ceremonial importance. Essentially, the bedchamber was coming out of the closet: it marked the move from private retirement room to public reception area.

In the ensuing decades, such beds became more and more elaborate, often with intricate carving and insets of gold, precious stones and fine silver; drapes were decorated with golden embroidery and sheets and blankets were of the finest silk and wool. The bed morphed into both a status symbol and a sign of wealth.

With the advent of colonialism, such beds found their way to Asia. Even though there is a legacy of day beds in Asia, the four-poster as a piece of furniture for sleeping was a novelty. Eagerly embraced by wealthy locals (especially the Chinese), it became more "Asian" in style: Oak was replaced by teak, *huanghuali* and mahogany; headboards became ever more elaborate with carved Chinese (and other) motifs; and, eventually, the curtains were replaced by mosquito nets.

Today's romantic net-draped beds found in every self-respecting villa in Bali trace their roots to this European and Asian ancestry; taking influences from both the four-poster and the day bed, many have been fashioned into works of art.

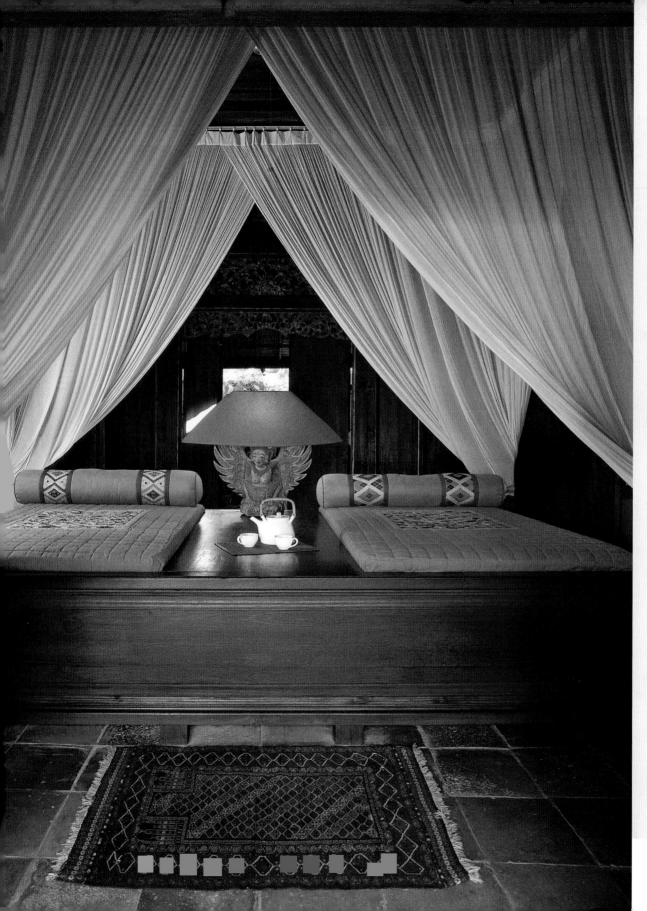

**Opposite** Nomadic chic: A simple bamboo bed and folding console at its foot look as if they can be dismantled, folded away and reassembled at another location in a jiffy. Gauzy drapes and bedlinen by Esprite Nomade.

**Left** A 19th-century royal pavilion from Madura houses this simple platform bed decorated with Laotian textiles and floor-to-ceiling mosquito nets. The intricate door carving and the lamp base in the form of Sendi or "the lady with wings", a Balinese symbol of prosperity, further the cosy feeling of ethnic luxe. Flagstones are cool underfoot, while the rug is from Pakistan.

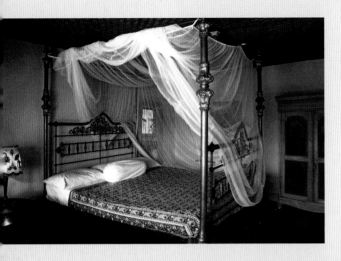

Left Sumptuous four-poster bed in the former home of the painter Theo Maier in Iseh sports an Asian cotton bedspread, but its elegant iron posts have their roots in European design.

Below, left The exceptionally tall silhouette of this four-poster bed at the Club in the Legian illustrates designer Jaya Ibrahim's passion for proportion. White drapes contrast beautifully with the handspun bedspread from a village in East Java that was inspired by a Scottish tartan.

Below A Javanese platform with Chinese influence forms the bed here, but further light and space are added because it sits on a much wider terrazzo platform holding four posters and gauzy drapes. A second mosquito net hangs from the ceiling furthering the double-draped look.

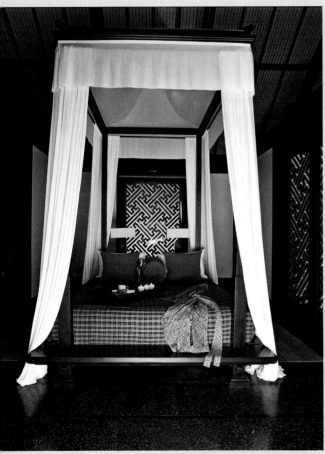

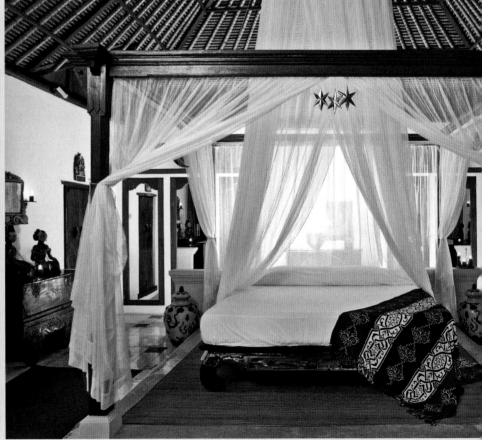

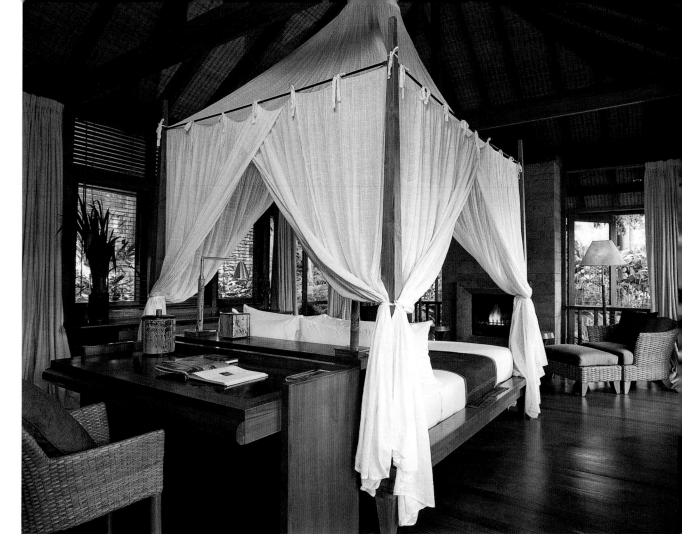

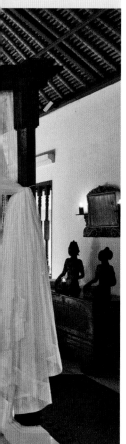

**Above** A fireplace at one end of the bed and a desk at the other makes for a cosy scene in this tropical villa. The mosquito net hangs from high in the roof giving the enclosed area below more breathing space.

**Right** With its roots in primitive Chinese style, this "cage bed" is made from recycled wood and features a simple slim mattress and cotton drapes. The overall feeling is light and airy.

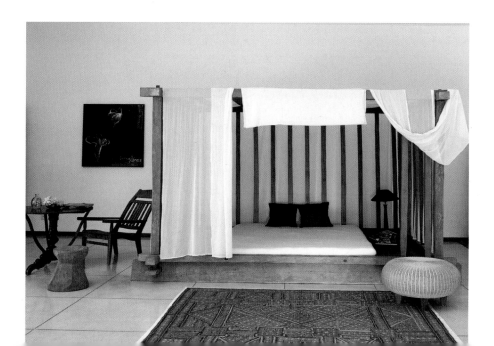

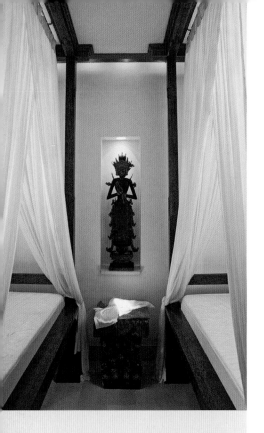

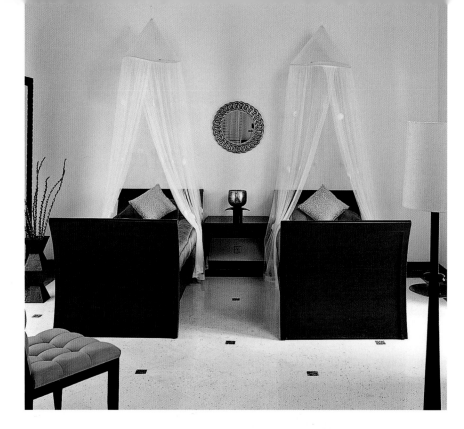

Many villas follow the draped-bed theme into children's and guest rooms where twin beds are offered as a matter of practicality. Mosquito nets vary from decorative hangings to stand-alone gossamer-thin muslin numbers suspended from the ceiling; as with their more romantic double counterparts, they give a feeling of light, airiness and other-worldliness to the rooms.

**Above** Fashioned almost entirely from old Chinese coins, a statue of Dewi Sri, the goddess of rice and prosperity, stands in a niche between these two identical beds. The bed posts are in-built into the ceiling for extra sturdiness.

**Above, right** Two sleigh-style beds in dark-stained wood with gossamer nets keep the color scheme strictly monochromatic in this guest room. Gold accents, in the form of cushions, gilt mirror and lacquer bowl, add a luxe touch.

**Right** Guests are drawn like magnets to this nest-like, cosy bedroom in a *lumbung* rice barn conversion in Legian.

**Far right** A truly tropical night's sleep is an option for guests in this open-plan second-floor space where curtains separate "rooms" and beds. Open on all four sides, protection comes in the form of suspended mosquito nets.

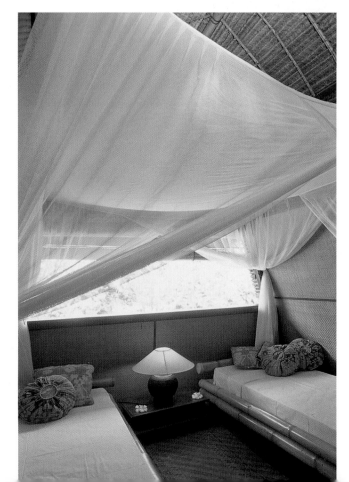

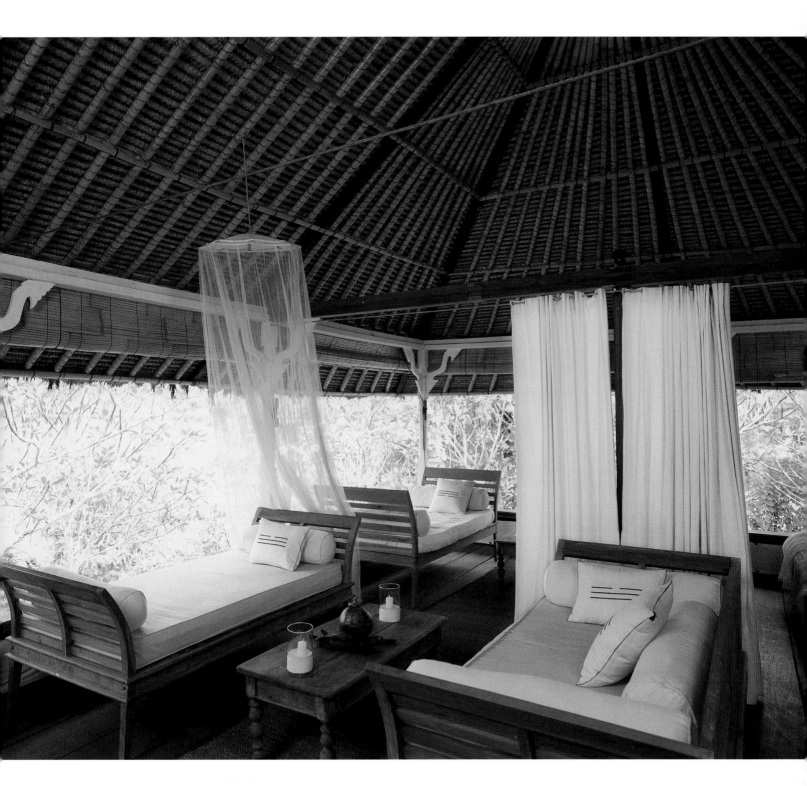

BENEATH THE MOSQUITO NET / *WHITE DRAPES, ROMANTIC ALLURE*

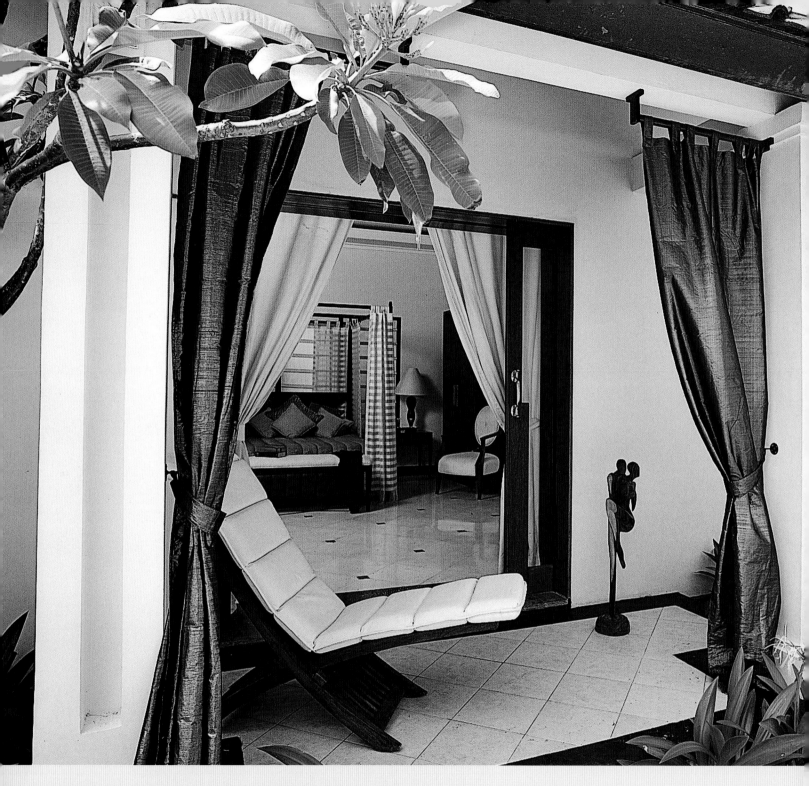

**Above** At luxurious Villa Ylang-ylang, this bedroom boasts a verandah that acts as a buffer between it and the garden, ensuring both privacy and space. Subtle changes in flooring delineate in and out.
**Opposite** A modern take on the net-draped bed: A futon mattress, a couple of rails running the length of the room, and some soft cotton hanging above. Wonderful garden views are a bonus, too.

# GUEST **QUARTERS**

**Having the luxury of space, many villas in Bali boast a** free-standing building that houses guest quarters. Connected to the main house by garden, pool, paving and so on, it is nonetheless entirely separate.

Oftentimes, though not always, this structure takes the form of a rice barn or granary which, in the traditional Balinese compound, accompanies the main house. Coming in a variety of different styles and sizes, they are usually made from bamboo and grass either in the four-posted *jineng* or six-posted *lumbung* style and are elevated a few feet off the ground.

Other home owners opt to build entirely new structures, often mimicking the style of the bigger main home. Giving guests privacy is obviously a high priority, but these structures also aim to be more than just a bedroom. Garden court bathrooms, exterior verandahs or balconies, wireless Internet and ricefield views are only some of the extras. Many have attendant outside lounging spaces with garden vistas. Silk curtains both inside and out, custom-crafted furniture and a cool interior are welcoming in the extreme.

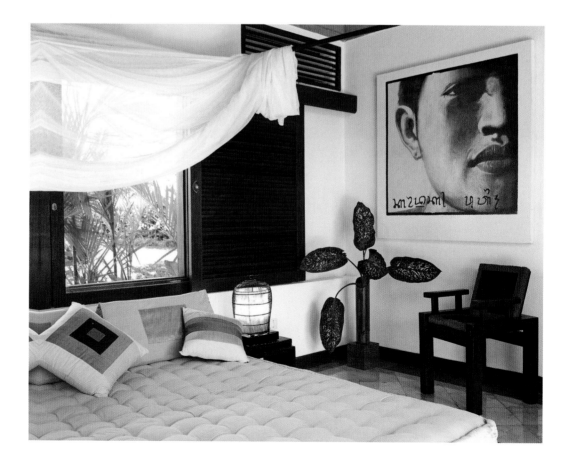

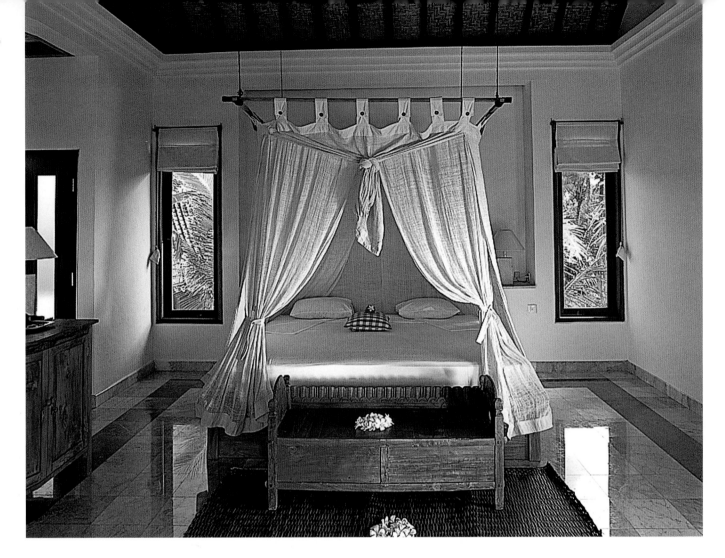

# WOOD **AND WHITE**

**Wood is warm; white is cool. Wood has all the energy of a living organism.** Each individual piece is unique with different grains, colors and shapes. White is pristine, powerful and pure.

As such, in an interior decorative scheme, the two can complement and contrast with each other in innovative, inspiring ways. The soothing, soft tones of organic bamboo, aged or recycled teak, matting, rush or tatami work well with white-tiled floors, whitewashed walls and soft cotton furnishings in ivory, light beige and white. White tones bring out the depth and beauty of a piece of wood.

In the bedroom, where tranquility, calm and softness are often the order of the day (or night), wood and white make for particularly fine coupling. As chameleon-like white has the ability to change with the time of day — it can have a bluish cast in low light, a red tinge at sunrise and sunset, a golden hue in candlelight — it is incredibly versatile. It takes on different characters, all the while allowing the beauty of its wooden companions to shine through. We showcase some examples of this duo in a variety of Bali's bedrooms. In some cases, another neutral tone such as grey in the form of polished concrete or terrazzo, is introduced as well.

Opposite Guest rooms at the Komaneka resort in Ubud are furnished simply with an emphasis on the natural. Drapes here are suspended from a frame hanging from the ceiling. **Right** A table runner as wall hanging and fish trap, with delicate wooden strands, as lamp complement the grey-and-white tones of this Filipo Sciassia painting. It's a simple composition, given some verticality by the dark tones of a warm wood console. **Below** An austere headboard framing a window in dark-stained wood contrasts with soft white bed linen and double blinds in this striking bedroom at The Balé in Nusa Dua. Another dimension is added by the grey terrazzo on platform and floor.

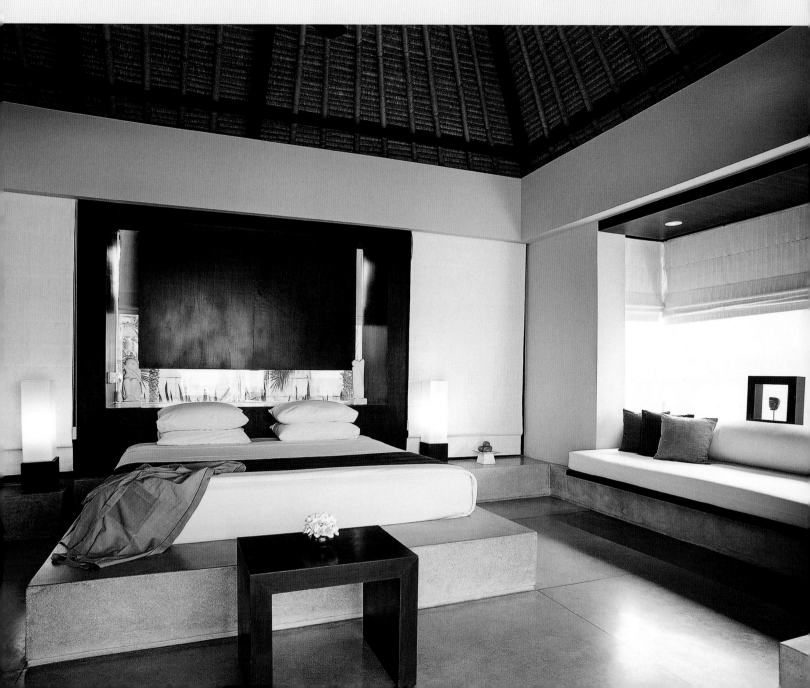

**Below** All is airy, bright and light in an upstairs bed-room. Here, white drapes and bedding from Esprite Nomade take on a greenish tone, reflecting the garden that encircles the room and is visible on three sides.

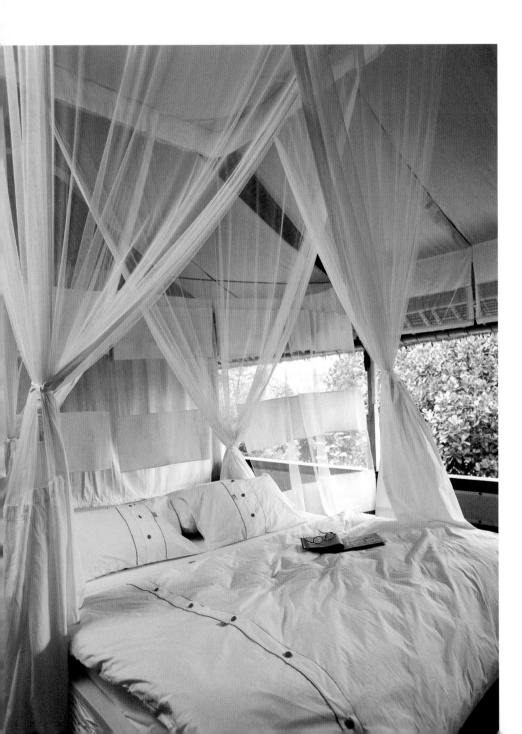

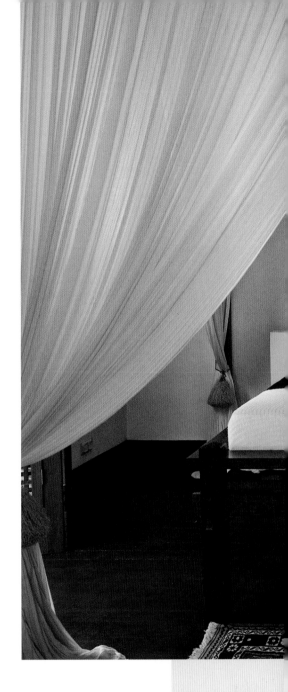

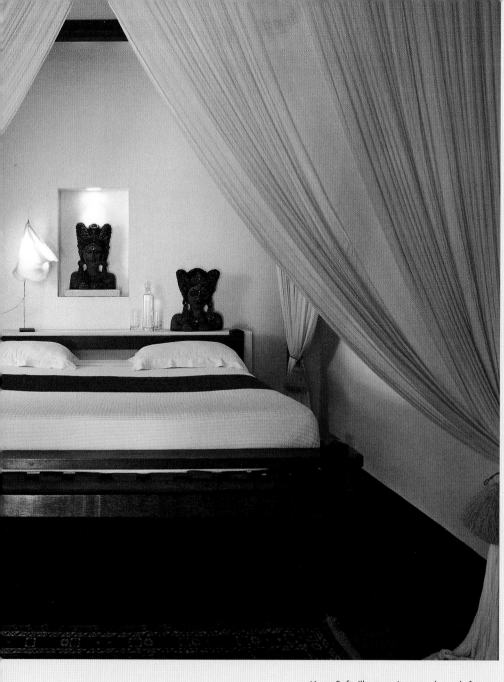

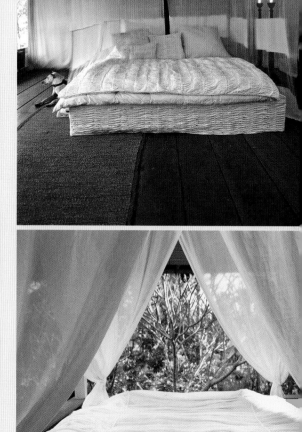

**Above** Soft silk mosquito nets elegantly frame a coconut wood bed to give a feeling of secluded intimacy in the master bedroom of a villa in Legian. The rug is from Afghanistan and the pair of statues symbolize Dewi Sri, the goddess of rice and prosperity.

**Top** Layering of white on white with voile curtains and gauze panels surrounds this bed beautifully decked out with Esprite Nomade fine-woven linen. The *alang-alang* roof and candlelight allow the white to take on a warm, golden tone.
**Above** Aaagh . . . zzzz.

**Right** Colonial-style bed with swirling posts and sturdy headboard is captured beneath an expansive mosquito net and thatched roof. Overlooking a pretty courtyard garden, the room can be open to the elements or enclosed at will.

**Below** Designer, Fredo Taffin, better known for his tropical modern creations has created a country-style bedroom in this home. The ivory-tinged cement wall finish gives the room a somewhat rustic air, a look that is furthered by the distressed chair and roughly rendered bed in old wood.

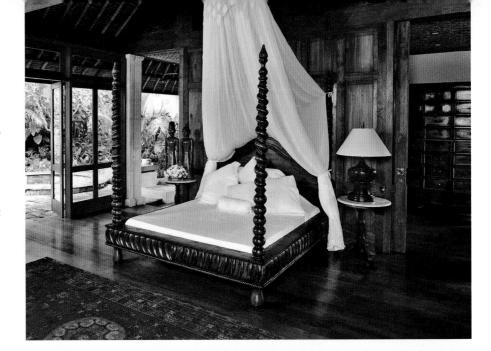

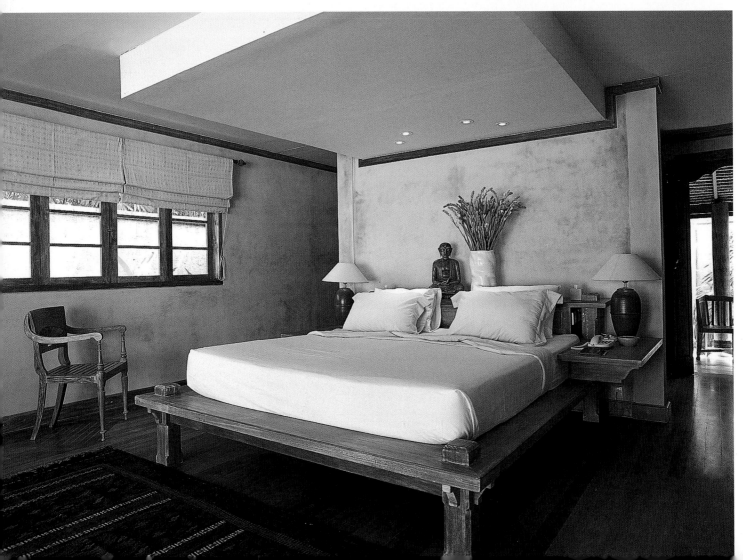

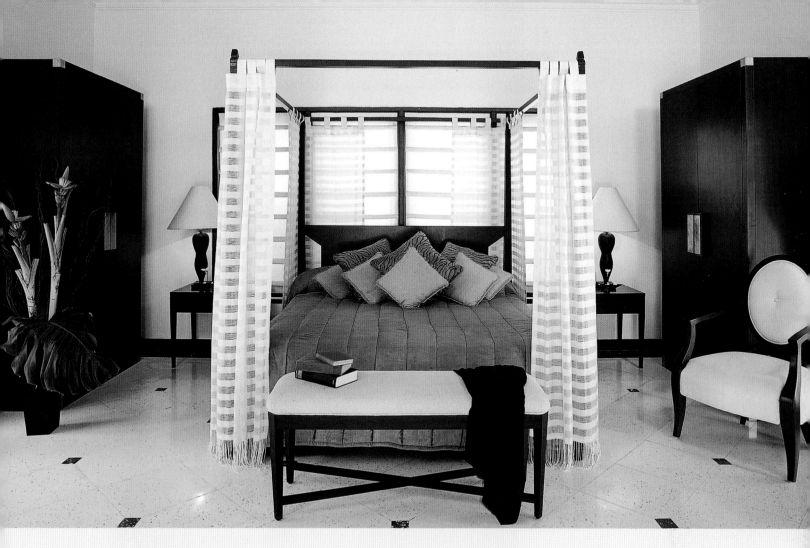

**Above** The master bedroom at Villa Ylang Ylang was designed by Danielle Mahon who was inspired by Aman hotels' interior decor. Dark-stained wooden wardrobes and furniture contrasts with the pristine white floor, walls and white drapes for a luxe, layered look. The bedlinen is super high quality, with animal prints and quilting giving further texture.

**Right** In the same villa, two sweet sleigh beds have views out to an open-air bathroom. Contrasting textures are seen in the heavy silk cushions and bed covers and the gossamer thin netting hanging from the ceiling.

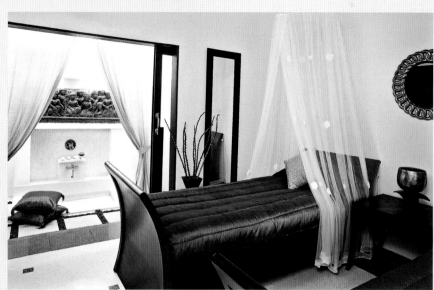

# TEXTURED **TREATMENTS**

**Walls are often overlooked** in a home. Seeing them simply as boundaries between rooms undermines their importance as they can be much more: Backdrops for artifacts or collectibles, instigators of color schemes and ornamental items in themselves.

Decorative wall painting techniques, such as sponging, ragging, stenciling or stamping, are easily managed by even the least artistic amongst us. Take two tones of the same color and give it a go. To avoid overkill, some designers suggest painting only one wall in this manner; leaving the others in a neutral tone brings attention to the treated wall and prevents the room from becoming overdressed.

Bespoke plaster finishes using combinations of lime, marble and porcelain chippings, gold dust, natural earth pigments, or even spices and crystals can create glamor and interest on a wall. Or adapt the Indian art of insetting an adobe wall with glittering glass to produce a wonderfully textural and exotic finish.

Experimentation is the name of the game here. Take a look at some of these gorgeous bedrooms: colour, texture, *trompe l'oeil*, nuance and stenciling create some stunning effects.

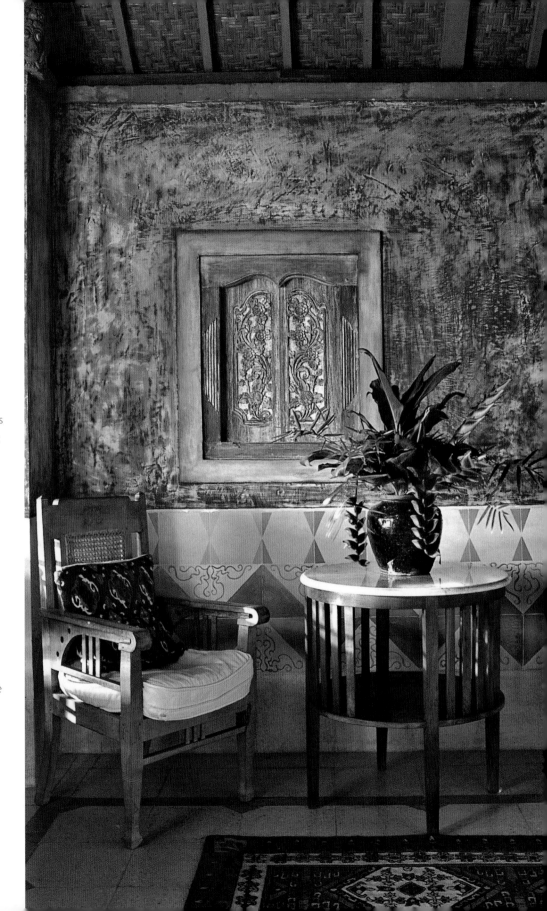

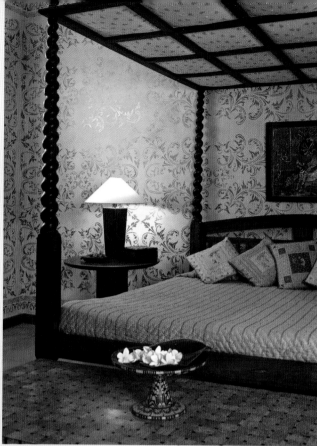

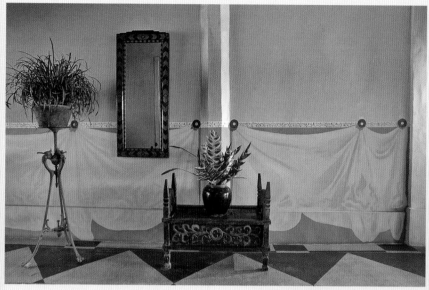

**Above** A thin corridor wall is characterized by some whimsical *trompe l'oeil* drapery painting by Australian artist Stephen Little; neutral colors are echoed in the floor tiles.

**Left** This gorgeous bedroom at Taman Bebek was also realized by Stephen Little and intended for royalty and rockstars! Avoiding over-opulence, the distressed paint finish in terracotta tones sits above a tiled section that comes to hip height.

**Above, right** An antique Javanese bed with attendant wall finish in traditional Javanese motifs complements both the simple *fleur-de-lys* pattern on the canopy fabric and geometric design in the coconut shell low table. The overall composition is balanced and serene.

**Right** Life-sized Javan nobles attired in court dress are painted on bathroom doors; they are surrounded by old Dutch tiles in shades of cream and celadon.

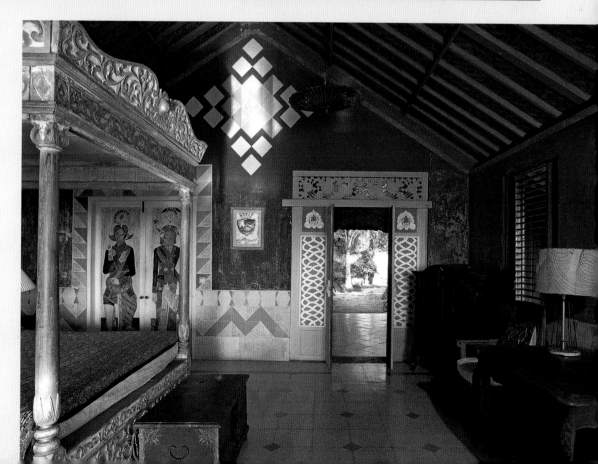

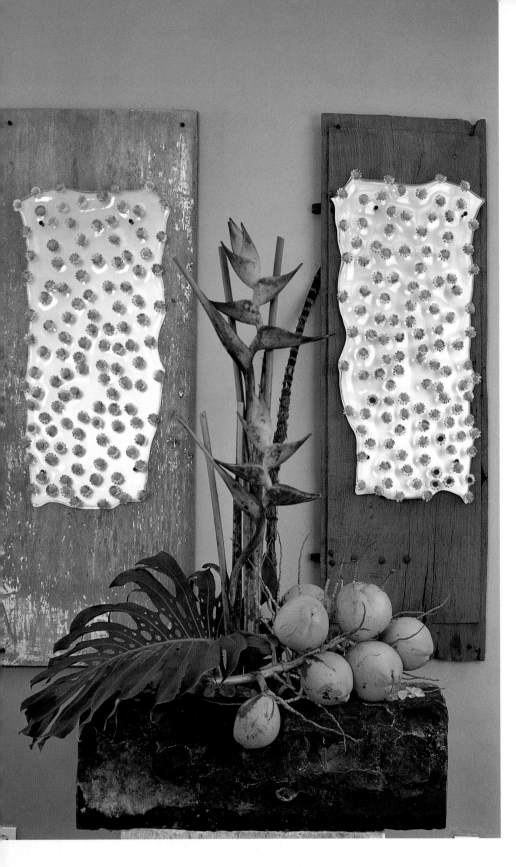

# RUSTIC AND RECYCLED

**Although all the vogue** in the '70s, the "Rustic Charm" movement lost momentum in the '80s and beyond, perhaps because new technology seemed to offer many solutions to design problems. Expansive glass doors replaced rice paper and bamboo blinds; *alang-alang* roofs were swept away by shingle tiles or synthetic counterparts; imported white goods were finally available in Bali, so it was out with the old, and in with the new!

The result was a frantic building boom that incorporated many international, homogenized elements into Bali villa design, a trend that seems set to stay. However, in recent years, there's also been a noticeable movement in the opposite direction: sustainability is the buzzword, some softer touches are becoming evident, and, surprisingly, people seem to want to admit to living in Bali after all! Equally surprising, such homes can look modern in a post-modern way.

If too much vernacular is too much of a mind jump, we suggest starting with the bedroom. Incorporating nature's charm into the bedroom instantly brings the comforts of country living into one of the most intimate and peaceful places in the home. Giving it a Balinese or tropical "theme" with indigenous statuary, recycled wood furniture and local textiles is soothing for the soul as well as the eye.

It also anchors the home with a sense of place: something the tropical international style, sadly, lacks.

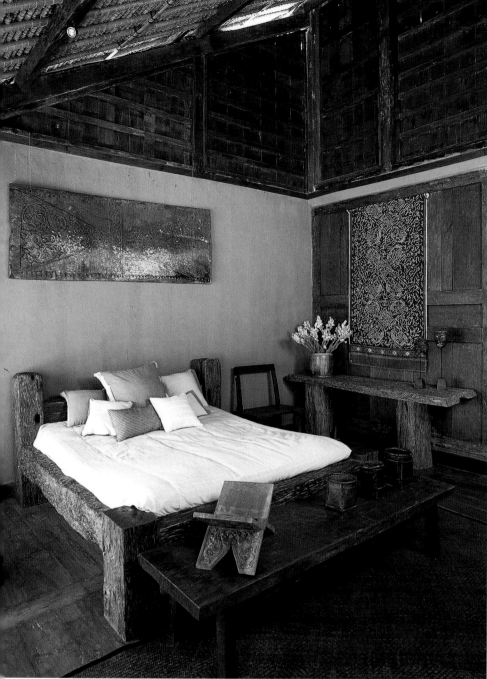

**Opposite** Mixed media work by Seiki Torige combines elements of old and recycled with high-tech glasswork. The sculputural young coconut and heliconia arrangement complements the two panels.

**Above** Antique wood panels, clunky furniture in recycled wood, a traditional hanging, *alang-alang* roof, rush mat — all elements of trad Bali style, yet somehow tantalizingly ethnic-modern.

**Right, top** A pair of *loro blonyo* figures, symbolizing marriage and good luck, appropriately sit on a bedside table.

**Right** Rustic-modern lamp, with resin shade and bamboo ladder stand, sits aside an old rice storage chest. The antique textile behind looks surprisingly modern.

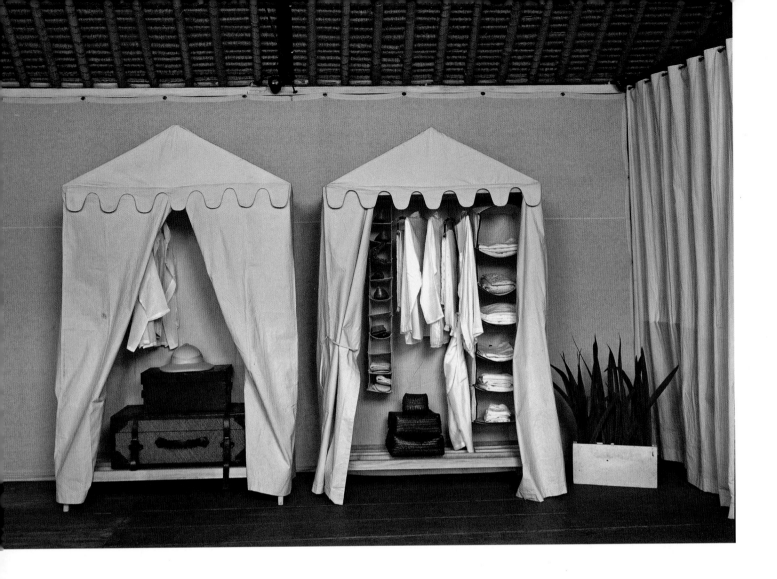

# STORAGE
# SOLUTIONS

**Tropical living often poses problems when it** comes to storage. The abundance of termites (they can chew through a largeish bookcase in less than a day, believe me!), damp and humidity, excessive heat and the life cycle of bacteria are all serious concerns when it comes to keeping prized possessions safe.

When locked away in an airless cupboard or chest, textiles, leather goods, clothes, shoes and more tend to either rot or start sprouting extraordinary growths of mold. Whilst the speed of such a phenomenon is no doubt extraordinary, it isn't what you wish for that new jacket or prized pair of Manolos, is it?

So, how to store them safely? Essentially, there isn't a perfect answer, but good air circulation, plenty of movement and constant dusting, polishing and airing are recommended. As a result, some innovative designers have come up with moveable wardrobes. Rather, they've designed a number of smaller, easily transportable cases, shelving units and cupboards that can be taken out into the sunshine for an airing if necessary. We highlight the cream of the crop here.

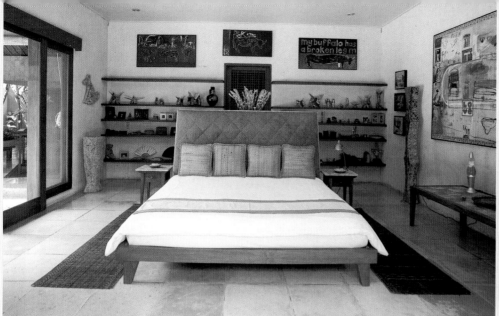

**Opposite** Innovative canvas portable cupboards from Esprite Nomade, a Bali-based wholesale and retail product design and manufacturing company that focuses on developing luxury products for home and travel. It is also well-known for its tents and tented events.
**Below** Display case for toiletries in teak. Designed by Giuseppe Verdacchi, it can be removed from its lava stone base for easy cleaning.

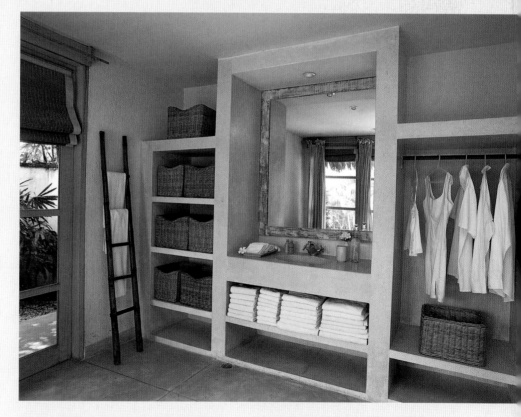

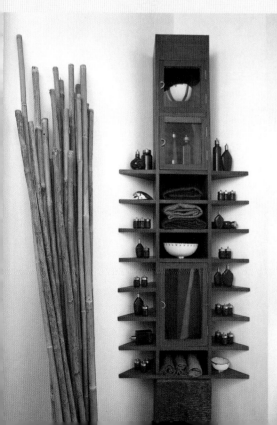

**Top, left** One way to avoid mold and other problems associated with humidity is to store goods in open shelving. Here, the bed is placed away from the shelves behind; these are peopled with possessions of all sorts. It's labor-intensive, as they need constant dusting, but safe.
**Top, right** Mimicking the traveling trunks of old, this portable storage container doubles up as suitcase and cupboard. The folding stool sits neatly on the top shelf when not in use. From Esprite Nomade.
**Above** Wicker baskets, either freestanding or placed on shelves as here, make for useful containers. Similarly, ladders always look elegant when they double up as towel rails.

# BOUDOIR CHIC

**The British designer, William Morris (1834–96) once said:** "Have nothing in your houses that you do not know to be useful, or believe to be beautiful," a tenet that still resonates more that 100 years later. Beauty and utility: both are highly prized in architectural, product and interior design.

This is especially true if you are lucky enough to have a nook or cranny, or even a stand-alone room, that can be decorated as a boudoir. A somewhat old-fashioned concept (its dictionary definition is "a woman's dressing room, bedroom, or private sitting room"), the boudoir is seeing a resurgence in the homes of women with time, resources and space. Self-indulgent, certainly; frivolous, without a doubt! It should be like a box of chocolates, full of "naughty but nice" confections.

Usually attached to an area of walk-in wardrobes, the modern boudoir is opulent, plush, neo-boho and bold. When designing such a space, allow creativity full rein: Lashings of silks, satins and organzas layered in luscious colors and textures. The space should be theatrical and dramatic, sensuous and louche. Keep lighting low with dimmers; better still, use candles.

Even though Morris's concept of utility may be questioned in such a room, its beauty cannot be denied. Take inspiration from the two examples shown below and opposite.

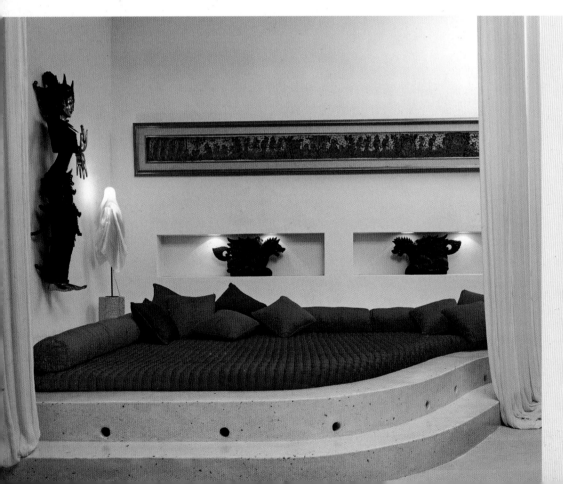

Left A secret hideaway effect is achieved in this corner niche where a terrazzo bed nestles behind silk curtains; local antiquities accentuate the precious feeling. Set adjacent a wall of tall mirrors and wardrobes, this nook makes for the ultimate dressing (and lounging) room.
Right An Arabian Nights-style effect is achieved beneath the pitched roof of this decadent den. The color palette and textured layering are key: skillfully employing deep bottle greens in the low-level seating, organza and raw silk drapes in scarlet, cerise and malachite, and matching them with the copious use of thatch and dark stained wood is masterful. The detailing is cleverly thought through too: soft lighting from table lamps; spots and a central wrought-iron chandelier; top-quality materials; an lush antique carpet from Uzbekistan, silver lamps from India and opium table for both romance and drama.

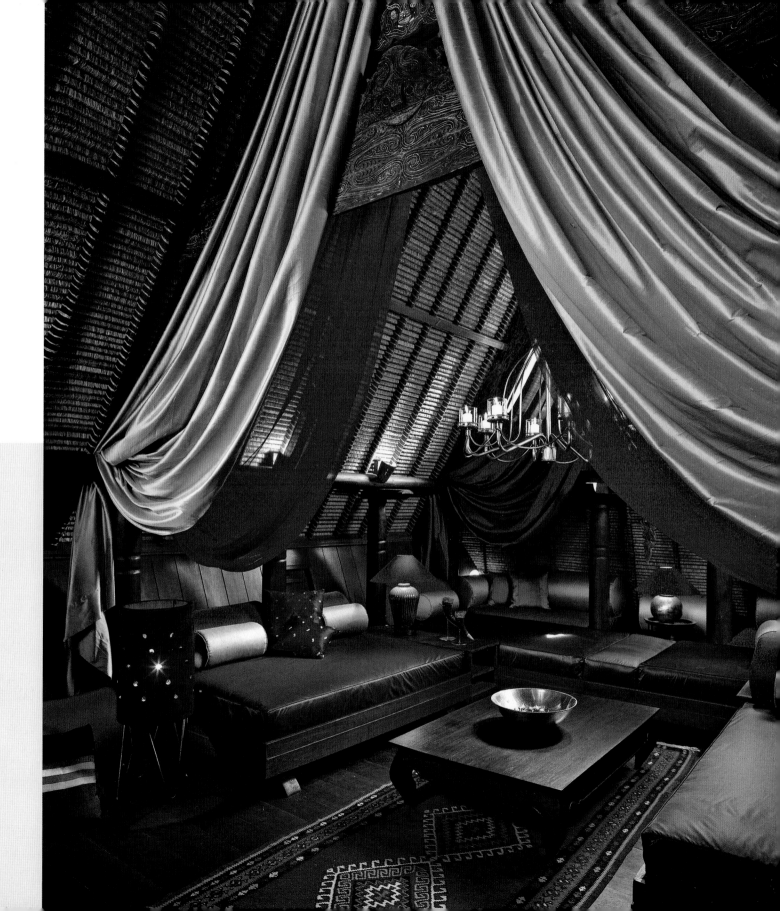

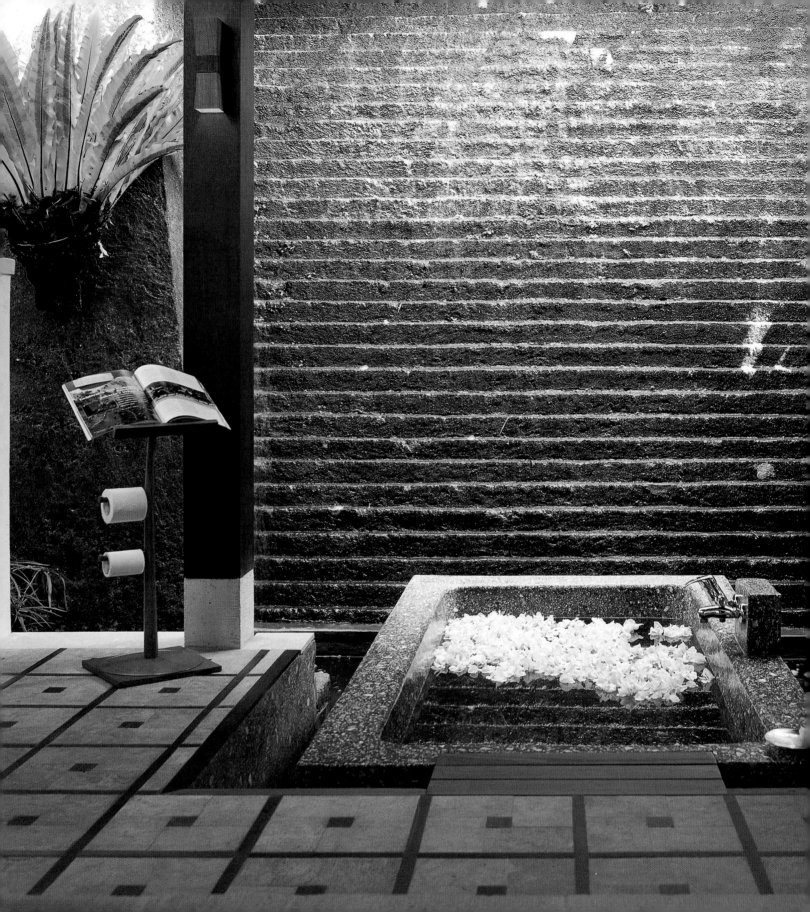

# BATHING IN THE TROPICS

**No self-respecting holiday villa** in Bali is without at least one indoor-outdoor bathroom, a concept that originated with Peter Muller's seminal Kayu Aya Hotel design in 1972. Inspired by traditional Balinese bathing and the bath houses of vernacular homes, it was considered revolutionary in its time. In the following years, however, it soon became de rigeur in hotel, villa and garden estate designs.

The standard elements aren't difficult to clone at home: Lashings of light and water (obviously), a riotous profusion of greenery and flowers, organic materials such as bamboo, river pebbles and resin and, preferably, a garden court, French windows or skylight. Add to these state-of-the-art, gadget-heavy fittings and you have the modern-day equivalent.

Power showers, ideally with huge heads and jets, are accompanied by a sleek tub whose sole aim is to provide therapeutic "me-time" in secluded surrounds. In today's fast-paced world, the experience of bathing may be the only "slow time" that people have: as a result, the trend is moving away from opulence towards more pared-down, austere designs to produce a kind of Zen-den bathing experience.

In this chapter we showcase Bali's best: Cutting-edge tubs often have all extraneous features removed or hidden; taps, spouts, plugholes and overflows are almost invisible. Shapes range from sunken squares to moulded forms, with blockier models having the ubiquitous head-rest. Materials are either pricy and man-made

or even more pricy, in super-luxurious natural stone or marble; bespoke, naturally, takes the bottom line even higher. Down-sizing is only to be found in dimension: women, especially, are requesting smaller tubs as yesteryear's super-size models are deemed difficult to anchor oneself in.

The size of the bathroom itself, on the other hand, is growing. Because it is the only room in the house that one is unlikely to be disturbed in, it's evolving from the strictly utilitarian towards a "lifestyle space". It's no longer simply a room for cleansing. Storage space in the form of book-shelves and cupboards, a side table for a glass of wine or cup of tea, and wall space for artworks are finding their way into the bathroom. Planter boxes for cascading ferns and potted palms also take up space.

In recent years, whirlpools and steams have experienced a renaissance, along with taste-ful water features, such as small cascades or fountains preferably with an attendant "garden". These, naturally, aren't opulent; rather, they provide the calming sound of falling or trickling water and help to give the room a more out-doorsy feeling.

The following pages offer a plethora of ideas for Bali-style bathrooms: Ranging from jungle settings and open-to-the-sky courts to strictly indoor rooms (albeit with outstanding views), they encapsulate all that is romantic about the contemporary bathroom. Take some tips for feel-good design for strictly private time.

Designed by Guiseppe Verdacchi and hand-crafted in limestone with a textural finish, this wall acts as a back-drop to the bath. With water cascading over its surface, it is both decorative and cooling.

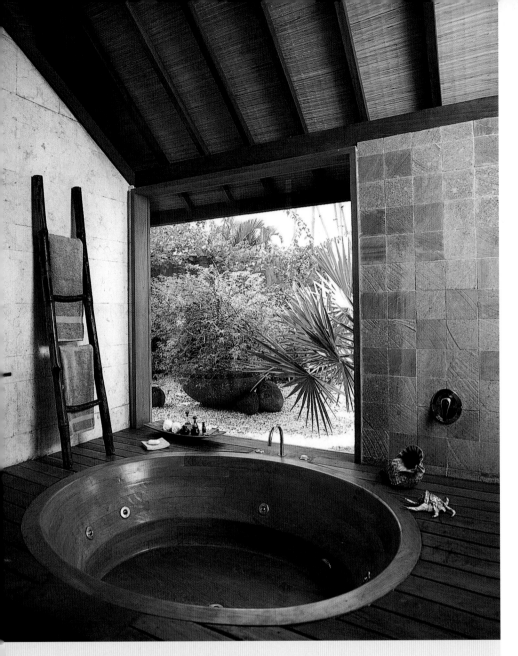

# GARDEN
# BATHROOMS

**Today's garden bathrooms in Bali** have their roots in traditional river, spring and *mandi* bathing; all three, to a greater or lesser extent, involve both physical and spiritual cleanliness. As with Japanese practice, the bathing act itself involves throwing water over the body rather than submerging oneself in it.

The last Raja of Karangasem was so taken with outdoor bathing, he built splendid water gardens at Tirta Gangga and Taman Ujung (the former with public bathing added in 1948), as well as at Taman Narmada in Lombok. Designed for pleasure, as well as ceremonial and spiritual functions, they were a mix of Balinese and European styles — with vast pavilions and pools intermingling with formal gardens.

Reducing the scale more than just a tad, it is possible to create a garden bathroom at home. Wood, marble, planter boxes with a profusion of ferns and other tropical greenery, pebbles and a great light source are the raw materials. Add a dash of imagination and color, and anything is possible.

If space permits, try keeping the tub and sink separate from and overlooking a small garden court. The ideal is to have the former indoors and the latter outdoors — to reduce mosquito activity whilst performing ablutions.

**Above** This Japanese-style bathroom takes its inspiration from Zen concepts of simplicity as well as *onsen* natural spring bathing. The Jacuzzi tub and surrounds are made from teak, while the oversized picture window gives views over a spare pebble-and-palm garden.
**Opposite** The Villa Ylang Ylang's master bedroom has a palatial bathroom to match: Overlooked by a life-size statue and landscaped pool, the sunken bath combines lava and *palimanan* stone for a richly textured bathing experience.

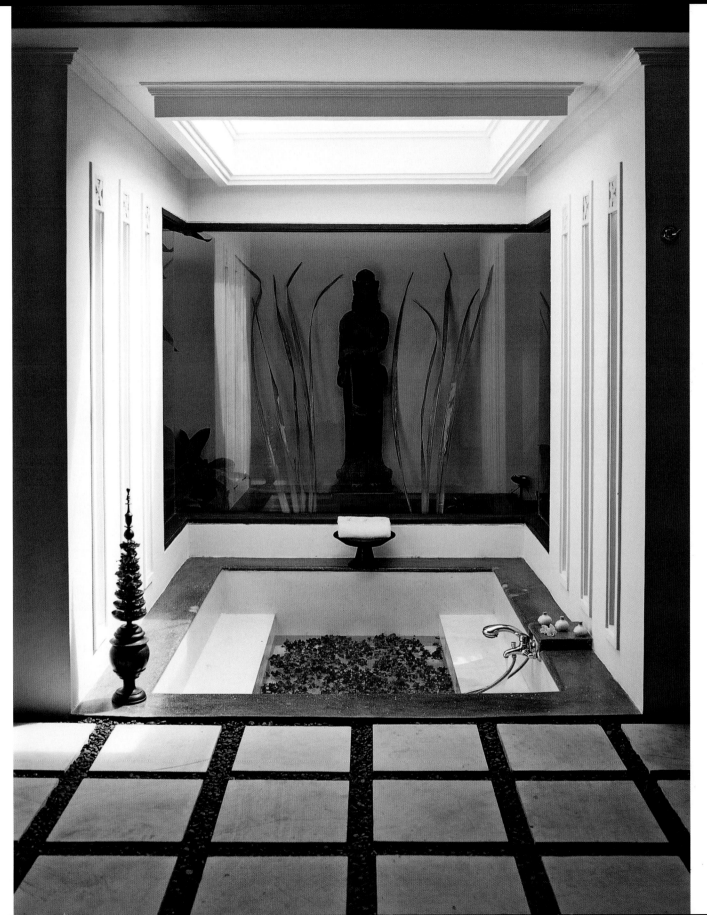

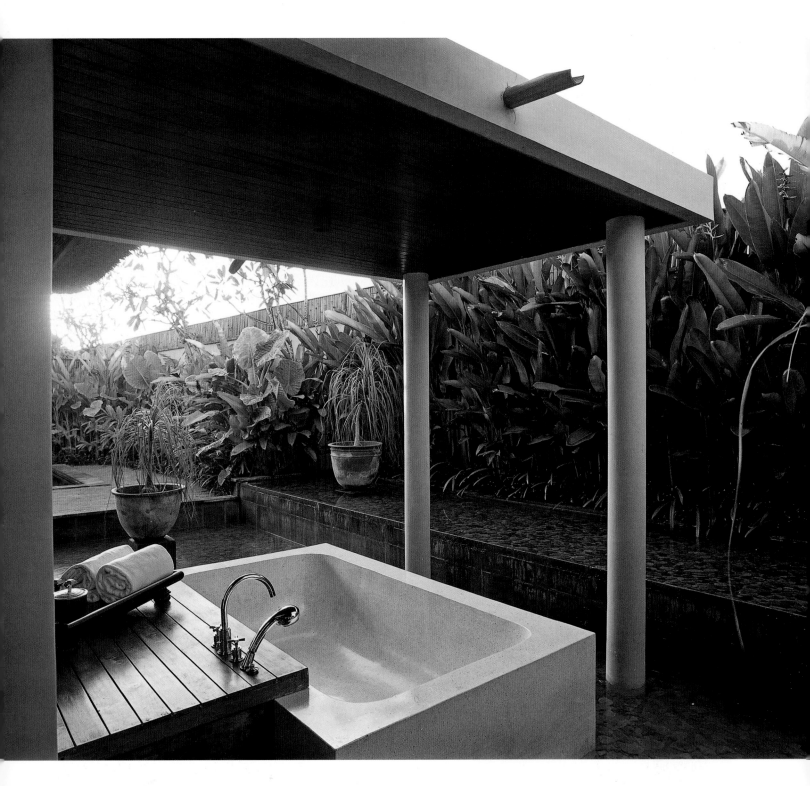

**Left** Surrounded by a water garden and lush foliage, this terrazzo tub in one of the villas at the Club at the Legian has a view over a private lap pool (just seen).
**Right** A grey stone sheath houses the pipes for this garden shower, where heliconias mix with garden statuary for open-to-the-elements bathing. A Balinese sculpture doubles up as an unusual towel rail.
**Below** Private villa bathing in a sunken pool made from volcanic rock from Mount Kintamani is all the more pleasurable when it is conducted within the confines of a secluded water garden. Wood, stone and water all combine here for an unparalleled al fresco experience; the two statues from Singaraja add an exotic touch.

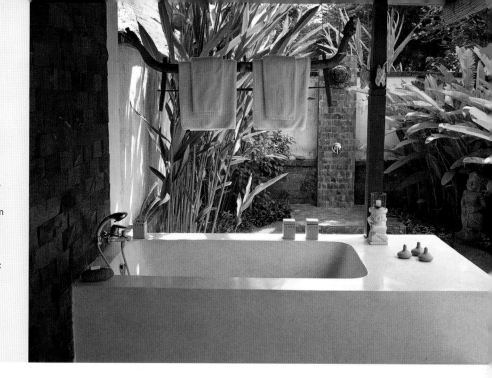

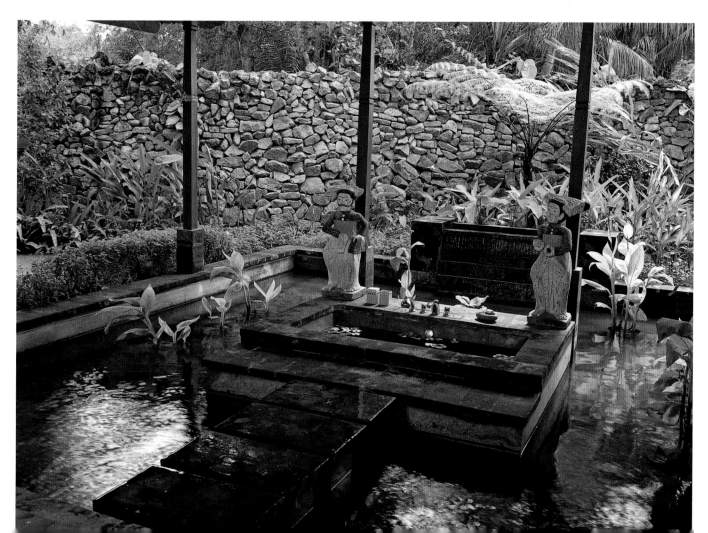

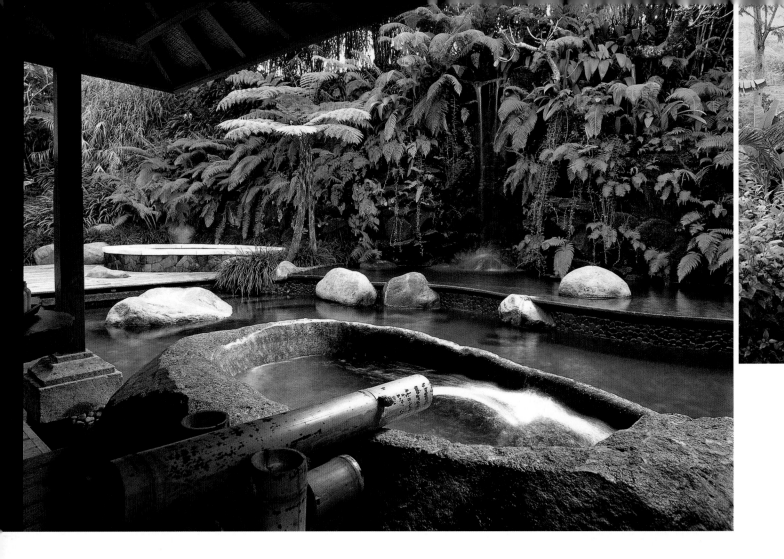

# BESPOKE TUBS: **THE ULTIMATE IN LUXURY**

**As architectural language becomes increasingly stark, the addition** of one or two bespoke elements into a home adds luxury and originality to an interior. At the higher end of the market, pared-down styles are tending to accompany this trend; as a result, a custom-crafted item allows a home-owner to express his or her own personal style.

One designer says that it's interesting to note that, in many cases, clients are willing to blow a big portion of their budget on the master bathroom. Because this may be the only truly private room in the home, owners want it to reflect their tastes, needs and desires. And a bespoke tub is — apparently — not an unheard of luxury.

Add to this the fact that bathing is now considered a "lifestyle experience" rather than a mere wash, and you begin to understand why people want their own particular style of tub. It's seen as an expression of their individuality or personality — a beautifully crafted item of beauty taking center stage in one's own personal sanctuary.

We showcase four truly outstanding bathtubs here: Taking hedonism to new heights, they provide the ultimate bathing experience.

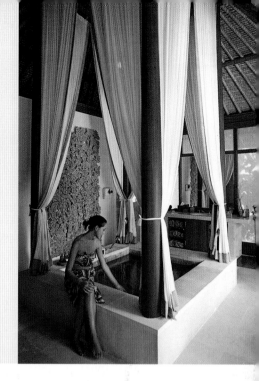

**Opposite** A villa at Begawan Giri Estate is a water wonderland with naturalistic waterfall and Jacuzzi set in a luxuriant garden complete with a six-tonne single stone-carved bathtub. The bamboo faucet is an inspired touch.

**Left** Here, a private *balé* houses a spectacular bath within a private outdoor garden. It's a heady mix of modern and traditional.

**Right** A sunken tub in white stone at the Four Seasons Resort at Sayan complete with four teak posters and drapes is big enough for the whole family! The bas-relief on the wall behind gives a sense of refinement to the whole.

**Below** An oversized tub — smooth and polished on the inside, roughly hewn on the exterior — is crafted from a single block of Javanese stone by architect Cheong Yew Kuan.

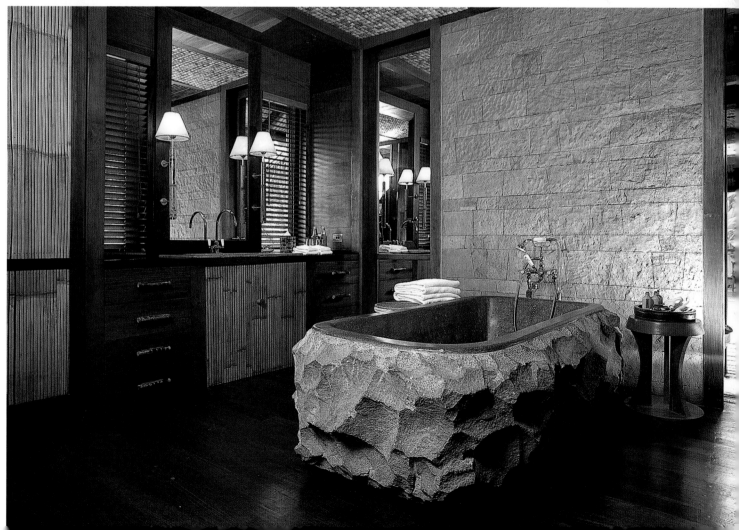

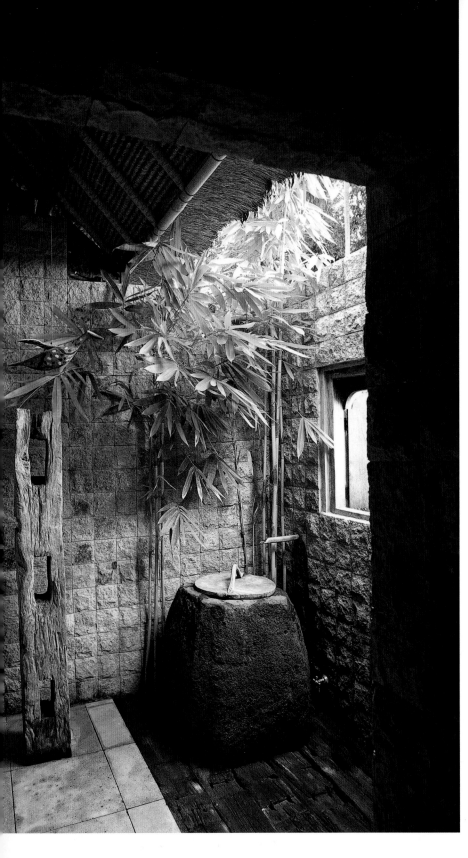

# SHOWER
# POWER

**An outdoor shower is simply an** extension of the traditional *mandi* bathing practices of the Balinese: a waterfall, some soap, a loofah (and a sarong in the case of the locals) is all that's needed. With the sounds of frogs and crickets all around, the sight of a star-studded tropical sky above and the caress of cool water on the skin, outdoor showering can be a sensational experience.

There's seemingly no limit to the imagination of such shower design in Bali. From high-tech, multi faucet water-blasters to recycled wood or bamboo spouts, the range is very impressive. Where they are unified, how-ever, is in their surrounds: adjacent pools in the garden or in small garden courts, they're often accompanied by verdant tropical foliage.

A visit to one of Bali's superior hotels or villas gives guests many opportunities to shower in some fabulous outdoor bath-rooms, many of which also have private plunge pools. Alternatively, take some ideas from these photographs — and re-create the experience for yourself at home.

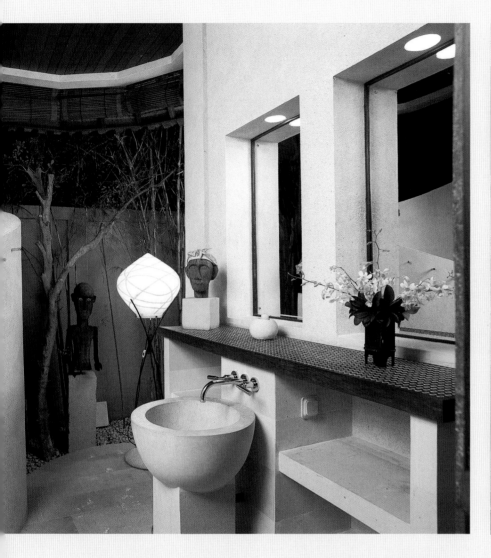

**Opposite** Rough, unfinished textures of wood and stone combine here to create a garden bathroom that offers the most basic of amenities: an ancient water storage jar and a bamboo spout.

**Above** A combination of round shapes (shower unit with decent-sized head, sink) and angular ones (long shelving, recessed mirrors) gives this indoor-outdoor bathroom panache and style. A sink such as this one is useful in a cramped bathroom.

**Above, right** Access to the grotto-like pool at Four Seasons Resort at Jimbaran Bay necessitates a fresh water shower first. This is provided by a homespun bamboo shower and huge earthen water container — very naturalistic, very fresh.

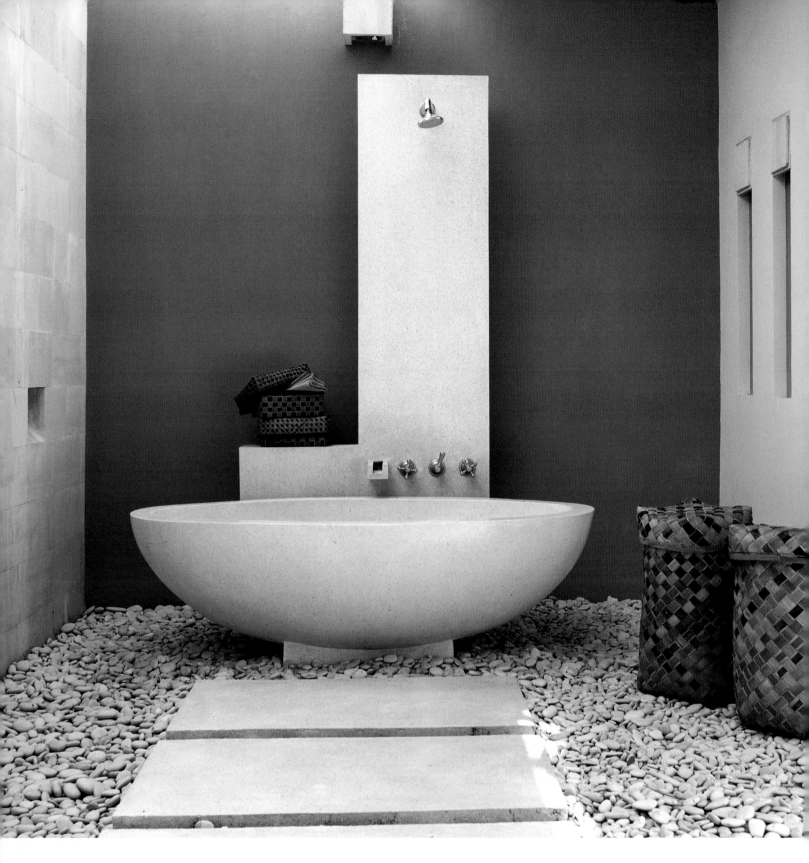

**Left** Vernacular woven basketware brings warmth into this somewhat cold patio bathroom, where the shape of the oval bath complements the rectangular form of the shower stand.

**Right** In keeping with its jungle backdrop, this simple outdoor shower in bamboo and stone is refreshingly unpretentious.

**Below** Set within a back garden, this "bathroom" is truly tropical: a bamboo faucet, a glazed water jar and a Japanese-style wooden tub provide the basics, whilst the bigger picture is supplied by the profusion of plantings, natural stones, thatch and wooden decking.

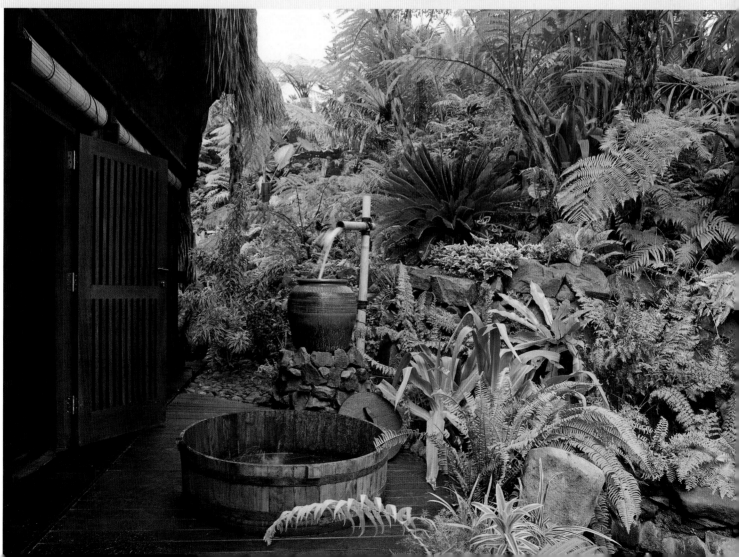

# CHIC **SINKS**

**If you want to give a tired bathroom a makeover, you may** find that a replacement sink is all that is needed to give the room a totally new look and feel. From the standard white porcelain option to more cutting-edge glass, granite, corian or ceramic freestanding basin styles, there are infinite options.

Naturally, you'll have to consider faucet and countertop design in conjunction with the sink — and again there are plenty of styles to choose from. Many manufacturers sell the three together in one package. Contemporary sinks are very clean in design, with little ornamentation, and shape often dominates the look. Relatively new additions to this category include the angled sink where the water doesn't gather, but runs straight into a collection unit behind. Another popular style is the vessel sink: this comes in a multitude of materials, is generally round and sits on top of the counter. It needs a tall elegant faucet.

Pedestal sinks, on the other hand, are useful if space is limited. If a warm, yet up-market, look is preferred, you might want to consider a copper sink. It will add character to any room and gives peace of mind as it's a healthy choice: While bacteria can live for days on porcelain, it survives only hours on a copper sink. It's increasingly the designers' choice these days.

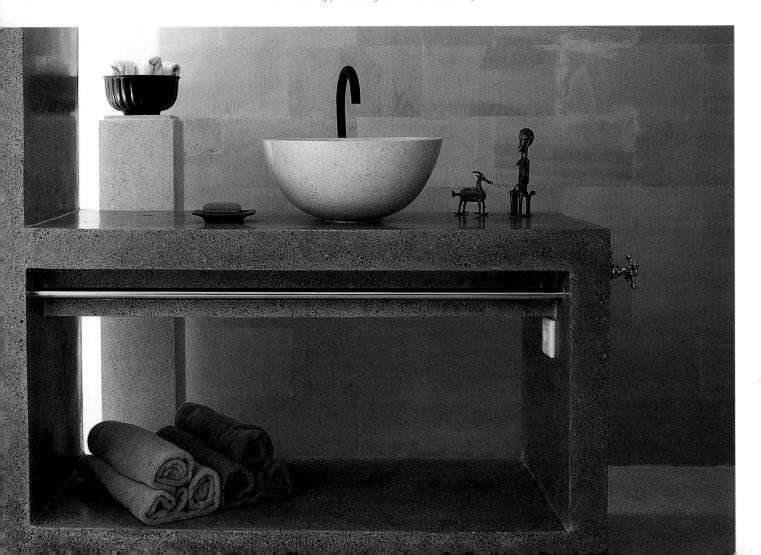

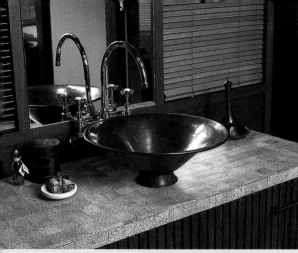

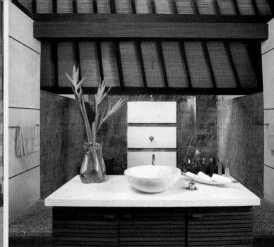
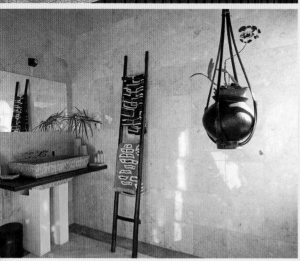
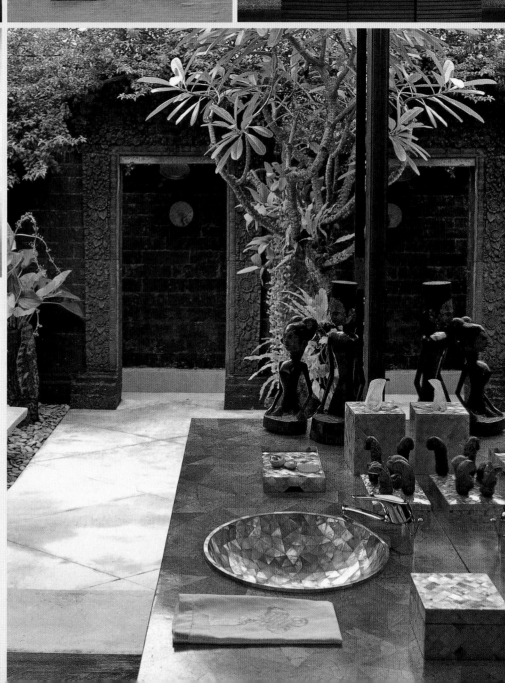

**Opposite** An angular green terrazzo unit works well with the pure round shape of this basin and ivory *palimanan* stone wall.

**Clockwise, from top left** Luxurious materials, in the form of copper for the vessel sink and coconut shell for the vanity, give this unit a masculine feel.

Contrasting textures and tones make for dramatic coupling here: A black terrazzo sink, a counter in unfinished ivory stone, stainless steel amenities and beige window drapes.

Mimicking the trend for free-standing island units in the kitchen, this vanity and sink acts as a buffer between the indoor bathroom and the outdoor shower area.

The highlight of this beautifully composed bathroom is the mother-of-pearl pedestal basin set in a coconut shell vanity unit. Matching accessories and cool marble floors further the wow factor in this sensuous sanctuary.

Texture predominates in this simple, clean bathroom where the stone sink is roughly finished on the outside, yet smooth and clean within. It is unusual how it is balanced within the wood countertop.

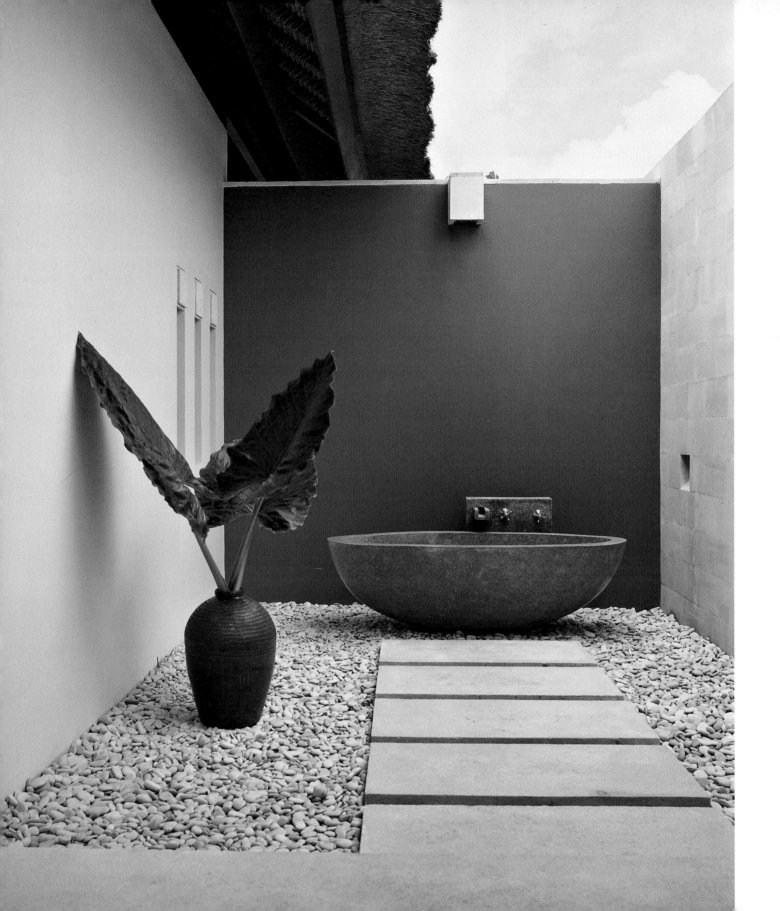

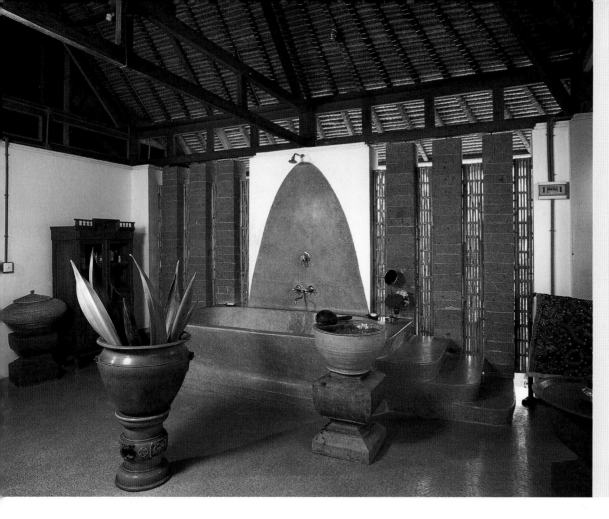

**Opposite** The serenity of this open-air bathroom comes from its beautiful combination of shapes, textures and tones: a perfectly oval terrazzo tub, a deep green wall, ivory limestone flooring and walls, and a carpet of white pebbles. The addition of alocasia or elephant's ears leaves in the Chinese water urn is inspired.
**Left** This sage green bathtub was cast in situ so as to form a curvy shaped splashback. Its smooth form contrasts with the rough *paras* columns interspersed with split bamboo on either side.

# TERRAZZO: **THE DESIGNERS' CHOICE**

**Initially created by Venetian builders as a low cost flooring material,** terrazzo has been in almost continuous use since the 15th century. Originally composed of leftover marble chips from up-market construction jobs and mixed with clay and goat's milk as a sealant, it is durable, flexible, hygienic and sustainable.

These days, the goat's milk has been replaced by a processed cement or epoxy binder, but the basic composition remains the same. And, instead of being reserved solely for flooring, terrazzo is finding its way into bathrooms and kitchens. It is particularly suited to the formulation of free-form bathtubs.

Sunken varieties, where the bath itself is an extension of the flooring, probably came first, but pre-cast models are gaining popularity with designers. Shapes and colors can be chosen pre-production, and, if made well, the tubs should be both heat- and scratch-resistant. Furthermore, clients can sleep soundly in their beds knowing that the material they're using is eco-friendly.

That's right. Much of today's terrazzo uses crushed porcelain, marble or other stone from old fixtures and fittings. Once combined with modern resins and sealants, the material takes on a new life in the home.

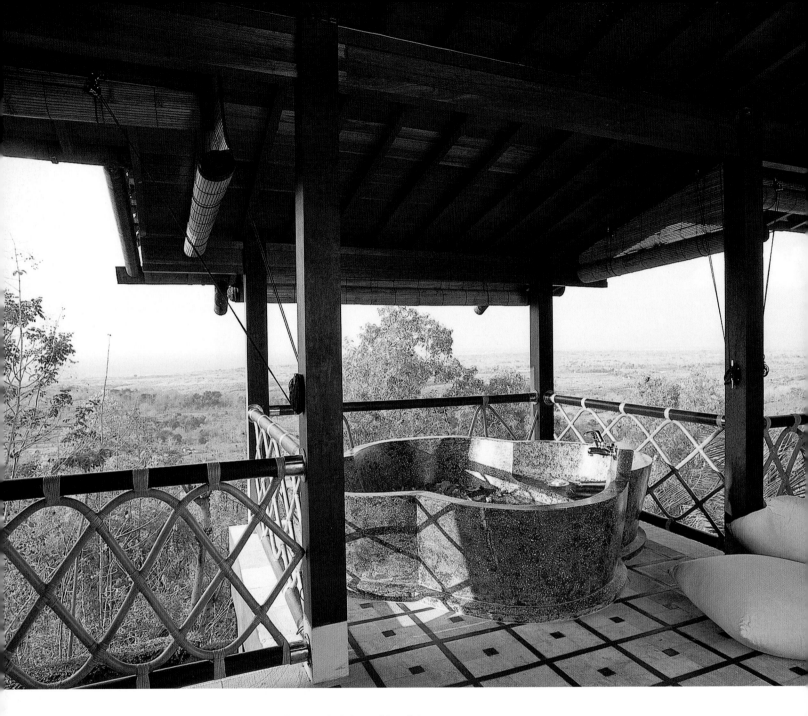

Four-leaf clover shaped tub in pink terrazzo takes pride of place on the balcony of this villa in Uluwatu. The dramatic inlaid flooring is matched only by the stupendous view.

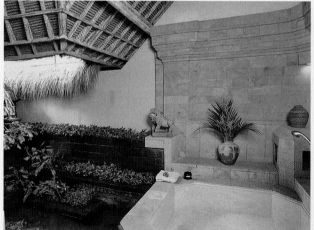

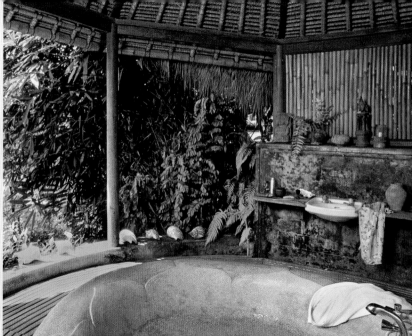

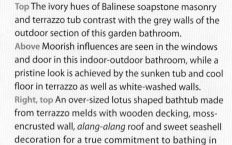

**Top** The ivory hues of Balinese soapstone masonry and terrazzo tub contrast with the grey walls of the outdoor section of this garden bathroom.

**Above** Moorish influences are seen in the windows and door in this indoor-outdoor bathroom, while a pristine look is achieved by the sunken tub and cool floor in terrazzo as well as white-washed walls.

**Right, top** An over-sized lotus shaped bathtub made from terrazzo melds with wooden decking, moss-encrusted wall, *alang-alang* roof and sweet seashell decoration for a true commitment to bathing in harmony with nature.

**Right, below** The focus of this bathroom is the huge limestone boulder that was *in situ* before the project took shape. It has been incorporated into the bathroom interior, because the sink and sunken bath were flexible enough (being made from terrazzo) to take its massive form.

# FEATURE
## WALLS

**Feature walls are experiencing** something of a comeback as house design becomes ever more homogenized in today's world. Commissioning bespoke decorative surfaces of custom-mixed plaster, stone-carved reliefs, mosaic murals or natural stone finishes is a luxury for sure, but nonetheless do-able with today's budgets.

Somehow, the bathroom lends itself to such an idea. This may be because it is considered a "wet room" (think of the Turkish *hammam* with its antique mosaic tiling) or because it often has an outside element, at least in the tropics. Often backing the bath or shower, the feature wall sometimes acts as an extension of the decorative boundary wall of a courtyard.

We showcase a couple of beautiful bathrooms with particularly fine examples of craftsmanship here. From mosaic tiling to intricate carving, they're the work of some of Bali's talented design ateliers. But, remember, if considering something like this in your own home, one wall, or a segment of a wall, is usually enough. Avoid over-ornamentation at all costs.

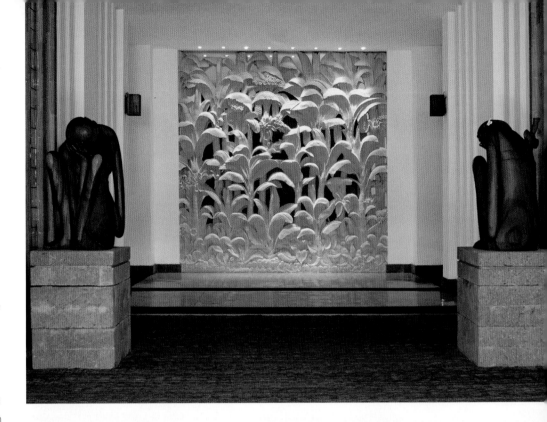

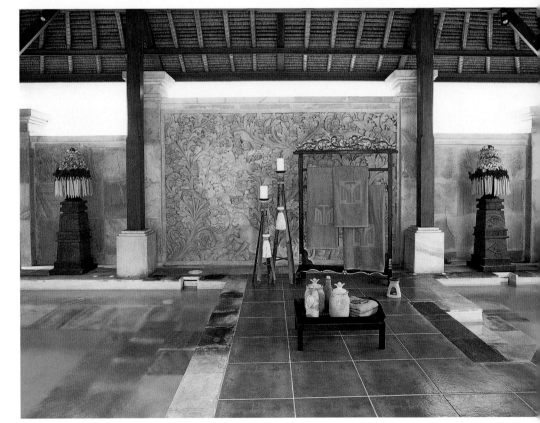

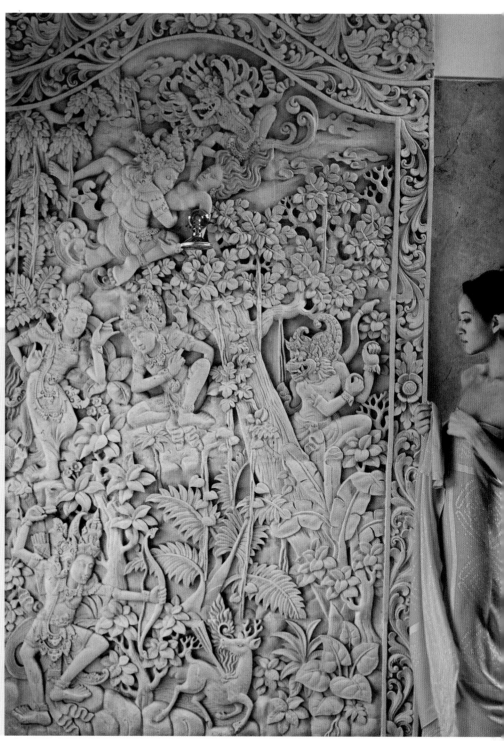

**Left, top** Making a statement, an intricately carved stone wall with floral motifs takes pride of place in the lobby at the Legian. Such a piece, at home, needs high ceilings and a cavernous space.

**Left** Open-air plunge pools at the Martha Tilaar spa in Ubud are surrounded by a boundary wall, the central part of which is beautifully carved with vegetal and floral depictions. Something similar could easily be replicated in a spacious outdoor bathroom in a luxurious home.

**Above** Carving in niches is a rich way of decorating a feature wall. This one here brings a sense of romance and history to an outdoor poolscape space.

**Right** Scenes from the Hindu epic, the *Ramayana*, are depicted on this elaborate wall containing a power shower. Crafted in temple relief style, the detailing is incredibly complex.

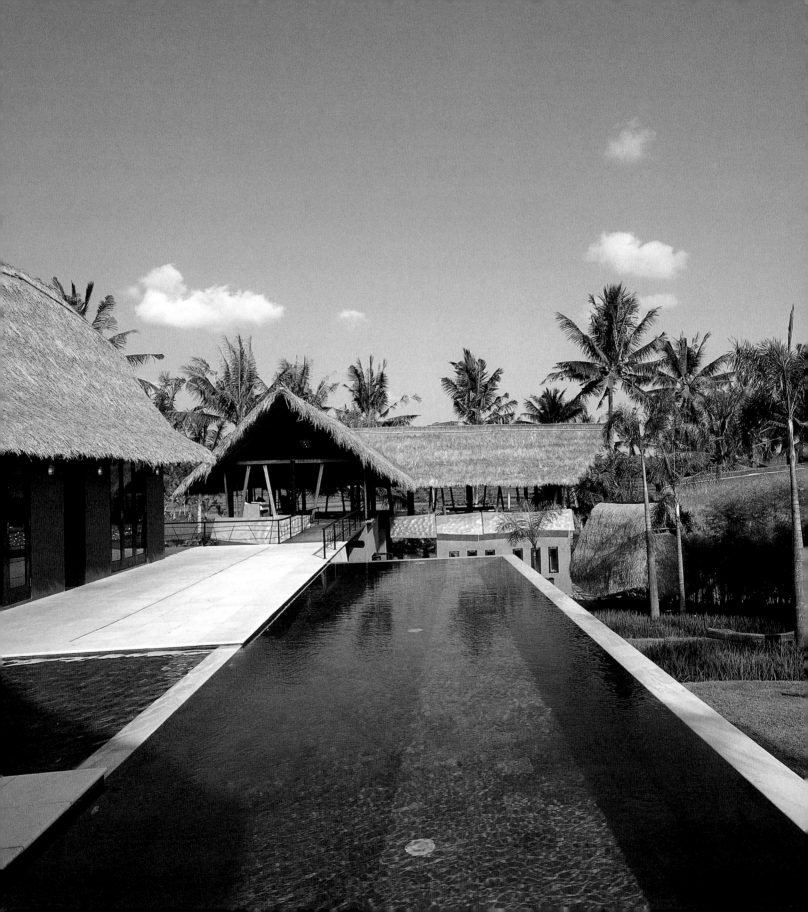

# TROPICAL AL-FRESCO

**One of the true joys of living** in the tropics is access to the great outdoors — and, because we are talking equatorial, sunny, hot, humid, moist and more — every tropical garden needs to be accompanied by a pool with attendant pavilion. These, in turn, are desirous of garden decoration, lighting, statuary and more.

For obvious reasons, the tropics leads the globe in swimming pool design. An abundance of natural materials — a variety of stones, slates, tiles, mosaics for lining and timber, stone and ceramic for decking — plus the fecundity of prolific plantings and a benevolent climate has led to some ground-breaking pool forms.

The infinity-edge pool, first experimented with in the 1950s, has come of age in some of Bali's resorts and private villas: Whether it merges with the ocean, horizon and sky, or with a jungle vista is immaterial. Other designs include the free-form, maze-like style where a number of interconnected amoeba-shaped water bodies merge and mingle with landscaped "islands" and natural rocks; the starkly geometric; the multi-tiered and layered pools that play with the light at different times of the day; the mini plunge pool; and the private, extra-long courtyard pool often isolated for serious lap swimming.

Similarly, architects and landscape designers have made huge inroads into amalgamating swimming pools with other water features. When a swimming pool is placed adjacent reflecting lily ponds it tends to merge with the landscape more. A case in point is the azure garden pool of Madé Wijaya's atelier home: it blends almost seamlessly with the surrounding water garden characterized as it is with statuary, pathways, pavilions and plantings, yet retains its centerpiece status. Another example of water meeting water is at the Four Seasons at Sayan (see overleaf); here, the resort's small, multi-level swimming pool seems to merge with its close neighbor, the serpentine Ayung river.

Naturally pools cannot exist in isolation. They need pavilions, pergolas and pathways, decks and decoration, and furniture for serious lounging. We give you ample illustration of the world-famous Balinese *balé*, along with a host of ideas of how to create and furnish such a structure at home. Similarly, there are top tips for pool edging, decking and paving as well as some beautiful ideas for garden lighting.

Unfortunately, garden design is beyond the remit of this book, but we show some examples of well-tended, imaginative gardens. Read on for some inspired modernist and rustic looks.

A clean-lined, rectangular pool is linked physically and decoratively with its surrounding courts, structures and gardens by expanses of ivory *palimanan* stone.

# EDGING **TOWARDS INFINITY**

**Even though the infinity-edge pool (also known as the negative-edge pool)** was first trialled in France in the late 1800s, the American architect John Lautner is considered the father of infinity-edge pool design. His vanishing edge of water at the Silver Top residence in Silver Lake, California, received rave reviews in 1957 and fueled the fires of infinity-edge experimentation. The '50s and '60s saw mass consolidation with the form in California, the Caribbean and Mexico in particular, with the pool engineer being elevated into the aquatic designer, aquatic architect, watershape designer or watershaper seemingly overnight.

Blurring boundaries between water and its surroundings is the infinity-edge pool's principle feature. Even though it sounds obvious, an infinity-edge pool is an in-ground pool that lacks one or more edges. This creates the illusion that the area of water lacking edges is supported by nothing. In fact, there is a water collection reservoir below the pool and out of sight which harnesses and filters back the overflow of water from the pool.

In the past 30 years Bali has proved fertile ground for imaginative aquatic designers. Most agree that such a pool is especially effective when the edgeless parts are located over high ground that drops away. They are also eye-catching when positioned near another water source such as an ocean, river or lake. Turn overleaf for Bali's infinity-edge classics.

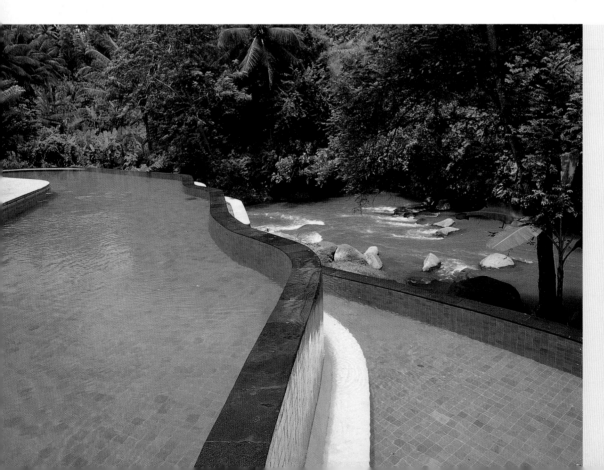

**Left** The free-form lines of this double-level pool at Four Seasons Resort at Sayan merge into the rushing waters of the mighty Ayung river below. **Right** A residence at Begawan Giri Estate designed by Cheong Yew Kuan, elevates water as its main element. The swimming pool is lined on one side with wooden decking and on the other . . . with a seemingly vertical drop into endless forest.

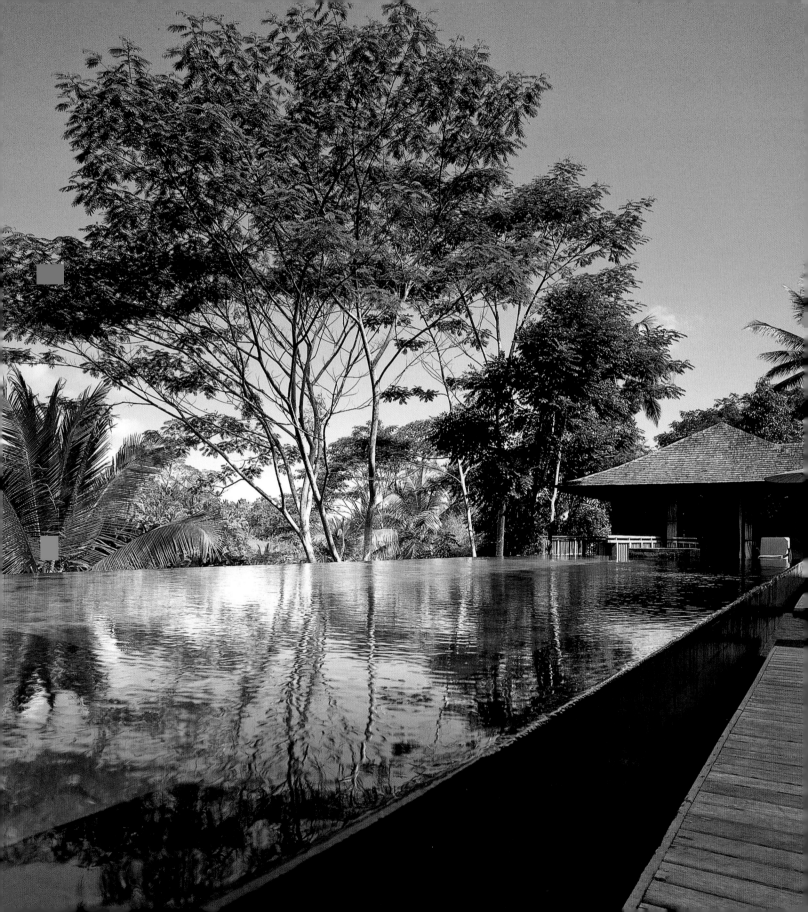

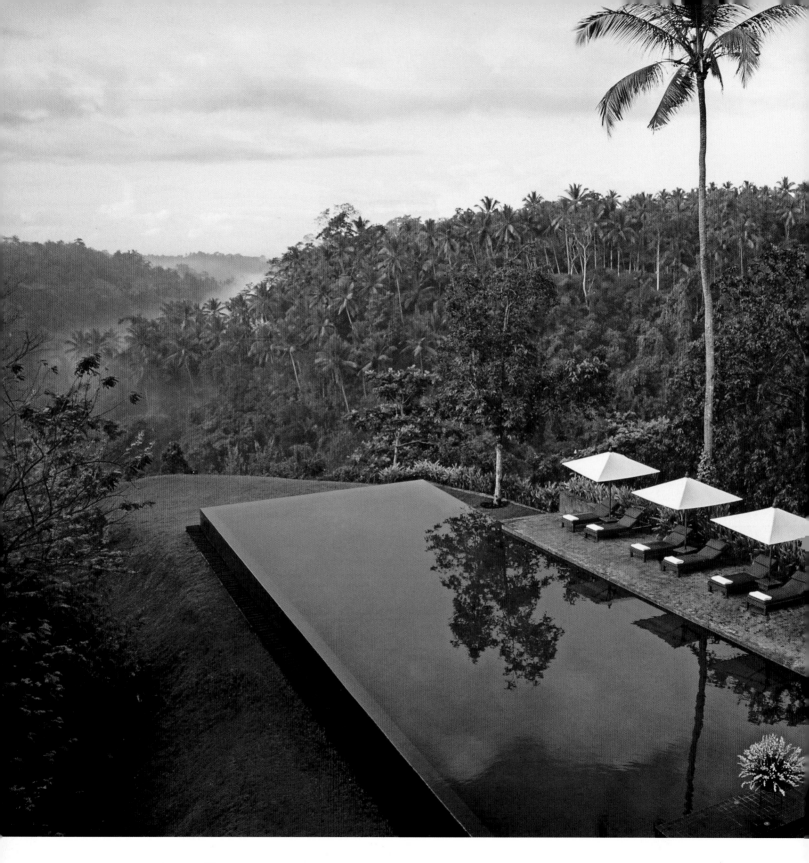

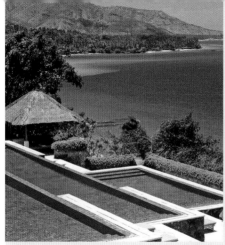

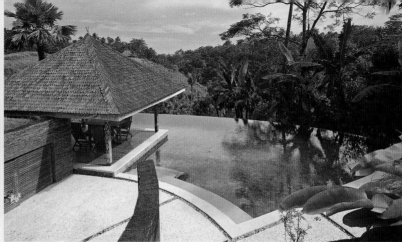

**Left** Designed by Kerry Hill for what was originally the Chedi in Ubud, this streamlined gem of an apparently floating pool has been much copied over the years. Its stark geometric form cuts like a knife into the surrounding jungle landscape.

**Above, left** Although not technically an infinity-edge pool, Ed Tuttle's multi-tiered design for the Amankila is included because it seemingly cascades down the hillside at a cantilevered gallop into the Indian ocean below. It has also spawned its fair set of copies.

**Above, right** Set on a steep slope, the gentle curve of this pool's edge seems to drop straight into the jungle beyond. The shingle-roofed *balé* placed poolside offers magnificent views, while the sinuous form of the deck mirrors the pool form.

**Below** Nestling into a steep rocky outcrop setting, this bi-level pool has astounding views over scrubby vegetation to the ocean beyond. Water from the top tier drops into the bigger bottom pool, which then recycles the water upwards again.

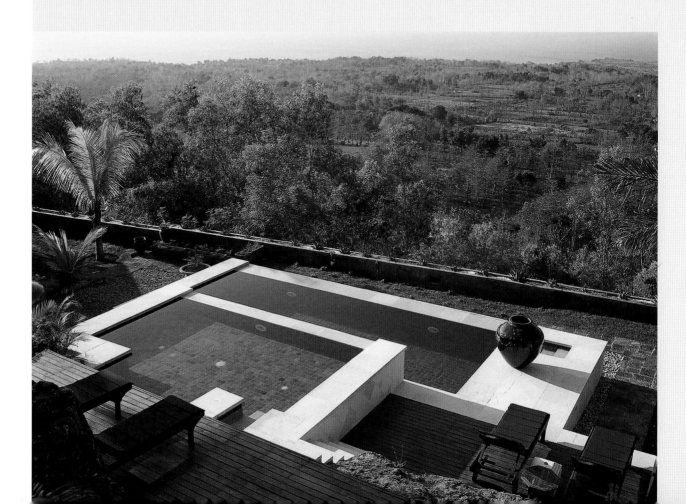

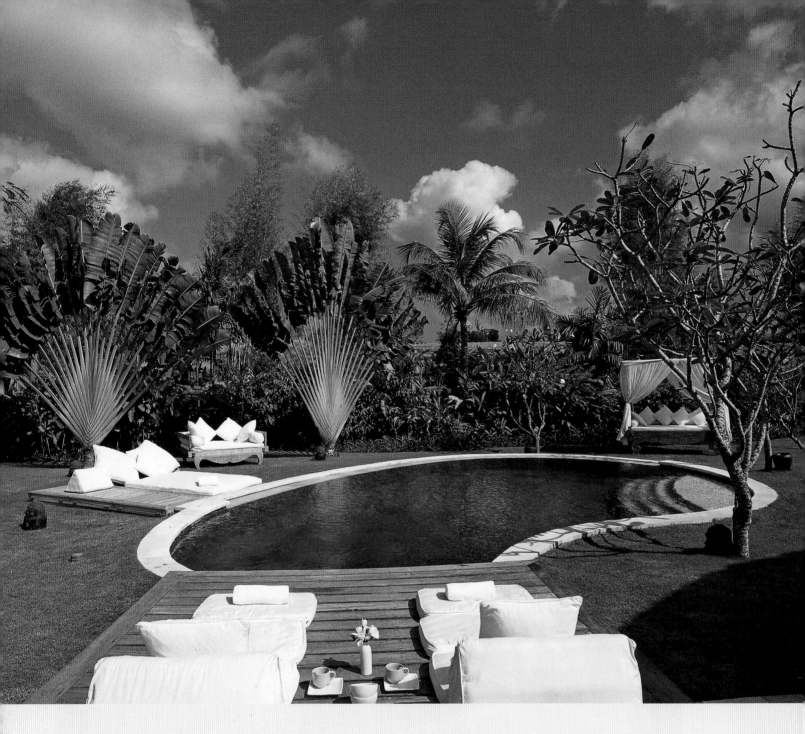

**Above and opposite, top** Ivory *palimanan* stone is used for pathway, deck edge and pool edge in this curvaceous, free-form swimming pool designed by Valentina Audrito. Soft white cushions and aged decking complete the bigger picture.

**Opposite, bottom** Detail of the *palimanan* steps and double edging showing the pool overflow facility.

# MULTIPLE EDGES

**Today, more than ever,** poolscapers have a plethora of choices when it comes to the materials used in swimming pool construction. Even though the lining of the pool is critical, it is increasingly the pool edging that is . . . well . . . edging up the design stakes.

A well-edged pool can elevate a blue blob in the garden to a water body with serious design credentials. Naturally, the edging needs to contrast in both color and texture with the inside tiles and the outside environment; that way, it draws the eye and pleases the senses.

Tiles, made from glass, slate or natural stones such as *sukabumi* with its greenish tone, still seem the first choice for pool linings. Despite a flirtation with dark, even black, tones, most people opt for azure, aquamarine and blue. These refract and reflect light, causing a pool to shine. When edged with darker, contrasting shades of stone, such pools are elevated to near-art status, especially if there is an infinity edge somewhere.

Take a look at our cutting-edge ideas: whether staying on the straight and narrow or tending towards the curvy and cool, they make for high definition statements.

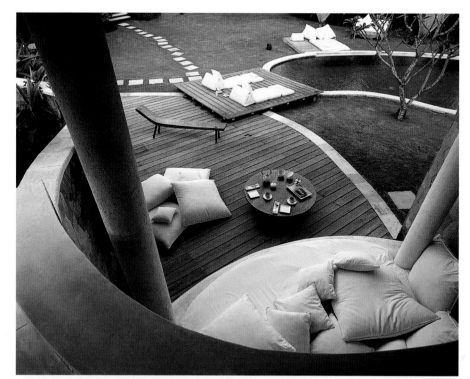

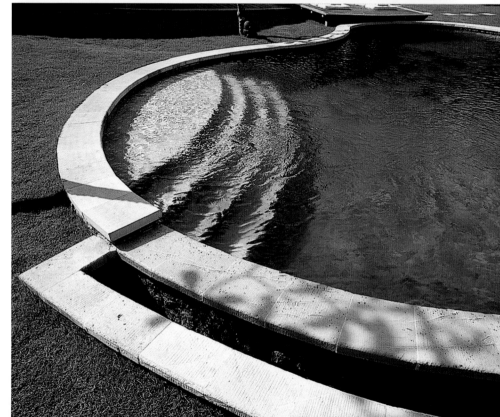

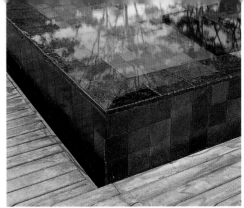

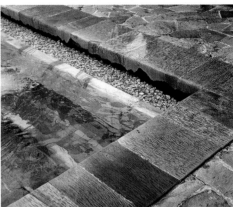

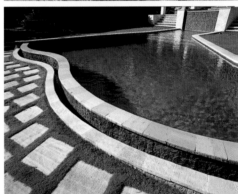

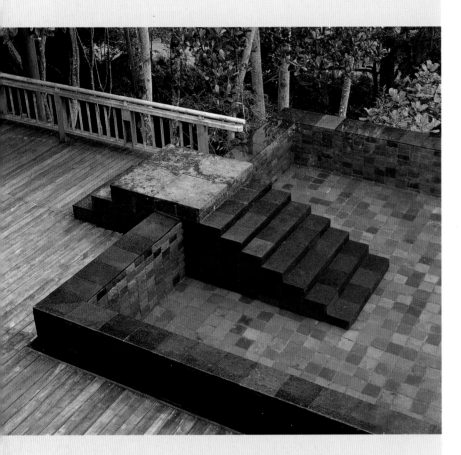

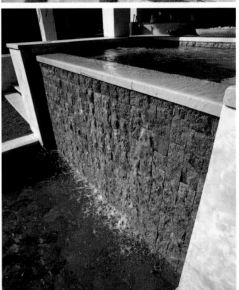

**Above** *Batu candi*, a grey lava stone, is used for the edging and steps in this pool. It contrasts beautifully with the aquamarine tone of the tiles.

**Right, from top to bottom** In the same pool, the clean lines of the grey edging are softened by the aged teak decking.

Limestone, in a variety of textures and sizes, is used along with small pebbles inside the lip of the pool to demarcate the edges at the Novotel Benoa. Designed by Lek Bunnag and Bill Bensley, the effect is multi-textured.

Another design by Audrito utilises *palimanan* for stepping stones inlaid in the grass and double-edged boundary of the pool. *Palimanan* is a type of sandstone that is often used roughly rendered for wall cladding and smooth for flooring.

A Jacuzzi overflow made from roughly finished *batu hijai* stone is attractive when the sun shines through the water to bring out the granite's green grain.

**Opposite** A simple rectangular pool, landscaped by Trevor Hillier, is given visual appeal with contrasting stone textures. The *palimanan wonosari* stone used for the decking continues through into the steps, whilst the edging is given definition with *batu candi* stone.

# THE BALINESE
## BALÉ

**Essentially comprising a platform base, some supporting pillars** and a pitched roof, the Balinese *balé* is a wonderfully adaptable architectural gem. With its origins in the island of the gods' rice fields and temples, it has now traveled the globe, gracing poolsides, gardens and courtyards from Australia to America.

Perfect as a lounging space, dining pavilion, entertainment centre or simple viewing platform, the *balé* can be as intricate or as simple as you like. Dress it up with ornate wood carving, sumptuous silks, floaty drapes and furniture, or keep it austere and unadorned. Either way, it is sure to become a talking point in any home — and a useful space to boot.

Madé Wijaya, arbiter of taste, design guru and expert on all things Balinese, describes the Balinese *balé* or pavilion as "the arms and legs of courtyard design". Originally considered a living organism, it was given consecration rites and even had its own shrine. Ceremonial pavilions were dressed in sarong and sash for special occasions. In today's homes, however, it is likely to serve a more functional role: See our selection for some bright *balé* ideas.

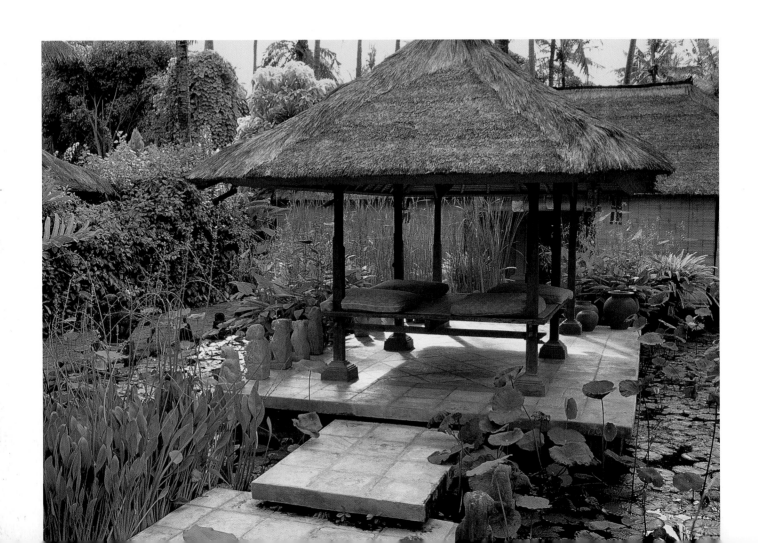

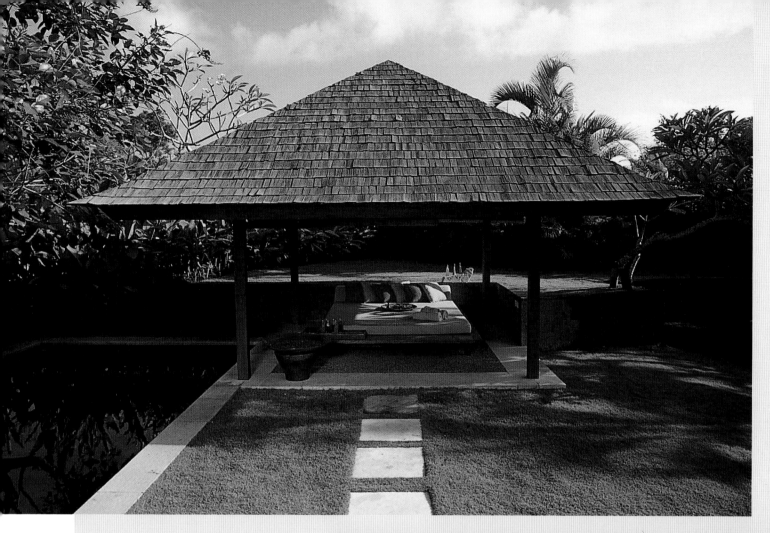

Above An over-large wood shingle roof, clean-lined columns and simple lounging platform give this *balé* a Japanese aesthetic.

Left Accessed by a small stone bridge, this *balé* is situated on a stone platform straddling a lotus pond. Water-cooled breezes bring natural air-conditioning into its confines.

Right A simple *balé* with a ceramic tiled roof and typical Balinese roof decoration sits aside a pool at the Grand Hyatt in Nusa Dua. The grounds at this resort are characterised by water bodies, with attendant *balés* and lounging spaces.

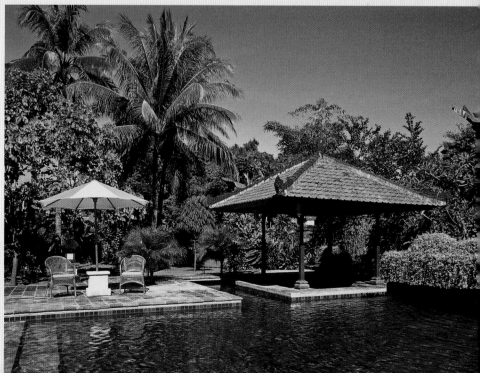

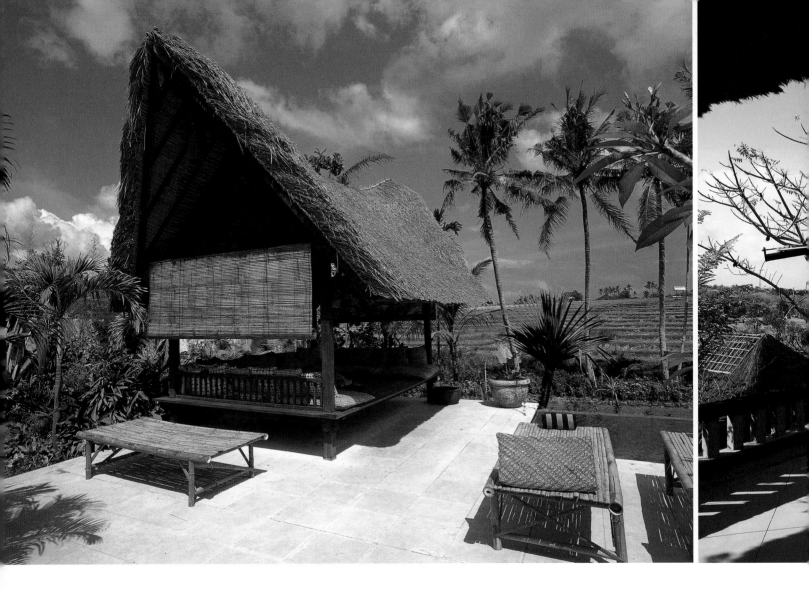

**Above** An upward sloping roof in the style of Toba Batak architectural traditions gives this poolside *balé* a distinctly imposing air. Sporting simple rattan matting and plenty of comfy cushions, it has the addition of roll-down chicks for further shading. Expansive rice field views are a bonus.

**Above, center** With a canvas umbrella style roof, sturdy limestone posts and elevated posiiton, this lounger is a modernist interpretation of the Balinese *balé*.
**Right** Pavilion architecture is the result of intense experimentation with different forms from as far afield as Polynesia, China, India, Indonesia and Japan. This *balé* is trad Balinese vernacular in form.
**Middle, right** A raised dining pavilion in one of the villa compounds at the Oberoi, Bali has views to the beach and sea behind.

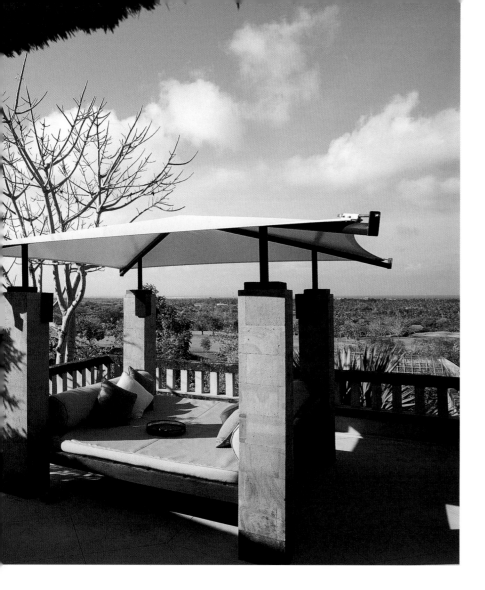

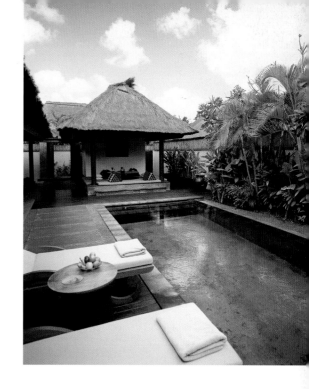

Above Of course, the *balé* has its equivalents in other Asian cultures, the Javanese *pendopo* and the Thai *sala* being two examples. Often employed poolside in Asian resorts, as here, they make for cool, shady lounging spots. This particular example, sporting a novel sunken dining table, is found next to a small pool within a compact, yet luxurious, mini-compound at the Club at the Legian.
Below The much-copied infinity-edge pool at Amandari in Ubud, designed by Peter Muller, features green slate tiles, a limestone trim and a perched 12-poster *balé* that doubles up as a stage for musicians in the evening.

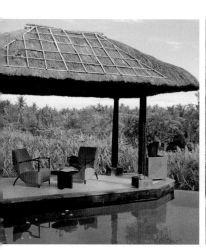

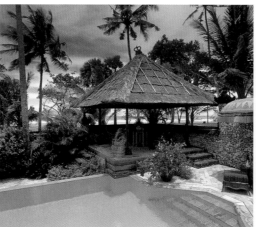

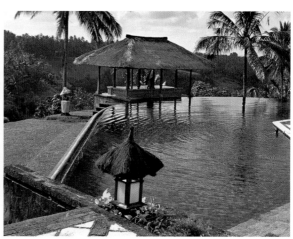

# OUTDOOR
# LIGHTING

**In the tropics, the garden** (or courtyard, patio, verandah, *balé*, pool deck, etc) is often chosen as a spot for nighttime entertaining. As such, its lighting is as important as the indoor lighting.

Outdoor lighting is all about introducing mood, atmosphere and sculptural forms into the garden, so don't overdo it; after all, a bit of mystery is far preferable to over illumination. Take into consideration light that will be "borrowed" from inside and indoor/outdoor spaces, and try to highlight key areas such as water bodies or a particularly beautiful tree (with a spot from below).

Tables need tea-lights, and not much more. Not only do they cast flickering light, they add scent such as lemongrass or citronella to deter mosquitoes. Candlelit lanterns on the pool perimeter and hanging lights from trees above or around a pool are preferable to in-built pool lighting — the latter is often too glaring. And verandahs need dimmers.

Garden light design is no longer the preserve of the Neanderthal; these days, there is huge choice. Of particular note is Bali's Wijaya Classics range: Primitive and modern styles of lamps and lanterns celebrate the time-honored artistry, skilled craftsmanship and indigenous materials of Southeast Asia.

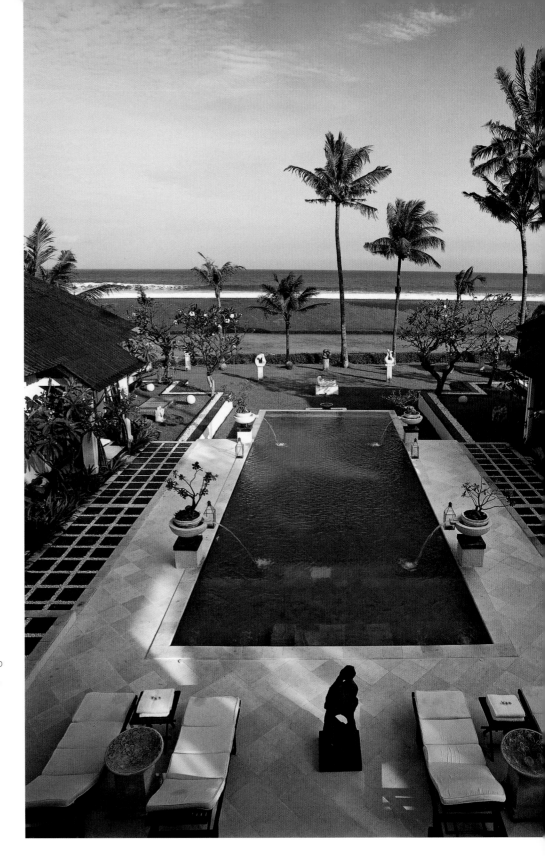

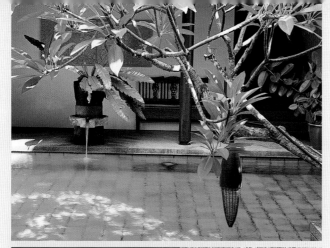

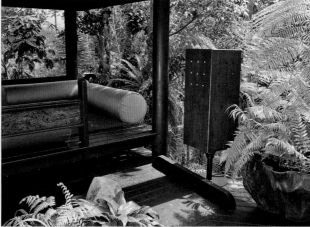

**Opposite** Sweet metal-and-glass lanterns alternate with stone gargoyles along the pool edge of this luxury villa for a romantic evening atmosphere.
**Top** Hand-crafted hanging lamp made from solid brass and finished with a natural, oxidized patina from the Wijaya Classics range is perfect for producing a dancing shadow effect above a pool.
**Above, center** A sturdy, perforated copper lamp on a simple stand prevents people from stumbling at night when entering this *balé*.
**Above** Large traditional thatch lanterns with dori crown on a decorative,

hand-carved base are used in this villa garden to throw light on elegant stepping-stone pathways; they also cast a gentle glow onto the trunks of the tall palm trees.
**Top** The same style of lantern lights up the lily pond in the Matahari garden at the Bali Hyatt garden.
**Above** A lantern from the Wijaya Classics range of garden lighting features a glazed ceramic hat, a metallic body with abstract pattern and a stone base. The red color of the hat adds attitude.

# BAMBOO SOLUTIONS

**Ubiquitous throughout the tropical world as both a building** and scaffolding material, bamboo is fast gaining credibility with architects and designers keen to explore avenues that impact less on the environment, use ecologically friendly materials and reflect the bio-diversity of a locale.

Long championed by Bali residents, designer Putu Suarsa and environmentalist Linda Garland, bamboo has always been popular in Bali. Its versatility has never been questioned: whether we're talking about the bamboo light sheath that was de rigeur in 1970s villas or the chic bamboo mixed with acrylic, polycarbonate, glass and steel structures of today, bamboo never goes out of fashion. Most people who live in the tropics have at least one bamboo chaise or sofa on their verandah, most likely crafted in one of Bali's furniture ateliers.

Bamboo offers an ecologically viable alternative to timber for construction as it is extremely fast growing. Also, unlike other trees, bamboo plants are not killed when harvested, so erosion problems are avoided. With 150 varieties available on the island of the gods alone, it makes for a practical alternative to wood from fast-diminishing tropical forest resources.

Linda Garland's non-profit concern, the Environmental Bamboo Foundation, is dedicated to furthering bamboo use and educating people about its many benefits; for further information, visit their website at www.bamboocentral.org.

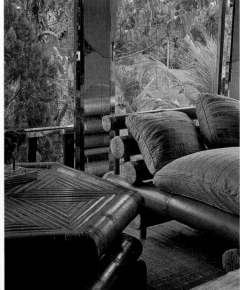

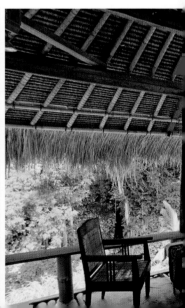

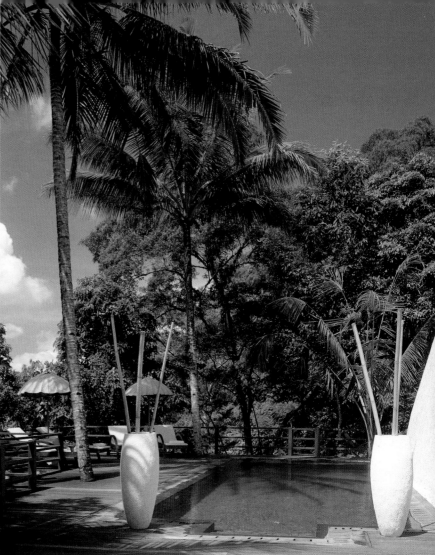

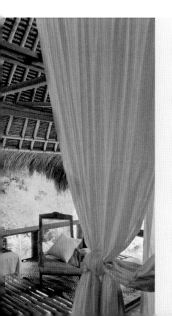

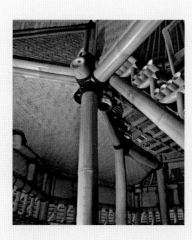

**Above, left** The entrance to designer David Lombardi's funky home is a mix of tropical materials: an *alang-alang* roof, a bamboo fence and an ivory *palimanan* stone gateway, accessed by path and stairs in local stone.

**Above** Perched high in mountainous jungle, this rectangular pool set within teak decking is extremely private and serene. Two limestone planters with decorative bamboo sticks are set on either side of the pool stairs.

**Opposite, far left** The headquarters of Linda Garland's bamboo foundation outside Ubud is called Nyuh Kuning or Yellow Coconut Village. It consists of a unique collection of structures that utilise bamboo in one way or another.

**Opposite, center** American artist, Nadya, built her atelier home in the 1980s using almost entirely recycled materials for walls, doors, flooring and furniture: here, we see a sofa and coffee table in dark-stained bamboo.

**Opposite, right** One of the buildings in Linda Garland's compound sports an airy verandah with split bamboo floor. It juts out into a ravine, merging the interior with the landscape.

**Left** Intricate roof, beam, wall and window forms, all constructed from bamboo.

# PAVING
## THE WAY

**The choice of materials for garden hardscapes is constantly expanding**, so, when planning pathways, patios and paving, the choice is almost limitless. Practicality (non-slip, good drainage) is important, as are the choice of attendant plantings and waterscapes.

Color is another factor that needs to be carefully considered, especially if the paving needs to contrast with the aquamarine of a bright-tiled pool. Dark grey is serviced by andesite and granite, lighter grey by concrete, ivory by limestone, and reds and browns by terracotta or bricks. Contrast can be achieved by setting pavers in a lawn of pebbles or by using pebbledash (the art of placing stones into a bed of mortar over a concrete base).

Naturally, rot-resistant wood is a popular option for pool decks as timber is readily available in the tropics. However, it can be artfully combined with stone edging or paving for added effect. And, when water is involved, remember to take into consideration reflections, the position of the sun and the possibility of slipping; a pathway snaking over a pool needs to be clearly delineated.

Take some inspiration from our selection of pathways on these pages; it's interesting to see how a path can create the optical illusion of making a space bigger than it actually is.

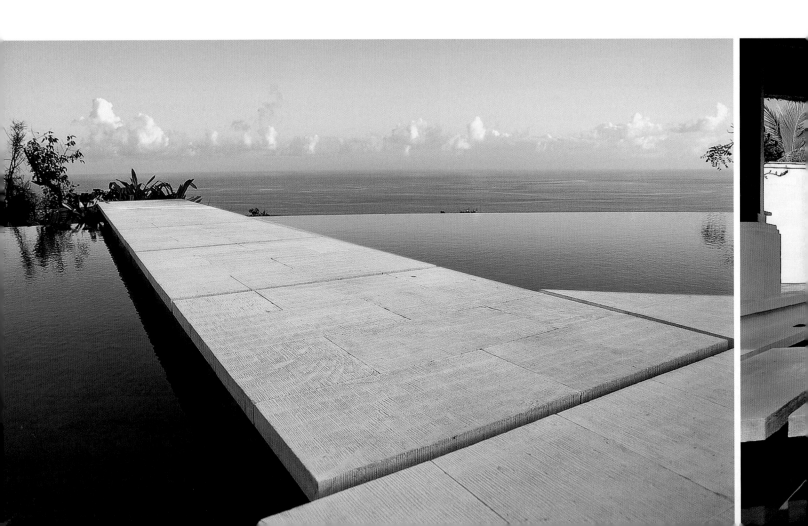

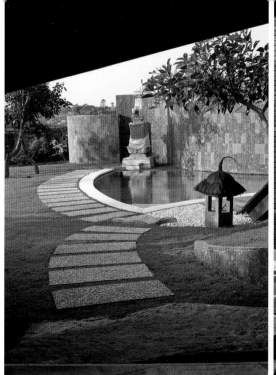  

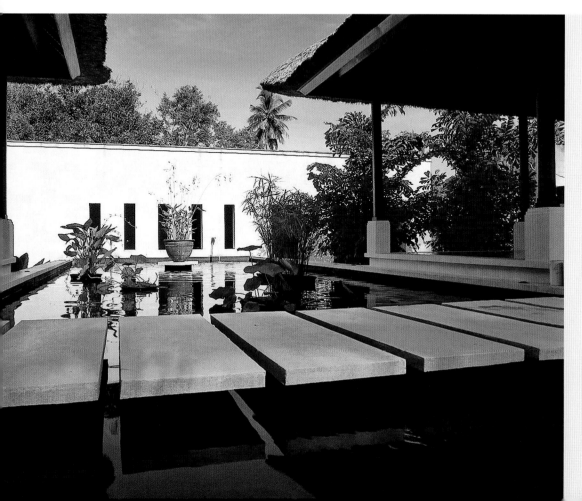

Opposite A white *palimanan* stone pathway leads from this deck across an expanse of pool to seeming infinity beyond. The purity of the stone serves to highlight the breadth of the water — both close and far.

Left The dining and lounge areas of this home, designed by Dutch architect Joost van Grieken, are connected by custom-made ivory paving stones elevated over water. The pathway is mirrored by the picture-window wall behind.

Above, left A ribbon of pebbledash set in the lawn leads out of this home to curve around the contour of the pool. Interjected with untreated stone, deck, pebbles and a limestone pool edge, the overall look is artfully naturalistic.

Above, center Grey andesite pavers and natural boulders contrast with a white pebble lawn and tidy wooden wall at Downtown Villas' entrance. The stark shape of the yuccas is sleekly modern too.

Above Mosaic-effect relief cast ceramic tiles set in an unerring straight line counterbalance the fecundity and fluidity of the plantings in this lily pond. Once on dry land, they are set in a bed of grey river stones.

# POOLSIDE **DECORATIONS**

**Tropical gardens are about much more than the plantings**, the pool and the pavilion. Around these three central elements one should find a multitude of moss-encrusted statuary, aged walls and gates, water features such as rills, fountains and gargoyles, pots and planters — and more. If made from stone or terracotta, they quickly take on an attractive patina when left outside, thereby adding character and mystery to a garden.

Balinese traditional religious symbols — statues, temple decorations, bas-reliefs of epic scenes, either originals or replicas — are now just as much part of a tropical villa's poolside decoration as is the ubiquitous lounger. Similarly, for special parties and events, populating a garden with *penjor* (the tall woven banners that decorate Bali's roads during the Galungan-Kuningan holy period) is festive and fun.

Whether you want a modernist, clean-lined solution to garden decoration or a rustic look with interesting textures and tones is ultimately up to you. We offer a variety of attractive ideas, ranging from contemporary and sculptural on these two pages to whimsical and witty overleaf. Take your pick.

**Opposite** This strategically placed Jacuzzi — between the verandah and the pool, creates a focus in this garden. The roundly carved wooden bowl with white pebbles adds a modern touch.

**Left** Sand-cast ceramic bowl with delicate patterning complements this clean-lined pool edge. By Philip Lakeman and Graham Oldroyd.

**Top** A Seike Torige shallow glass vessel, filled to the brim with delicate blooms, is eye-catching poolside.

**Above** Gardens, including the numerous water features at Four Seasons Resort at Jimbaran Bay, were designed by Madé Wijaya's atelier of Balinese craftsmen. This geometric patterned fountain is a good example of how different stones can be combined together for a pleasing decorative effect.

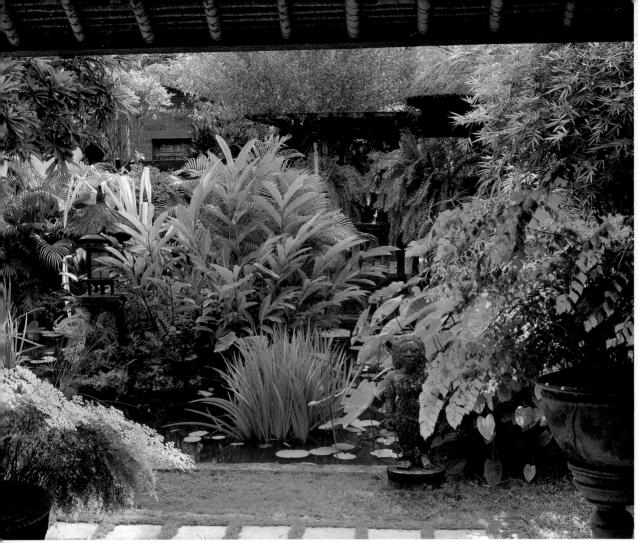

**Above** Water plays a significant role in the Balinese garden: in this area of a Villa Bebek court a profusion of ferns, heliconia, palms, iris, water lily and other water plants is accompanied by stone in the form of plinths, wall, statuary and urns.

**Left** An aged urn filled with fresh frangipani and hibiscus blooms nestles in a luxuriant corner of a resort garden.

**Above right** Carved from single pieces of teak, this dynamic chair and table duo makes a statement by a simple rectangular pool. The combination of the textural with the hard-edged is quite unusual.

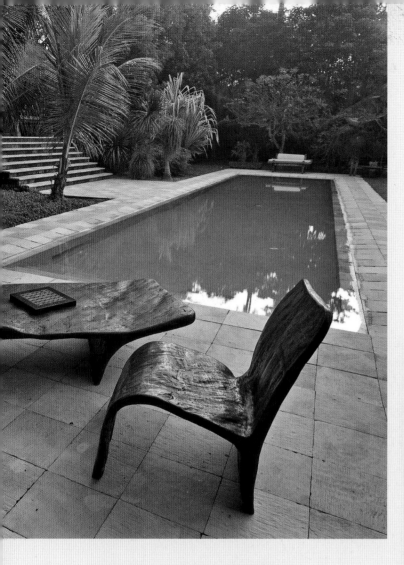

Below A limestone bowl of fruit on a plinth juts into a pool at the Novotel Benoa. All three pools at this resort were designed by Bill Bensley with poolscapes a riot of statuary, planters and fountains.
Below, left The Balinese Goddess of the Arts, Dewi Saraswati, has gathered moss and lichen after lengthy exposure to the humid conditions of a tropical garden. Set in a small court, she forms an atmospheric talking point.

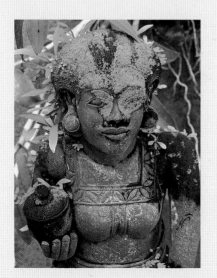

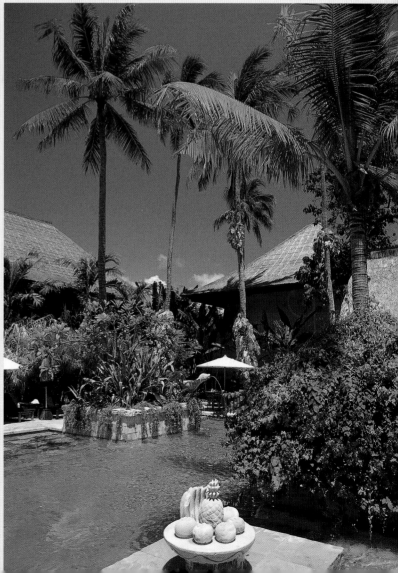

# ACKNOWLEDGMENTS

The author and photographer would like to thank a great many people for their help during the production of this book. To those who opened their homes for us, we are truly grateful. Many more gave logistical aid and encouragement, and we are particularly indebted to our friend and colleague, Gianni Francione, without whom we would not have a book at all. In addition, thanks go to:

### Home Owners

David Lombardi; the owners of Villa Umah de Beji; Carlo Pessina; Mike and Danielle Mahon of Villa Ylang Ylang; Claude Paparella; Leonard Lueras at Taman Mertasari; Joost van Grieken; Richard North-Lewis;  Filippos; Nadya;  Ross Franklin; Bruce Carpenter; Carole Muller; Christopher Noto; Lorne Blair; Edith Jesuttis; the owners of Villa Surga.

### Hotels, Resorts, Spas and Galleries

The Club at the Legian; The Legian; The Balé; Gaya Gallery; Kirana Spa; Como Shambhala Estate at Begawan Giri; Downtown Villas; Komaneka Resort; Four Seasons Resort & Spa at Jimbaran Bay and at Sayan; Alila Manggis; Alila Ubud; Galeri Esok Lusa; Warisan; Palanquin; The Oberoi; Amandari; Amankila; Martha Tilaar Eastern Rejuvenating Center; Grand Hyatt Nusa Dua; Bali Hyatt;  Tirtha Uluwatu; Novotel Benoa.

### Architects/Designers

Karina Zabihi of kzdesigns (www.kzdesigns.com); Jaya Ibrahim (jayaibrahim@jaya-associates.com); Shinta Siregar of Nexus Studio Architects (nexus@dps.centrin.net.id); Seiki Torige at Galeri Esok Lusa (gundul@eksadata.com); Etienne de Souza (etienne@idola.net.id); Roberto Tenace and Meriem Hall at Produs Trend (trend777@indosat.net.id); Carlo Pessina (www.nusafurniture.com); Valentina Audrito (vale-studio65@dps.centrin.net.id); Cheong Yew Kuan of Area Design (area@indo.net.id); Gianni Francione (giannfr@tin.it); GM Architects (gmarc@tiscalinet.it and gmarch@indo.net.id); Dominique Seguin of Disini (disini_bali@yahoo.com); Anneke van Waesberghe of Esprite Nomade (esp2000@indo.net.id); Sumio Suzuki (sumio@indo.net.id); Pintor Sirait (www. pintorsirait.com); Guiseppe Verdacchi (gvbali@indosat.net.id); Fredo Taffin of Espace Concept (www.espaceconcept. net); Filippo Sciascia (sciascia72@hotmail.com); Veronique Aonzo (mymonamour@hotmail.com); Jenggala Keramik (www.jenggala-bali.com); Graham Oldroyd and Philip Lakeman (www.ceramic-bali.com);  Dean Kempnich (deank91@hotmail.com); Marilena Vlataki (www.bali-marilena.com); Giada Barbieri (jada.b@tiscalinet.it); Madé Wijaya (www.ptwijaya.com); Glenn Parker of Glenn Parker Architecture and Interiors (gpai@indosat.net.id); Linda Garland (www.lindagarland.com).

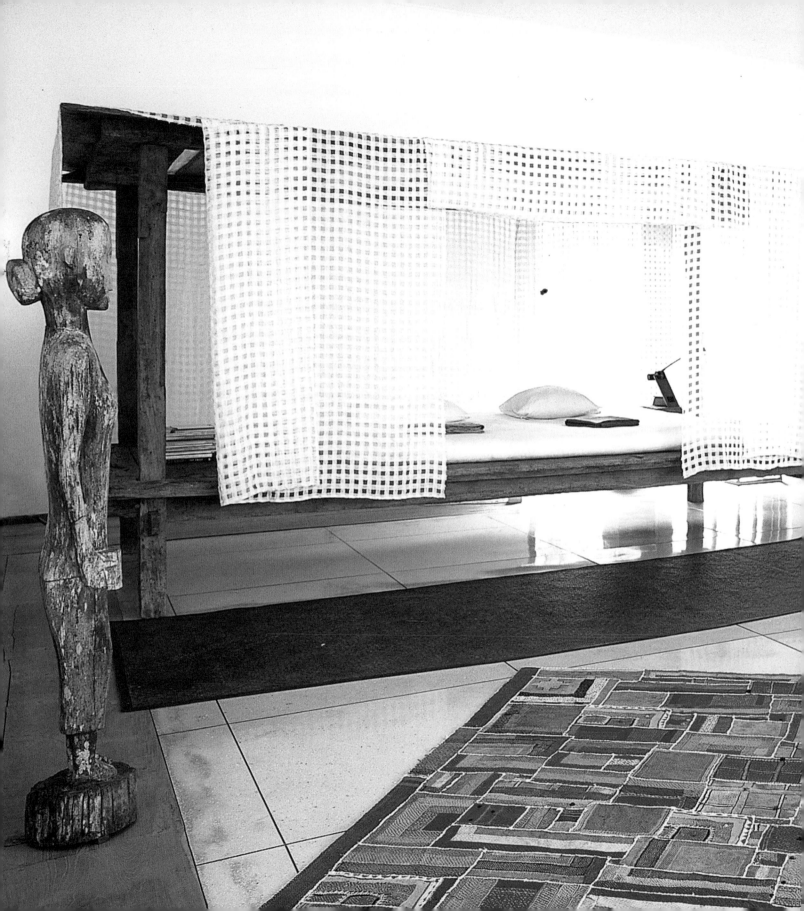